A History of Horror

WHEELER WINSTON DIXON

RUTGERS UNIVERSITY PRESS
New Brunswick, New Jersey, and London

LIBRARY OF CONGRESS CATALOGING-IN-PUBLICATION DATA

Dixon, Wheeler W., 1950–
 A history of horror / Wheeler Winston Dixon.
 p. cm.
 Includes bibliographical references and index.
 Includes filmography and top horror websites.
 ISBN 978-0-8135-4795-4 (hardcover : alk. paper) —
 ISBN 978-0-8135-4796-1 (pbk. : alk. paper)
 1. Horror films—History and criticism. I. Title.
 PN1995.9.H6D59 2010
 791.43′616409–dc22

 2009044965

A British Cataloging-in-Publication record for this book is available
from the British Library.

Visit our Web site: http://rutgerspress.rutgers.edu

Manufactured in the United States of America

A History of Horror

For Dana Miller, who made it through the night

I have found it! What terrified me will terrify others; and I need only describe the specter which had haunted my midnight pillow.

—Mary Shelley, Preface to *Frankenstein*

Where there is no imagination, there is no horror.

—Sir Arthur Conan Doyle

Contents

ACKNOWLEDGMENTS

BRIEF PORTIONS OF THIS BOOK previously appeared in the following publications: "The Site of the Body in Torture/The Sight of the Tortured Body: Contemporary Incarnations of Graphic Violence in the Cinema and the Vision of Edgar Allan Poe," *Film and Philosophy* 1.1 (1994): 62–70, Dan Shaw, editor; "The Child as Demon in Films Since 1961," *Films in Review* 37.2 (February 1986): 78–83, Roy Frumkes, editor; "Cinematic Interpretations of the Works of H. P. Lovecraft," *Lovecraft Studies* 22/23 (Fall 1990): 3–9, S. T. Joshi, editor; "Gender Approaches to Directing the Horror Film: Women Filmmakers and the Mechanisms of the Gothic," *Popular Culture Review* 7.1 (February 1996): 121–134, Felicia Campbell, editor; and a brief section on the film *Homicidal*, pages 18–23, from my book *Straight: Constructions of Heterosexuality in the Cinema* (Albany: State University of New York Press, 2003), courtesy of Jennifer Doling, Rights and Permissions Manager.

In creating this book, I have been most crucially assisted by Dana Miller, my typist for more than twenty years and, in many respects, a guiding force behind the creation of all my books; Jack Gourlay, horror buff extraordinaire; Dennis Coleman, whose vast knowledge of the cinema is a source of wonder; and other friends and colleagues, including Guy Reynolds, Marco Abel, Greg Kuzma, Murray Pomerance, Grace Bauer, Michael Downey, Stephen C. Behrendt, Steven Prince, Mikita Brottman, David Sterritt, Peter Brunette, Marcia Landy, Donovan K. Loucks, Deborah Minter, Kwakiutl Dreher, Bob Hall, Lloyd Michaels, David Sanjek, and Hilda Raz. Of course, my most sincere thanks also go to the staff at Rutgers University Press, who made the publication of this book possible, especially the editor in chief, Leslie Mitchner.

Two research trips to the Mayo Clinic in Rochester, Minnesota, were invaluable for gathering information to create this manuscript; my long conversations with Father David Byrne on the theological aspects

of the horror film, especially in the case of Terence Fisher, were most illuminating, and Deborah Fuehrer, of the Mayo Foundation Library, was also extremely helpful in locating reference materials in this regard. Most of the stills that grace this volume are from the Jerry Ohlinger Archive; many thanks to Jerry, as always, for his expert work in locating these ever-more-difficult-to-find images. Some of the stills in this text are from Photofest; my sincere thanks to Ron and Howard Mandelbaum for their help with this volume. Gretchen Oberfranc did a superb job in copyediting the final text. Jennifer Holan provided the index; my sincere thanks to her. Joy Ritchie, chair of the Department of English at the University of Nebraska, Lincoln, has steadfastly supported my work, for which I am deeply grateful. I also want to thank my colleagues in the department for their collegial and constant friendship. And, of course, I want to thank most of all Gwendolyn Audrey Foster, my wife, to whom I owe a literally incalculable debt.

Any work such as this truly has multiple authors; while this text reflects my lifetime fascination for the horror genre, it also builds upon the strengths of many other scholars who have accomplished significant work in the field and whose works are acknowledged in the bibliography. I have also made use of the Internet Movie Database to check release dates and titles of the films discussed here and have also found a number of interesting leads on Wikipedia, which, despite its uneven quality, offers a number of intriguing connections from one film to another, as well as links to sources for further research. What I have done here, then, is to examine some of the key films that formed the genre in the early years of the twentieth century and then trace the various permutations of the themes and iconic structures developed in these original films through a multiplicity of social and political landscapes. Where this ultimately leads is anyone's guess, but I hope I have offered here a detailed outline of the horror film's past, as well as some clues to the direction it will take in the future.

This text is organized in roughly chronological order, but of necessity there is considerable overlap, particularly in the case of "franchise" films, which can easily start in one era and continue through multiple iterations for several decades. Then, too, the years given in the chapter headings are approximate; there are always "outliers" in any genre, films

that defy the established values of a given time frame. And yet these periods of the genre–in which the basic precepts of the horror film were established, then burnished into conveniently reliable and malleable forms, and finally, after collapsing into parody, rose again and again to create new levels of intensity and menace–form the basic template of the history of the horror film, not only in the United States, but also throughout the world.

Certainly, no volume that deals with the entire field of horror films on a worldwide basis can be absolutely comprehensive, nor is it the intention of this book to attempt that task. During the 1940s, for example, Universal studios cranked out a plethora of minor horror films, including a group of "ape woman" films starting with Edward Dmytryk's *Captive Wild Woman* (1943) and continuing on through Harold Young's *The Jungle Captive* (1945), as well as series of films (such as Jean Yarbrough's *House of Horrors* [1946]) with Rondo Hatton, a young man affected in real life with the glandular disorder acromegaly, which distorted his features into the rough mask of a brutal killer; while interesting as a footnote, these films are hardly central to the history of the genre. Other, more major Universal efforts, such as Edgar G. Ulmer's *The Black Cat* (1934) and Louis Friedlander's (aka Lew Landers) *The Raven* (1935), co-starring Boris Karloff and Bela Lugosi, are also not detailed here; while both are remarkable films, they fall outside the world of the key figures in the Universal mythos (Dracula, the Frankenstein monster, the Wolf Man, the Invisible Man, and the Mummy). In considering which films to focus on, then, I tried to stick to the most representative examples of the genre, so if your favorite film is missing in action, it is only for reasons of space or continuity. What one will find in this volume are the key films that defined the genre, and continue to influence the horror films of the present day.

A History of Horror

CHAPTER 1

Origins

1896–1929

BEFORE THERE WERE horror movies, there were written or spoken horror narratives, fables handed down from one generation to the next, and, as we shall see, theatrical presentations designed to thrill and horrify audiences. The origins of the horror story may be traced to the beginning of narrative itself, or at least as far back as the Babylonian *Epic of Gilgamesh* (circa 2000 B.C.) and Homer's *Odyssey* (circa 800 B.C.), both of which involve a variety of contests between mortals and monsters with a strong otherworldly flavor, in which man is but a tool, or pawn, of the gods. Dante's *Divine Comedy* (1310) has served as the template for a series of terrifying visions of eternal damnation, as we shall see, and stories of lycanthropy can be traced to the Middle Ages, especially in French folk tales. Marlowe's *The Tragical History of Dr. Faustus* (1590), along with Johann Wolfgang von Goethe's two-part poem *Faust* (1808 and 1833), also proved fertile ground for filmmakers from the late nineteenth century onward, chronicling the tale of a man who sells his soul to Satan in return for illimitable wisdom and power, only to be (perhaps inevitably) disappointed by the transaction. Horace Walpole's *The Castle of Otranto* (1764) is generally considered the first horror novel, and the work of Gothicist Ann Radcliffe, whose most successful foray into the genre was undoubtedly *The Mysteries of Udolpho* (1794), was also popular with audiences. M. G. Lewis's *The Monk* (1795) was an even more horrific novel, and Charles Maturin's *Melmoth the Wanderer* (1820) chronicles another ill-advised pact with Satan.

Most famous of all these early works is Mary Shelley's *Frankenstein; or, The Modern Prometheus* (1818), which was created as the result of a bet of sorts by Lord Byron, who, ensconced in his summer house on Lake

Genève in 1816 with Percy Bysshe Shelley, John Polidori, Mary Godwin, and Claire Clairmont in attendance, proposed that he and his friends should try their hand at writing ghost stories to pass the time—the weather was cold and rainy, and created the proper mood for such an enterprise. Shelley and Clairmont ignored the suggestion; Byron himself started a short story and then abandoned it. But Mary Godwin (she was at this point Shelley's mistress and not actually betrothed to the poet) sat down and attacked the task with vigor and imagination—no small feat for an eighteen-year-old who had never written anything nearly as ambitious in her short life. When it was published in 1818, the novel became a sensation, and it has served, as everyone knows, as the basis for literally thousands of films, of all nationalities, from the dawn of cinema to the present.

For his part, John Polidori took Byron's fragment and expanded it into *The Vampyre: A Tale* (1819), imagining an aristocratic vampire as a figure of heterosexual erotic desire, a concept that would remain unexplored by the cinema, amazingly, until Terence Fisher's *Dracula* (1958; *Horror of Dracula* in the United States) made an overnight star of Christopher Lee as the bloodthirsty count. In addition, James Malcolm Rymer's serial *Varney the Vampyre,* which ran from 1845 to 1847, consisted of lurid tales told with penny-dreadful relish and the requisite amount of gore, suitably illustrated with blood-drenched engravings of Varney attacking a seemingly endless series of nubile victims.

Sheridan Le Fanu's *Carmilla* (1872) exhibited literary ambition of a much higher level, but it too had to wait nearly a century for its most inspired cinematic adaptation, Roger Vadim's hallucinatory *Et mourir de plaisir* (*Blood and Roses,* 1960), which fully exploited the lesbian theme of Le Fanu's source text. Victor Hugo's 1831 novel *Notre Dame de Paris* became the basis for Alice Guy Blaché's film *La Esméralda* (1905); Guy also directed a twenty-two-part sound version (with sound and music recorded on wax cylinders in synchronization with the images) of Goethe's *Faust* in 1905–1906.

In the mid- to late 1800s such disparate authors as Nikolai Gogol, Nathaniel Hawthorne, and, most notably, the tormented Edgar Allan Poe would all put their own stamp on tales of the weird and supernatural, with Poe, especially, embracing the short story format as the ideal vehicle for his tales of the macabre, such as "The Murders in the Rue Morgue" (1841) and "The Tell-Tale Heart" (1843). Robert Louis

Stevenson's *The Strange Case of Dr. Jekyll and Mr. Hyde* (1886) and *The Body Snatcher* (1885) further expanded the horizons of the horror genre. Wilkie Collins created the superb Gothic mysteries *The Woman in White* (1860) and *The Moonstone* (1868), and Oscar Wilde brought *The Picture of Dorian Gray* to life in 1890, in which a man's portrait ages while its subject remains eternally young.

Indeed, as one can see from this brief survey of supernatural literature, nearly all of the major thematic constructs that still fascinate us today—the man-made monster, the vampire, the pact with the Devil—date from this early period of experimentation. By the time Bram Stoker published *Dracula* in 1897 and the modern serial killer was embodied by Jack the Ripper, whose string of vicious murders began in August 1888 and ended with no clear resolution in 1889, most of the major themes of cinematic horror were fully formed.

In addition, Henry James's *The Turn of the Screw* (1898), one of literature's greatest ghost stories (superbly filmed in 1961 by director Jack Clayton as *The Innocents*) and Charlotte Perkins Gilman's feminist psychological horror story *The Yellow Wallpaper* (1899), in which a young woman is suffocated by the constraints of Victorian patriarchy and goes mad, also had a considerable influence on the development of the classic horror narrative. Short story writer W. W. Jacobs contributed "The Monkey's Paw" (1902), in which three wishes bring misfortune on a family that discovers too late the dreadful truth to the adage, "Be careful what you wish for."

Similarly, the horror film has been a cinematic staple since the inception of the medium. Thomas Edison, that most exploitational of entrepreneurs, produced the first filmic version of *Frankenstein,* directed by J. Searle Dawley, in 1910, but that film was preceded by a series of equally bloodthirsty entertainments, including the bizarre *Electrocuting an Elephant* (1903) and *The Execution of Mary, Queen of Scots* (1895), the first an authentic "snuff" film depicting the execution of a "rogue" circus elephant, and the latter a lip-smacking vignette depicting Mary Stuart's death by the ax. Indeed, the cinema was made to order for horror, bringing the various special effects, tricks, and prosthetic makeup devices used in theatrical presentations—such as the Grand Guignol in Paris—to a considerably larger audience.

Georges Méliès, too, dealt in the grotesque and the fantastic in his films from 1896 onward, most famously with *Le manoir du diable*

(*The Devil's Manor,* 1896), in which the director himself played a Mephistophelean vampire in a two-minute short often cited as the first true horror film. Méliès returned to the short in his 1898 *La caverne maudite* (*The Cave of the Demons*). Japanese filmmakers also created early, extremely short horror films, such as *Bake Jizo* (*Jizo the Spook*) and *Shinin no sosei* (*Resurrection of a Corpse*; both 1898, directors unknown).

Alice Guy Blaché, one of the true pioneers of the cinema, adapted Edgar Allan Poe's *The Pit and the Pendulum* into a thirty-minute "epic" in 1913, making a film much longer than most others of this era from Poe's slight tale of torture during the Inquisition. The extremely rare film *Le spectre rouge* (*The Red Spectre,* 1907), which for years lacked precise directorial attribution, has recently been identified as the work of the prolific Ferdinand Zecca and his scenarist, Segundo de Chomón; in its nine-minute running time it presents a series of phantasmagorical illusions involving a conjuring devil who levitates several women, shrinks them to doll size, and imprisons them in a series of glass bottles. Hand-tinted in lurid shades of red, *Le spectre rouge* is at once an item of morbid curiosity and a tour de force of trick cinematography.

Thomas Edison's 1910 version of *Frankenstein* was an ambitious affair for the period, with a viewing time of sixteen minutes, and featured Charles Ogle as the monster and Augustus Phillips as Frankenstein. Although the film's length allowed for only the briefest sketch of Mary Shelley's novel, the sequence in which Frankenstein brings his creation to life still exudes an eerie sense of the unknown, and, as with *The Red Spectre,* the film is suitably hand-colored in sepulchral hues of red, blue, and purple. Five years after that, the American director Joseph W. Smiley made the oddly titled *Life Without Soul,* a five-reel 1915 production of *Frankenstein.* Despite the sensationalistic subject matter and the novel's notoriety, the film was a commercial and critical failure, even after extensive recutting with additional "scientific footage." In Italy, Eugenio Testa directed yet another version of the Frankenstein saga, *Il mostro di Frankenstein* (*The Monster of Frankenstein,* 1921), running nearly four reels, or forty minutes.

Other "origin" films from the primitive days of the genre include Méliès's *Une nuit terrible* (*A Terrible Night,* 1896), in which a man is menaced by a giant beetle; Méliès's *L'auberge ensorcelée* (*The Bewitched Inn,* 1897), a brief vignette of a traveler trying to sleep while his clothing

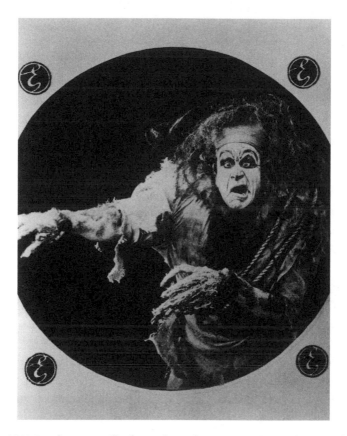

1. The 1910 *Frankenstein;* Charles Ogle as the monster. Courtesy: Jerry Ohlinger Archive.

takes on a life of its own; George Albert Smith's *Photographing a Ghost,* an 1898 film in which a frustrated photographer attempts to "capture" a ghost on film; and Méliès's *La colonne de feu* (*The Column of Fire;* aka *Haggard's She: The Pillar of Fire,* 1899), a one-minute film that depicts the final scene in Sir H. Rider Haggard's novel *She,* in which the queen of a lost civilization gains immortality by stepping into a sacred fire (compare this to Robert Day's 1965 version of *She,* with Ursula Andress, or Irving Pichel and Lansing Holden's 1935 version—Méliès was once again way ahead of his time).

Films of the bizarre and curious remained popular during the formative years of the cinema, including Walter R. Booth's short film *The Haunted Curiosity Shop* (1901), in which the proprietor of an antique

shop is confronted by a mysterious skull; Méliès's most famous film, the science-fiction/horror genre-bending *Le voyage dans la lune* (*A Trip to the Moon,* 1902), with its grotesque moon creatures, which can be dispatched into a puff of smoke with a whack of a well-aimed umbrella; and Alf Collins's bizarre *The Electric Goose* (1905), in which a goose is brought back to life, in a classical "mad lab" manner, with electrical apparatus. All of these films attested to the public's fascination with the unusual. Abel Gance, who would direct the epic film *Napoleon* in 1927, created *La folie du Docteur Tube* (*The Madness of Dr. Tube*) in 1915, shot in an abstract fashion with fragmented visuals, as a mad scientist's attempts to alter the nature of light go spectacularly awry.

Otis Turner's 1908 American version of *Dr. Jekyll and Mr. Hyde* was the first film version of Robert Louis Stevenson's novel, a thirteen-minute adaptation of a London stage play originally starring Richard Mansfield, with a young Hobart Bosworth as leading man. Viggo Larsen's Danish film *Den graa dame* (*The Grey Lady,* 1909), a Sherlock Holmes mystery, involves a mysterious ghost woman and a series of unexplained murders. A 1912 version of *Dr. Jekyll and Mr. Hyde* directed by Lucius Henderson starred future director James Cruze in the title role. The lurid *Conscience* (1912), a Vitagraph film directed by and starring Maurice Costello, featured a complex plot involving a chamber of horrors that drives a young man to death by fright and his wife into incurable insanity. And Luigi Maggi's Italian film *Satana* (*Satan,* 1912), adapted from John Milton's *Paradise Lost,* was a forty-minute spectacle that dwarfed many contemporary productions in size and scope.

Maurice Tourneur created the French production of *Le système du docteur Goudron et du professeur Plume* (*The Lunatics*), a 1913 horror film based on Poe's short story "The System of Doctor Tarr and Professor Fether," which would be remade in Mexico in 1973 as *La mansión de la locura* (*Mansion of Madness,* aka *Dr. Tarr's Torture Dungeon*) by director Juan López Moctezuma, with large quantities of sex and violence added to the project. In Germany, actor/director Paul Wegener seemed obsessed with the Jewish folklore figure of *The Golem,* co-directing a sixty-minute feature version with Henrik Galeen in 1915, then co-directing a sequel with Rochus Gliese, *Der Golem und die Tänzerin* (*The Golem and the Dancing Girl*), in 1917 and finally co-directing with Carl Boese *Der Golem, wie er in die Welt kam* (*The Golem: How He Came*

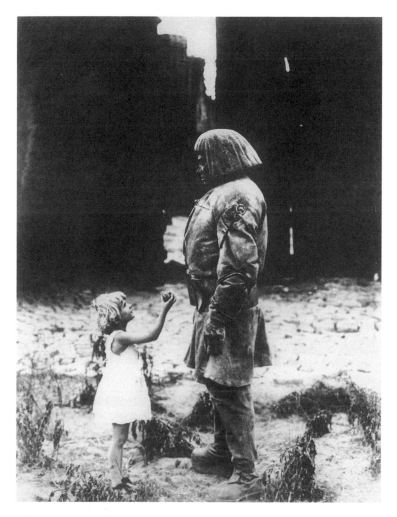

2. Paul Wegener in the 1920 version of *The Golem*. Courtesy: Jerry Ohlinger Archive.

into the World) in 1920. Wegener played the leading role in all three, but only the 1920 version survives.

Even more unusual is the 1913 production of *The Werewolf*, directed by Henry MacRae, who would go on to a long career as a director in both the silent and the sound eras, including his co-direction of Universal's *Flash Gordon* serials in the late 1930s, with a script by feminist filmmaker Ruth Ann Baldwin. Shot on location in Canada and running

eighteen minutes, *The Werewolf* tells the story of a young Navajo woman, Watuma (Phyllis Gordon), who is taught by her vengeful mother to hate all white men and turns into a wolf to attack them when they threaten her hearth and home. Generally considered the first cinematic telling of the werewolf legend, the film was unfortunately destroyed in a fire in 1924, and only secondhand accounts of its existence remain.

The screen had to wait for a definitive interpretation of Bram Stoker's *Dracula* until F. W. Murnau directed the first version, *Nosferatu* (1922)—but Murnau made the film without bothering to get permission from Stoker's estate. This moody, expressionistic vision of the classic vampire tale (employing negative images spliced directly into the positive print for an otherworldly effect, stop-motion photography to speed up the action, and other trick effects) was anchored by the mesmeric performance of Max Schreck in the leading role, and for many, for sheer atmosphere and visual brilliance, it has never been equaled.

When Stoker's widow discovered the existence of Murnau's unauthorized version, she demanded that all prints of the film be destroyed, along with the master negative. Thankfully, this never came to pass, as enough fugitive negatives and prints survived to ensure the film's continued existence, and now, fully restored, the film is readily available on DVD. *Nosferatu* is one of the few truly accessible horror films of the period, along with Robert Wiene's *The Cabinet of Dr. Caligari* (1920), a masterpiece of German Expressionist horror and paranoia centering on a somnambulistic murderer named Cesare (Conrad Veidt), who, under the direction of the sinister Dr. Caligari (Werner Krauss), commits a series of brutal murders in a small town. The grisly plot may or may not exist only in the imagination of the film's narrator, who is ultimately revealed to be an inmate of an insane asylum—an asylum run by Dr. Caligari himself. The script of *Caligari* was partially the work of future director Fritz Lang, who devised the film's famous unresolved ending.

Gaston Leroux's novel *The Phantom of the Opera* (1911) was adapted to the screen by Rupert Julian in 1925, with Lon Chaney Sr. in the title role; the "Man of 1,000 Faces" created a bravura performance that to this day remains unrivaled. Other writers, such as H. G. Wells, produced a mixture of horror and science-fiction novels along with other, more conventional works, such as *The Island of Dr. Moreau* (1896), which first came to the screen in Erle C. Kenton's superb *Island of Lost Souls* (1932),

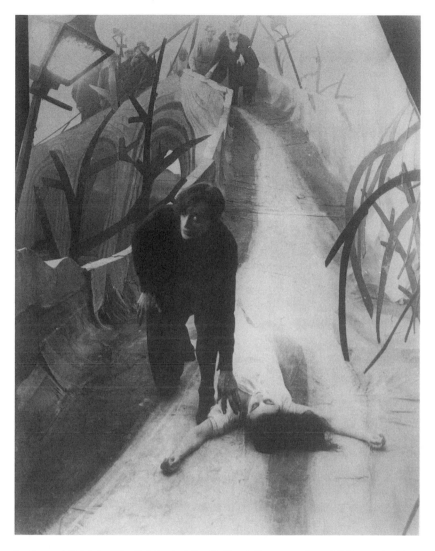

3. Conrad Veidt in *The Cabinet of Dr. Caligari*. Courtesy: Jerry Ohlinger Archive.

with Charles Laughton as a mad scientist intent on transforming jungle animals into humanoid hybrids in his laboratory, known to the island's inhabitants as "The House of Pain." Oscar Wilde's *The Picture of Dorian Gray* was filmed numerous times in the early years of the cinema, appearing in silent versions in 1913, 1915, 1916, and 1917; since then, the tale has gone through numerous additional adaptations.

Perhaps the most influential Gothic writer of the twentieth century, though he reaped little reward for his efforts within his own lifetime, was Howard Phillips (H. P.) Lovecraft, who wrote for the "pulp" magazines of the 1920s and '30s, lived a life of penury, and died in obscurity in 1937. His many works, such as his novella *The Case of Charles Dexter Ward* (1927), adapted, finally, by Roger Corman as *The Haunted Palace* in 1963 (with the title of a Poe poem tacked on as a sales gimmick), and his grisly serial *Herbert West—Reanimator* (1922), which reached the screen in near-parody form in Stuart Gordon's over-the-top *Re-Animator* (1985), and which Lovecraft originally wrote for the pulp magazine *Home Brew* for the astonishingly low fee of $5 per episode, or a total of $30 for six episodes, show him to be one of the most original horror writers of his era.

During this same period, film serials became popular, with a chapter being shown each week to enthralled audiences, each with a "cliff-hanger" ending to keep the audience coming back for more. One of the more sensationalistic examples was T. Hayes Hunter's *The Crimson Stain Mystery* (1916), a sixteen-chapter serial detailing the efforts of mad scientist Dr. Burton Montrose (Thomas J. McGrane) to create a master race; his experiments spawn abominable mutant beings that declare war on the society that rejects them with a wave of criminal activity. Louis Feuillade's *Les vampires* (*The Vampires,* 1915) is perhaps the most famous and influential serial of the era, with nine chapters, each running roughly three reels in length. Feuillade not only directed the film, but also wrote the serial's convoluted scenario, which chronicles the exploits of a group of daring criminals who employ a vast array of electronic devices to aid in their nefarious enterprises.

Bertram Bracken's 1917 *Conscience* was loosely based on John Milton's epic poem *Paradise Lost,* while Cecil B. DeMille's 1917 feature *The Devil-Stone* was a full-blown melodrama from a story by Beatrice DeMille and Leighton Osmun, dealing with a brilliant emerald, coveted by many, which has been cursed by Satan himself. In 1915 stop-motion model animator Willis O'Brien, who would bring his classic character *King Kong* to the screen in 1933, produced and directed *The Dinosaur and the Missing Link* for Thomas Edison. In the film, which many consider a dry run for his later, more celebrated creation, O'Brien began his life-long obsession with stop-motion models and miniatures, creating one of

the cinema's first explorations—albeit a highly fanciful one—into the origins of man. Even Ernst Lubitsch, who would later become internationally celebrated for his sparkling sex comedies, tried his hand at a horror film during this period, the curious *Die Augen der Mumie Ma* (*The Eyes of the Mummy,* 1918), with Emil Jannings and Pola Negri.

Fred Niblo's *The Haunted Bedroom* (1919) details the adventures of reporter Betsy Thorne (Enid Bennett) as she investigates mysterious happenings at a haunted estate. Erich Kober's German film *Lilith und Ly* (*Lilith and Ly,* 1919), with a screenplay by Fritz Lang, concerns itself with a statue that comes to life through the power of a magical jewel. Conrad Veidt's aptly titled *Wahnsinn* (*Madness,* 1919), produced and directed by and starring Veidt, centers on a prosperous banker whose life comes apart after an unfortunate encounter with a fortune teller. Director Richard Oswald's German film *Unheimliche Geschichten* (*Tales of the Uncanny,* 1919) was one of the first "omnibus" horror films, a format that persists to the present day, in which a group of short tales of horror and suspense is woven into a feature-length film. Once again, the star is Conrad Veidt, who was rapidly becoming a central figure in the horror genre, years before he portrayed the sinister Major Strasser in Michael Curtiz's *Casablanca* (1942).

John S. Robertson's adaptation of *Dr. Jekyll and Mr. Hyde* (1920) was highlighted by matinee idol John Barrymore's intense interpretation of the title role and thankfully still survives. In the same year, producer Louis Meyer (no connection with Louis B. Mayer) rushed into production his own version of Stevenson's classic tale, directed by J. Charles Haydon and with Sheldon Lewis in the title role. This cheapjack affair in no way approaches the power or artistry of the Robertson version, which was almost universally acclaimed as a cinematic masterpiece, due in large part to Barrymore's performance. Barrymore was appearing on Broadway in Shakespeare's *Richard III* at the time, shooting the film during the day and then being whisked off to the theater for an equally demanding role each night. The strain was eventually too much for the actor, who collapsed from a nervous breakdown at thirty-eight years of age.

Meanwhile, in Hollywood, Lon Chaney Sr. was poised to become a major horror film star, consolidating a long apprenticeship in the cinema with George Loane Tucker's *The Miracle Man* (1919), from a play by song-and-dance man George M. Cohan, in which Chaney Sr. appeared

as a supposedly crippled man who is miraculously "cured" by an unscrupulous "healer." Chaney had been kicking around in silent films since 1913 after a hardscrabble childhood, in which his deaf parents taught him to communicate with them through the use of facial expressions and pantomime, skills that stood him in good stead in the world of the silent cinema. After several years on the road in musical comedy roles, Chaney quit the stage and made the trip to Hollywood, where he rapidly rose in the movie business due to his nearly incomparable skill with makeup, leading to his famous sobriquet, "The Man of 1,000 Faces."

By 1915 Chaney was so much in demand that he was directing and starring in films for Universal—he directed six films in that year alone. His real success came with such films as Wallace Worsley's *The Penalty* (1920), based on Gouverneur Morris's short story, which, although nominally a crime melodrama, gave Chaney ample range to display his talents as a makeup virtuoso in the role of a master criminal whose legs are amputated, leading him to seek vengeance on society at large. But all this activity was just the curtain raiser for Chaney, whose talents would fully blossom in such films as Worsley's *The Hunchback of Notre Dame* (1923), Roland West's *The Monster* (1925), in which Chaney played an archetypal mad scientist, and, perhaps most famously, Rupert Julian's version of *The Phantom of the Opera* (1925), which instantly became Chaney's signature role. It was followed by Tod Browning's *The Unholy Three* (1925), another crime drama, in which a gang of three bizarre crooks—a strongman, Hercules (Victor McLaglen), a dwarf, Tweedledee (Harry Earles), and their leader, the ventriloquist Echo (Chaney)—wage a campaign of terror and deceit against conventional society.

Sadly, Chaney's career had by then reached its climax; in the now lost feature film *London after Midnight* (1927), directed by Tod Browning, Chaney appeared in one of his most impressive makeup designs as a *faux* vampire, but with the transition to sound films, which Chaney resisted, his star began to wane. Chaney's last film was a sound remake of *The Unholy Three* in 1930, directed by Jack Conway, which thankfully survives and suggests that, despite his personal misgivings, Chaney would easily have made the transition to the new medium. In the 1930 version of *The Unholy Three,* as in the original, Chaney appears much of the time in drag disguise and adopts a distinctly "feminine" voice, only to be tricked at the end of the film into revealing his true gender in a

4. Lon Chaney in Tod Browning's lost film, *London after Midnight*. Courtesy: Jerry Ohlinger Archive.

courtroom witness box, as prosecutor John Miljan extracts a confession from him through trickery and surprise tactics. The scene works much more effectively in the sound version than in the silent one, for obvious reasons, and Chaney pulls off the aural and visual masquerade brilliantly.

But during the filming, Chaney's throat began to bother him, and although he completed the production, it would be his last work. Only one month after the completion of the 1930 version of *The Unholy Three,* Chaney died of bronchial cancer at the age of forty-eight. He left behind a son, Creighton Tull Chaney, who would abandon his early

career as a plumber and enter the film business in 1932, soon changing
his name to Lon Chaney Jr. to capitalize on his father's reputation. The
often-maligned Chaney Jr. would become one of the most recognized
horror stars of the 1940s, working at his father's home studio, Universal,
and would gain a certain immortality with the creation of his signature
role, that of Lawrence Talbot, the Wolf Man, in George Waggner's
1941 film of the same name.

One of the most bizarre and most often censored films of the early
period is undoubtedly Benjamin Christensen's *Häxan* (*Häxan: Witchcraft
Through the Ages,* 1922), which was produced in Sweden by Svensk
Filmindustri, the national film company that would fund most of direc-
tor Ingmar Bergman's films beginning in the late 1940s. *Häxan* is a direct
attack on conventional religion. As director and scenarist Christensen
details the history of witchcraft from the Middle Ages onward, the film
abounds with scenes of nudity, sadism, and violence, complete with a
Black Mass depicted in graphic and uncompromising images that
shocked many viewers of the era and still retain their power today.

In Russia, director Yakov Protazanov produced the weird science-
fiction/horror film *Aelita* (aka *Aelita, Queen of Mars,* 1924), in which a
race of robots is found on Mars. Walt Disney began a long flirtation with
the supernatural with one of the short films in his *Alice in Cartoonland*
series, *Alice's Spooky Adventure* (1924), in which the title character is
menaced by a variety of animated spectral beings. Henry Otto's visuali-
zation of *Dante's Inferno* (1924), from a screenplay by future director
Edmund Goulding, was another unusually graphic film for the period, in
which a brutal and unscrupulous business magnate, Mortimer Judd
(Ralph Lewis), falls asleep while reading Dante's poem, is shown a vision
of Hell, and repents his sins. Leading lady Pauline Starke (as Nurse
Marjorie Vernon) played much of the film in the nude, surprisingly for
an American production, while her fellow inmates in Purgatory wore
flesh-colored body stockings to afford the appearance of naked torment.

Dante's Inferno is suffused with an intense sexuality, similar to that of
Häxan; hundreds of scantily clothed extras are shown wallowing in the
flames of perdition, creating a suitably nightmarish vision. It is interest-
ing to note that when the Fox Film Corporation remade *Dante's Inferno*
in 1935 under director Harry Lachman, with Spencer Tracy cast as an
unscrupulous carnival impresario and gambling overlord, much of the

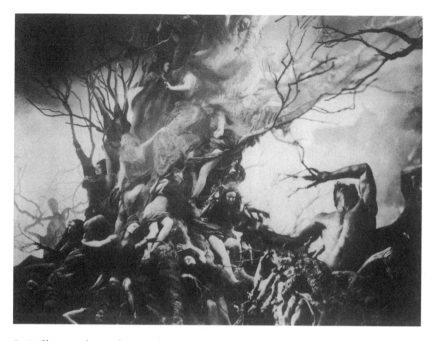

5. Hell as a place of eternal torment in the 1924 version of *Dante's Inferno*. Courtesy: Jerry Ohlinger Archive.

footage of Hell from the 1924 version was printed up again and inter-polated within the new narrative as a still-effective vision of eternal torment.

Robert Wiene, who had scored so decisively with *The Cabinet of Dr. Caligari* in 1919, returned to prominence in 1924, after the critical and commercial failure of his film *Genuine* (1920), with the grim *Orlacs Hände* (*The Hands of Orlac*), in which the now seemingly typecast Conrad Veidt appeared as internationally renowned concert pianist Orlac, whose hands are hopelessly mangled in an accident. A transplant operation is the only solution, and so Orlac receives a new pair of hands—the hands of a murderer. *The Hands of Orlac* has been remade numerous times; among the more influential versions were Karl Freund's 1935 *Mad Love*, with Peter Lorre in the mad doctor role, and Edmond T. Gréville's *The Hands of Orlac* (1960), shot simultaneously in French and English and starring Mel Ferrer as the tormented pianist, with Christopher Lee as the unscrupulous Nero, who tries to blackmail Orlac after discovering his secret.

Leo Birinsky and Paul Leni's *Das Wachsfigurenkabinett* (*Waxworks*, 1924) is the first in a long series of films in which a wax museum figures as the central location for tales of mystery and horror. In this case, future director William (then Wilhelm) Dieterle, who would go on to direct Charles Laughton in the remarkably faithful 1939 remake of *The Hunchback of Notre Dame,* is an out-of-work poet who gets a job in a wax museum writing copy describing the various figures on display. This central plot device serves to yoke three stories together, including one vignette starring the now-inevitable Conrad Veidt as Ivan the Terrible, who is depicted as a murderer who delights in tormenting his victims, and another with Werner Krauss as Jack the Ripper. *Waxworks* was the first film to convey the inherent menace of a wax museum, in which dummies either come to "life" or are imbued with an artificial existence through the power of imagination. It was remade in two-strip Technicolor by Michael Curtiz in 1933 as *The Mystery of the Wax Museum,* starring Lionel Atwill, and again in 3-D Natural Vision (as *House of Wax*) by director André de Toth in 1953 with Vincent Price in the leading role.

The prolific Edgar Wallace saw many of his horror and mystery novels adapted to the screen, including Spencer Gordon Bennet's version of *The Green Archer* (1925) as a ten-chapter serial; James W. Horne remade it in 1940, also as a serial, at Columbia Pictures. The French experimental filmmaker Jean Epstein made a feature-length film of Edgar Allan Poe's *The Fall of the House of Usher* (1928) in the same year that Melville Webber and James Sibley Watson created a short, experimental version of Poe's work; at the fringes of the cinema, independent filmmakers were starting to make a mark on the horror genre.

By this time, too, the horror genre was overdue for parody, and such trifles appeared as Fred Guiol and Ted Wilde's *The Haunted Honeymoon* (1925), a two-reeler centering on the misadventures of a honeymoon couple in a haunted house. This light and pleasant film was remade, after a fashion, in 1986 by actor/director Gene Wilder as *Haunted Honeymoon,* starring Wilder and his wife, Gilda Radner; it was Radner's final role in a feature film before her untimely death. Paul Terry's *The Haunted House* (1925), an animated cartoon with a supernatural theme—much of Terry's work in his later sound cartoons would deal with the supernatural and the bizarre—and Dave Fleischer's *Koko Sees Spooks* (1925) also

gently spoofed the by-now-established genre, while Walt Disney consolidated his hold on extreme effects in animation with his groundbreaking short *The Skeleton Dance* (1929), one of the first sound animated cartoons, in which a group of skeletons cavort in a graveyard to musical accompaniment. The first of Disney's "Silly Symphonies" series, the film was a sensation at the box office and encouraged Disney to undertake more adventurous projects in the years ahead.

F. W. Murnau, by this time one of the screen's foremost purveyors of the macabre and the fantastic, outdid himself with his production of *Faust—Eine deutsche Volkssage* (*Faust,* 1926), based on Goethe's writings and centering on the damnation of a misguided academic, Faust (Gösta Ekman), who sells his soul to the Devil in exchange for supposedly unlimited knowledge. Recently restored in a magnificent DVD version, *Faust* is perhaps Murnau's finest achievement, topping even *Nosferatu,* which somehow survived in better condition (until now). It was one of Murnau's last films in Germany before his emigration to the United States and his death soon after in an automobile accident in 1931.

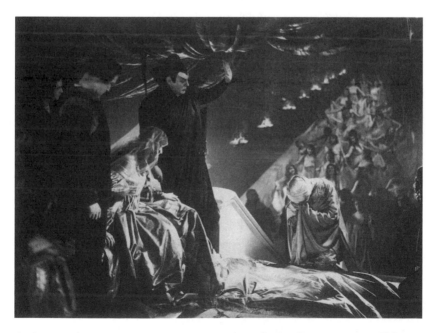

6. A scene from F. W. Murnau's masterpiece, *Faust.* Courtesy: Jerry Ohlinger Archive.

Visually stunning, *Faust* pits Mephistopheles (Emil Jannings) against the forces of Heaven in a simple wager: If Satan can seduce Faust into accepting a pact with him, then all Earth will fall under Satan's control. The picture of Satan enveloping a sleeping, unsuspecting town with his vast black cape and unleashing a plague on the world is one of the most awe-inspiring images in silent cinema. As it turns out, seven separate negatives for the film were created for the international market, each markedly different, and when Murnau left Germany for the United States, he took what many consider to be the definitive version with him.

For years, *Faust* has been available only in a 1930 version pasted together by UFA Film, the film's producers, from footage Murnau left behind when he decamped to the States. The newest version is stunningly clean, proof that films can, occasionally and providentially, come back from the brink of oblivion under the proper auspices. The 2009 reconstruction, created using a master plan of the material unearthed by Luciano Berriatúa of Filmoteca española, brings this haunting film back to life, providing the contemporary viewer with a visual experience that, when projected with proper digital equipment on a theater screen, approximates as closely as possible the power and authenticity of Murnau's original vision.

As the silent era came to a close, a handful of masterpieces appeared, among them Fritz Lang's well-known futuristic nightmare *Metropolis* (1927), about a civilization in collapse. *Metropolis* (begun in 1925 and finally completed in 1927) is a massively scaled science-fiction saga of a future civilization in which the poor are condemned to a life of near-slavery to satisfy the needs of the rich. The film used thousands of extras, enormous sets, and lavish special effects to dazzle audiences with a dystopian fable of society gone awry, a world in which social justice does not exist. With its vision of a hyper-capitalist, consumer-driven world of the future, Lang's *Metropolis* became the template for every cinematic vision of dystopia since, from William Cameron Menzies's epic *Things to Come* (1936) to George Lucas's *Star Wars* films (the first in 1977, with many sequels) and Ridley Scott's *Blade Runner* (1982), with numerous offshoots in between. *Metropolis* has gone through a number of edits in its long and illustrious life; the most complete current version runs 124 minutes in length, but in 2008 a 210-minute version, with many missing

scenes, was discovered in a museum in Buenos Aires, and it is now being restored for DVD release.

D. W. Griffith's *The Sorrows of Satan* (1926), based on an 1895 Faustian novel by Marie Corelli, features the demonic Adolphe Menjou as Prince Lucio de Rimanez, the Prince of Darkness in human form, who sets his sights on struggling writer Geoffrey Tempest (Ricardo Cortez), persuading him to leave his true love, Mavis Claire (Carol Dempster), for the overripe charms of Princess Olga (Lya De Putti) and the lure of immediate success. Henrik Galeen's *Der Student von Prag* (*The Student of Prague,* 1926), based on a novel by Hanns Heinz Ewers, which in turn was inspired by Edgar Allan Poe's short story "William Wilson," stars Conrad Veidt as Baldwin, a young student who sells his soul to the Devil for money and power.

Galeen's was actually the second version of the tale; in 1913, Stellan Rye and Paul Wegener co-directed their own interpretation of *Der Student von Prag,* which became one of very the first "breakout" hits that created an international market for German films. Meanwhile, German director Paul Leni, the auteur of *Waxworks,* followed the route of many of his compatriots when he left his homeland for a career in Hollywood, and in short order he created *The Cat and the Canary* (1927), based on a play by John Willard. Perhaps the ultimate haunted house story, *The Cat and the Canary* has been filmed numerous times since, in both serious and parodic versions. Although Leni's version has a certain power, Hollywood took much of the earlier sheen off his work, as it bent him to the will of the studio system. G. W. Pabst, prior to departing for the United States, created the brutal *Pandora's Box* (1929), in which the young and attractive Lulu (Louise Brooks) ruins the many men in her life with a variety of schemes and ruses, only to be murdered by Jack the Ripper in the film's final moments.

Universal, which would become the key horror studio from the early 1930s until the mid-1940s, would continue to benefit (as would the other major studios, albeit to a lesser degree) from the exodus of talent from Germany, which accelerated when Hitler swept to power in 1933. Indeed, the German Expressionist tone of such films as James Whale's *Frankenstein* (1931) is directly attributable to the influence of the Continental horror film, and Leni's work on this somewhat pedestrian script is what makes the project work. A skilled and resourceful imagist,

Leni took his source material and transformed it into a visual tour de force, simultaneously laying the groundwork for an endless series of "old, dark house" mysteries.

Benjamin Christensen, who had scored an international success with his film *Häxan,* moved to the United States from his native Sweden and ran into a problem that continues to plague the film industry to the present day: an all-consuming interest in the bottom line, in producing lowest-common-denominator films to reach the widest possible audience. Hollywood quickly put him to work, but the job was strictly "work" rather than art. Adapted from a play by Owen Davis, Christensen's first American film, *The Haunted House* (1928), is an utterly conventional effort in every respect, featuring a sinister, deranged scientist (billed only as "The Mad Doctor," which gives some idea of the generic feel of the piece) played by Montagu Love. The completed film, a tepid comedy/horror blend, was both pedestrian and predictable.

Not content with this, First National Pictures shoved Christensen into an equally vapid follow-up, *The House of Horror* (1929), a comedy-horror film starring Mack Sennett veterans Louise Fazenda and Chester Conklin and containing a brief sound sequence in an otherwise silent film. Christensen was then pressed into service to direct *Seven Footprints to Satan* (1929), based on the well-known novel by Abraham Merritt, concerning the search for a fabulous jewel in a haunted castle. Despite Christensen's desperate attempt to bring some life to the proceedings with his customarily dazzling visuals, the film collapses under the weight of a contrived dénouement. Filmed with limited dialogue sequences, plus added music and sound effects, *Seven Footprints to Satan* is one of those curious films that awkwardly straddled the gap between the sound and silent eras with distinctly limited success.

Director Paul Leni, the creator of *Waxworks,* had better luck in Hollywood with his production of *The Man Who Laughs* (1928) for Universal, a film that also reunited him with Conrad Veidt, one of the stars of *Waxworks.* In *The Man Who Laughs,* Veidt plays the role of Gwynplaine, a young man whose face has been disfigured so that his features are contorted into a permanent, hideous grin. Gwynplaine is in love with a young blind woman, Dea (Mary Philbin, who had starred as the ingénue in the original version of *The Phantom of the Opera*). A complex set of subplots drives the lovers apart; Gwynplaine discovers that he

7. Conrad Veidt in *The Man Who Laughs*. Courtesy: Jerry Ohlinger Archive.

is descended from royal blood, and the opportunistic Duchess Josiana (Olga Baclanova), seeing a potential for personal gain, tries to alienate Gwynplaine's affections.

Despite a somewhat artificial happy ending, *The Man Who Laughs* is remarkable for its grotesque makeup and its perverse scenario, as well as Veidt's understated performance. The film was also, quite famously, the inspiration for the character of the Joker in Bob Kane's comic strip *Batman*. *The Man Who Laughs* was remade, after a fashion, by director William Castle in 1961 as *Mr. Sardonicus*.

In 1928, sound definitively came to the horror film with *The Terror,* directed by journeyman Roy Del Ruth from a popular play by thriller writer Edgar Wallace. Despite the inherent clumsiness of the production due to bulky early sound equipment, the film transfixed audiences and was an instant box-office hit, just as Alan Crosland's part-sound film

The Jazz Singer (1927) had been the year before. There had been, as already noted, part-talking horror films in the final years of the silent era, but *The Terror* was Warner Brothers' second "all-talking" film. Coming from the studio that pioneered the commercial use of sound in motion pictures, it rode a wave of popular acclaim to become a substantial hit for the company, bringing the silent horror film to an unceremonious end. The film's promotional tagline said it all: "It will thrill you! Grip you! [. . .] HEAR this creepy tale of mystery—the baffling story of a detective's great triumph. With voices and shadows that will rack your nerves and make you like it. Come, hear them talk in this Vitaphone production of the play that has gripped London for over 3 years."

With this change there came a complete shift in pictorial values; visuals, which had once driven the horror film, were now relegated to background effects, and sound became the linchpin of the medium. The visually acrobatic brilliance of such artists as Pabst, Leni, and Murnau almost immediately suffered; those directors who were younger and perhaps more adaptable, such as Fritz Lang, prospered, although Lang was never really a horror auteur. The age of silent horror cinema had been a period of fecund experimentation in which the literary classics of the past had been plundered for source material and relatively new concepts (the figures of the werewolf and the mummy) had been introduced to the popular imagination for the first time.

But as sound technology improved rapidly in the early 1930s, the camera once again was free to create a plethora of visual effects to astound and horrify audiences, which brings us to another key element in the horror film—one that comes directly from the stage. For horror films, no matter what their literary origins, owe a considerable debt to another influence, this one both theatrical and disturbingly visual. Le Théâtre du Grand Guignol, founded in 1894 by the Frenchman Oscar Méténier, occupied a small (293-seat) theater in the Pigalle district of Paris, but its influence was worldwide.

From the day of its opening to the public in 1897, the Grand Guignol specialized in one kind of entertainment over all others: presentations of graphic violence and horror, which in their explicit detail and amorality are surprisingly close to the most brutal contemporary horror films. Under the direction of Max Maurey from 1898 to 1914, the Grand Guignol specialized in brief "playlets" that dealt with insanity,

violence, murder, and wanton amorality. Maurey's principal scenarist, André de Lorde, wrote more than a hundred plays for the Grand Guignol, often working with experimental psychologist Alfred Binet to heighten the disturbing reality of his scenarios.

Maurey judged the success of a performance from the number of theatergoers who fainted from shock or left in disgust. Adding to the blasphemy of the presentations was the fact that the theater had previously been a chapel; the theater boxes were designed to look like Catholic confessionals, and paintings of angels adorned the proscenium arch of the main stage. From 1914 to 1930, the formative period of the narrative cinema, Camille Choisy, the Grand Guignol's artistic director, continually improved the special effects used in the theater's grisly spectacles, while Paula Maxa, the theater's leading lady, became known as "the most assassinated woman in the world." By one count, Maxa was "murdered" more than ten thousand times in plays between 1917 and 1930, and "raped" three thousand times during the same "entertainments."

Synopses of three scenarios by de Lorde should suffice to give a sense of the international depravity of the brief plays presented at the Grand Guignol each evening, usually performed in groups of five to six at one sitting. In *Le laboratoire des hallucinations* (*The Laboratory of Hallucinations*), a doctor finds that his wife has been unfaithful to him and subjects her lover to brutal brain surgery, rendering the man a hallucinating idiot. Seized with a sudden violent impulse, the lobotomized victim pounces on the doctor and drives a blunt instrument into the doctor's brain, killing him. *Un crime dans une maison de fous* (*A Crime in a Madhouse*) offers the spectacle of two older women blinding a young, pretty inmate with a pair of scissors because they are jealous of her beauty. *L'horrible passion* (*Horrible Passion*) is simpler and even more violent; a seemingly caring nursemaid brutally murders the children in her care, with copious amounts of gore. In these brief, shocking scripts, there was often no motivation for the crimes committed, and the perpetrators were seldom brought to justice for their deeds. In short, the Grant Guignol depicted a world of evil and insanity triumphant.

The reach of the Grand Guignol was worldwide, and the Parisian theater was a "hot ticket" for slumming aristocrats and thrill-seeking "bright young things" out for a night on the town. But as World War II began and after the Nazis occupied Paris in 1940, the theater became

something of a relic. As Charles Nonon, the Grand Guignol's final direc-
tor, noted, "We could never equal Buchenwald. Before the war, every-
one felt that what was happening on stage was impossible. Now we
know that these things, and worse, are possible in reality." The theater
closed its doors in 1962. Although a brief attempt was made in London
in the 1920s to present an English "version" of Grand Guignol, it was
only marginally successful; certainly, local censorship rules would have
rendered such an enterprise impossible in the United States during this
era. Today, however, the San Francisco theatrical troupe Thrillpeddlers
performs English translations of "classic" Grand Guignol playlets in a
small theater that the troupe has dubbed the Hypnodrome.

The lasting impact of Grand Guignol is arguably most seen in the
cinema. If these violent visions have now come back to haunt us at the
multiplex, perhaps it is because they were first presented with unabashed
and unapologetic relish for an audience that clamored for more. Splatter,
then, is nothing new. Only the medium of transmission has changed,
and Grand Guignol violence has become the standard by which modern
horror films are judged. But in the 1910s and 1920s, the cinema could
only hint at what the Grand Guignol presented with graphic specificity,
and this self-imposed restraint—due also, of course, to the twin exigen-
cies of social norms and censorship—allowed a golden age of cinematic
horror to flourish.

CHAPTER 2

Classics

1930–1948

BETWEEN 1931 and 1948 one studio dominated the production of horror films, not only in the United States, but worldwide. That studio was Universal Pictures, which began an aggressive slate of horror films in 1931 with Tod Browning's *Dracula,* based on the stage adaptation of Bram Stoker's novel by John W. Balderston and Hamilton Deane. Though Browning's direction was unusually static, hampered by the constraints of early sound recording, the film was an immediate sensation with the public and made an overnight star of Bela Lugosi. In his native Hungary Lugosi had been something of a matinee idol on the stage, appearing in major roles from 1901 on, sometimes using the stage name Arisztid Olt. His real name was Béla Blasko, and the "Lugosi" surname derived from Lugos, Hungary, where he was born in 1882. The young Lugosi was drawn to politics and worked to form an actors' union in Hungary, but he was forced to flee when his political activities on behalf of the leftist regime he favored made him persona non grata upon the collapse of the government.

Traveling to Germany, Lugosi worked in films for a time, then emigrated to the United States in 1921 and began playing bit parts in films and on the stage. Learning English was difficult for Lugosi, who was by nature a proud and somewhat vain man, not accustomed to acquiescing to the demands of others. Nevertheless, he persevered, and by 1927 he was playing the lead in Balderston and Deane's stage version of *Dracula,* followed by two years on the road with the same production.

By the time Universal tapped Lugosi to reprise his stage role on film, the actor had played it hundreds of times and had no difficulty other than having to cut down his theatrical "projection" for the camera, not always

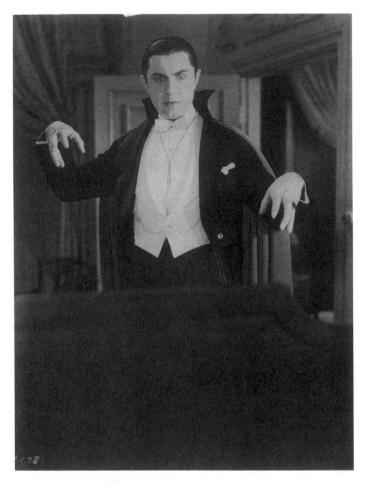

8. Bela Lugosi in his classic role in *Dracula*. Courtesy: Jerry Ohlinger Archive.

with success. In the early days of sound, the studios realized that the easiest way to adapt to the new medium was to transport both Broadway plays and their casts to Hollywood and essentially photograph the plays with a minimum of camera movement. Indeed, at the time, sound recording was usually done on large shellac phonograph discs, and directors would typically set up three or four cameras to cover a scene simultaneously in order to give some sense of cinematic style to their productions.

Lugosi, however, soon found himself hopelessly typecast as the bloodthirsty Count, or as a mad scientist or Satanist, and displayed remarkably poor judgment in his business dealings with the studios, which were only

too happy to take advantage of his vanity and naïveté. When *Dracula* proved a hit, Lugosi accepted all offers that came his way, appearing in no fewer than five horror films in 1932 alone, often at cut-rate prices in threadbare productions. As the star of Victor Halperin's classic *White Zombie* (1932), for example, Lugosi collected a paycheck in an amount somewhere between $500 and $800 (accounts vary), although at the time he was the hottest horror star in the film capital. *White Zombie* is superbly constructed, but as an independent production with minimal funding, it could not approach the lavish detail of *Dracula,* and Lugosi had marked himself as an easy target for cut-price producers. In the same year, he also appeared in Edwin L. Marin's *The Death Kiss* (1932), made for the fly-by-night independent Worldwide Studios on a routine murder mystery set in a Hollywood film studio, again for a fraction of the fee he should have been able to command.

Then, too, Lugosi suffered a tragic career setback when he was dropped as the lead in James Whale's *Frankenstein* (1931), when Whale replaced scheduled director Robert Florey at the last minute and decided that Lugosi would not be effective in the role. Had this not happened, Lugosi might well have cornered the market on cinematic menace in Depression-era Hollywood; as events transpired, of course, the role made the unknown Boris Karloff an overnight star, even though he was billed in the film's credits only as "?" to increase the mystery surrounding his role as the monster.

Lugosi had been deprived of the role of a lifetime, and thus missed not only a chance to originate the sound version of Frankenstein's monster, but also to broaden his public persona. The impact of the decision was almost immediate; by 1934, Lugosi was reduced to working in cheap films like Clifford Sanforth's *Murder by Television,* a dull film with static direction in which Lugosi plays twin brothers and trudges through a desultory plot having little to do with the title. Finally, as the result of an unscrupulous doctor's treatment for ulcers, Lugosi became addicted to morphine, and his health, along with his career, rapidly deteriorated.

But Lugosi's name still had marquee value, and so Universal lured him back to work in a variety of sequels and alternative roles in its horror films. In 1943 he finally donned the Frankenstein monster's famous makeup for Roy William Neill's *Frankenstein Meets the Wolf Man,* and in the same year he agreed to appear in William Beaudine's cut-rate Bowery

Boys comedy *Ghosts on the Loose* (the film's sole distinction is that it offered Ava Gardner a very early role). It was made by Monogram Pictures, one of the burgeoning "Poverty Row" studios that churned out B films for a flat rental fee to second-run theaters, where they played on the bottom half of a double bill. Lugosi's fortunes continued to dwindle until he was relegated to "red herring" roles in prestige productions, such as Robert Wise's *The Body Snatcher* (1945), where he has almost nothing to do as Joseph, an addled manservant, in sharp contrast to Karloff, who appeared in the same film in the leading role of Gray, a "resurrectionist" who supplies freshly buried corpses for an Edinburgh medical school in the 1830s.

In 1948, at the behest of his agent, Universal agreed to cast Lugosi one last time as Dracula, in Charles Barton's *Abbott and Costello Meet Frankenstein,* a lively horror comedy that nevertheless permanently marked the divide between a serious interpretation of the role and the use of Dracula as a comic foil for two erstwhile burlesque comedians. Worse was still to come; Lugosi became a parody of himself in William Beaudine's *Bela Lugosi Meets a Brooklyn Gorilla* (1952), an appalling film featuring a Martin and Lewis copycat team, Duke Mitchell (in the "Dean Martin" role) and Sammy Petrillo (in the "Jerry Lewis" role). The film was made in six days, Lugosi was reportedly paid $500, and the real Jerry Lewis sued Sammy Petrillo for impersonating him—an ignominious moment in the once-auspicious career of the aging actor.

But even this was not Lugosi's low point. Teaming with the only person who would now employ him despite his raging morphine habit, Lugosi found himself working for bottom-rung director Edward D. Wood Jr. in *Bride of the Monster* (aka *Bride of the Atom,* 1955), in which the seventy-three-year-old actor portrayed the satanic Dr. Vornoff, bent on creating a race of "atomic supermen" deep in the Louisiana swamps. Lugosi received a scant $1, 000 for the role. After committing himself to the California State Hospital as a hopeless drug addict in 1955, the actor agreed to work with Wood on another project, tentatively titled *Grave of the Vampire,* for which Lugosi shot a few minutes of scenes just days before his death. Released as *Plan 9 from Outer Space* in 1959, this infamously poor film has become, for all the wrong reasons, a "cult classic" over the years and is a shocking epitaph for an actor who once played Shakespeare, in translation, on the stage in the land of his birth. Lugosi

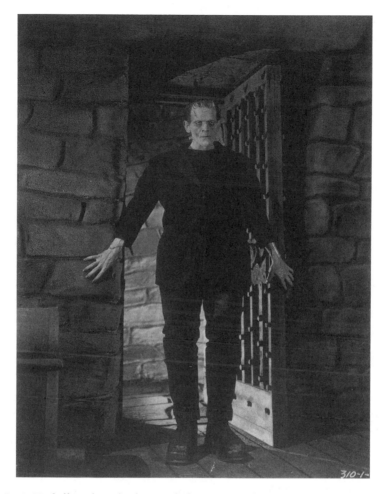

9. Boris Karloff in the role that made him a star, the monster in *Frankenstein*.
Courtesy: Jerry Ohlinger Archive.

was buried in his Dracula cape, and in 1994 director Tim Burton paid
Lugosi and Wood an affectionate homage with his biopic *Ed Wood*, one
of Burton's most aesthetically successful films.

Boris Karloff (born William Henry Pratt), Universal's other major
star of the 1930s, was much wiser in his choice of roles and also much
cannier in business affairs. Starting with his success in Whale's
Frankenstein, which established him overnight as a horror icon, and con-
tinuing with Whale's *The Bride of Frankenstein* (1935) and Rowland V.
Lee's *The Son of Frankenstein* (1939), Karloff capitalized on his fame as the

monster and shrewdly negotiated a series of lucrative contracts that allowed him to broaden his range as an actor. As a founding member of the Screen Actors Guild, Karloff knew how to play hardball with the studios and refused to be bullied into taking roles that would cheapen his stature as an actor.

Karloff, too, went through lean periods. In the late 1930s, with the horror market saturated, Karloff agreed to appear in a series of cut-rate films centering on the character of one Mr. Wong, an Orientalist detective who was an obvious knockoff of the hugely popular Charlie Chan character. Karloff made four Wong films for Monogram at his top price and then walked away from the studio, never to return—a rare feat in itself, for Monogram was usually the last stop for an actor on the way down in a highly competitive industry. When work in quality films still proved elusive, Karloff reinvented himself with a star turn on Broadway in *Arsenic and Old Lace,* playing the obsessed killer Jonathan Brewster in a dark comedy about two adorable yet unmistakably homicidal sisters who turn their Brooklyn home into a mausoleum by offering poisoned elderberry wine to homeless men who come to their door looking for a handout.

As horror came back into vogue in postwar America, Karloff teamed with visionary producer Val Lewton at RKO for a series of atmospheric modern-day horror films that departed from the usual Universal monster formula, such as Mark Robson's *Isle of the Dead* (1945), Wise's *The Body Snatcher,* and Robson's *Bedlam* (1946). With more than 140 films to his credit (as well as several television series, the best known of which was the NBC series *Thriller,* an anthology Karloff hosted and occasionally appeared in), Karloff capped his career with a memorable portrayal of an aging horror star in Peter Bogdanovich's debut film, *Targets* (1968), in which Karloff's character, Byron Orlock, confronts a psychotic sniper at the drive-in premiere of one of his last films (the scenes of which were actually lifted from Roger Corman's 1963 Karloff film *The Terror*).

Habitually modest, Karloff was nevertheless the consummate professional in all his work, an actor whose range and depth brought richness to each character he portrayed. He was as convincing in "straight" roles as he was in his signature hits, portraying a religious fanatic in John Ford's *The Lost Patrol* (1934) and Cauchon, bishop of Beaurais, in Jean Anouilh's *The Lark* opposite Julie Harris on the Broadway stage in 1955.

Karloff adapted easily to new media and loved the challenge of live tele-vision. He reveled in his role as Captain Hook in *Peter Pan* and a turn as King Arthur in a television adaptation of Mark Twain's *A Connecticut Yankee in King Arthur's Court*. In his final years, as his health declined and he was forced to use a leg brace and an oxygen tank on the set, he remarked that it was "a public scandal that I'm still around. Yet every time I act [in a film], I provide employment for a fleet of doubles."

Karloff remained in harness to the last, working with young director Michael Reeves in *The Sorcerers* (1967) and finally tackling four Mexican horror films back-to-back in May 1968; Karloff's scenes were shot in Los Angeles by director Jack Hill, while the balance of each film was shot in Mexico City. Karloff's death at the age of eighty-one on February 2, 1969, brought an end to one of the most prolific and distinguished careers in the horror genre. Unlike Lugosi, who died in penury and iso-lation, Karloff lived to see his work embraced by a new generation of admirers, and his final films in the 1960s, including Corman's *The Raven* (1963), are some of his best work.

Aside from Karloff and Lugosi, the two major figures of 1930s and '40s horror, one other name must be added, that of the much maligned, even tragic Lon Chaney Jr. Destined never to achieve the acclaim of his famous father, Chaney excelled in serious dramatic parts when he had the opportunity, as in his heartbreaking portrayal of the dim-witted Lennie in Lewis Milestone's adaptation of John Steinbeck's *Of Mice and Men* (1939), co-starring with Burgess Meredith.

Chaney's breakthrough came in George Waggner's *The Wolf Man* (1941), which also brought a new character into the Universal stable. Chaney starred as Lawrence Talbot, the Wolf Man, with Claude Rains as Lawrence's father, Sir John Talbot, Maria Ouspenskaya as Maleva, the Gypsy woman who helps him endure the curse of lycanthropy, and Bela Lugosi as Maleva's son, Bela, the werewolf who infects Lawrence with the fatal bite that transforms him from man to raving beast. There had been one werewolf film from Universal before this, Stuart Walker's *Werewolf of London* (1935), starring Henry Hull, but the film failed to catch on as a series and is in no way related to Chaney's work as the tor-tured Larry Talbot. Chaney conveys a depth of sadness and spiritual iso-lation in the role that shows what he could have done with his career had he been given material of this caliber on a regular basis.

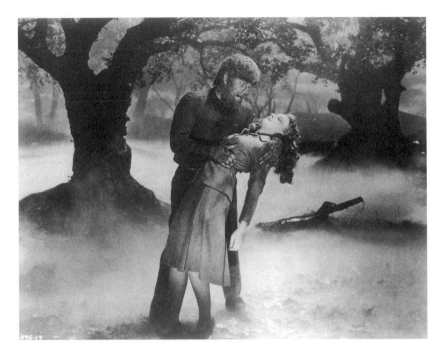

10. Lon Chaney Jr. in *The Wolf Man*, with Evelyn Ankers. Courtesy: Jerry Ohlinger Archive.

After *The Wolf Man*, however, Chaney was never really allowed to develop his identity as an actor and instead served as an all-around "utility man" at Universal, shuffled from one generic role and/or character to another with little regard for his ambitions or untapped abilities. He was the central figure in a string of six films in Universal's *Inner Sanctum* series, many of them directed by Reginald Le Borg, including *Calling Dr. Death* (1943), *Weird Woman* (1944), and *Dead Man's Eyes* (1944), and concluding with Wallace Fox's *Pillow of Death* (1945).

These eerie, insular films had only one unifying factor—Chaney's presence in all of them—and each followed a different plot line, with Chaney playing a new character for each film. Inspired by the popular radio series *Inner Sanctum,* these unsettling films have a strong psychological edge, as Chaney's differing characters are repeatedly portrayed as being on the brink of madness or homicidal frenzy. For the first five films in the series, although the protagonist falls under suspicion of murder or other misdeeds, Chaney's character always emerges in the

final moments as an innocent victim of circumstances. But in *Pillow of Death,* the final film of the series, Chaney's brooding introspection is justified; he is, in fact, a ruthless killer, whose mental instability and guilt are explored in the film's final, despairing scenes.

All too often, however, Chaney was called in to do the films that no one else wanted to do or was able to do. When Boris Karloff abandoned the role of the Frankenstein monster after *The Son of Frankenstein,* fearing that it would typecast him forever, it was Lon Chaney Jr. who was pressed into service in Erle C. Kenton's *The Ghost of Frankenstein* (1942)—and pulled it off. Similarly, when Lugosi became too sick to tackle the Dracula role due to his drug addiction, Universal cast Chaney as "Count Alucard" ("Dracula" spelled backwards) in Robert Siodmak's gorgeously atmospheric *Son of Dracula* (1943), and again, the actor acquitted himself with distinction, an especially tricky task considering that he was taking on a role with which Lugosi had become utterly identified.

In the 1950s Chaney alternated between straight dramatic parts, such as an aging sheriff in Fred Zinnemann's *High Noon* (1952), and more traditional horror fare, such as Jack Pollexfen's *The Indestructible Man* (1956), in which he plays a ruthless killer brought back to life after being executed in the electric chair. Yet, as with Lugosi, addiction was beginning to wear Chaney down, only in his case the problem was acute alcoholism. It got so bad that on the set he would walk up to the unfortunate director at the start of the day's shoot, pull a bottle of hard liquor out of his pocket, and pointedly tell the director to "get all you can out of me by noon," for after that time the actor would be hopelessly drunk.

Don Sharp's effective thriller *Witchcraft* (1964), shot in the United Kingdom on a modest budget, was probably the last role of any substance in Chaney's career; by the time he appeared in Jean Yarbrough's abysmal *Hillbillys in a Haunted House* (1967), he was clearly a dying man. His last film was Al Adamson's desperately impoverished *Dracula vs. Frankenstein* (1971), in which his character, Groton, the mad zombie, is mute as a result of Chaney's real-life throat cancer. He died shortly after the film's completion in 1973.

Thus, of the three major stars working at Universal during the Golden Age of American horror films, only Karloff managed to widen his range beyond the narrow scope of the genre and so keep his reputation and bankroll intact. For Lugosi and Chaney Jr. the studio system

effectively thwarted any outside pursuits they might have had, coupled, of course, with their own bad judgment in managing their careers in a notably treacherous industry. Having considered these three key players, we can go on to examine the films that contributed to Universal's success in the era and the ways in which they shaped the classic horror film genre, from first to last.

The Dracula series was perhaps the least consistent and the most adventurous group of films in the Universal horror canon. After *Dracula* in 1931, there is a long pause in the series. When *Dracula's Daughter* (1936) appeared under the direction of Lambert Hillyer, the Count himself had all but vanished, to be replaced by a lesbian vampire, Countess Zaleska (Gloria Holden), who is assisted by her familiar, Sandor (convincingly portrayed by actor/director Irving Pichel). Countess Zaleska is a doomed, tragic figure from the film's outset, when she coldly dispatches Lily (Nan Grey), a young streetwalker, for her life's blood after luring Lily to her studio apartment on the pretext of posing as an artist's model. This moody, despairing, almost willfully aberrational film did little to advance the franchise.

Although Lugosi was legally unable to use the Dracula name, he continued to play vampires, such as Count Armand Tesla in Columbia's 1943 *Return of the Vampire,* directed by Lew Landers, which also features Matt Willis as Andreas, a werewolf, thus further diluting Universal's hold on the character's identity. No matter what his character's name within the film, Lugosi *was* Dracula in the minds of audiences, and so Universal tried only one more time with *Son of Dracula* to revive the series. Yet, despite the energy that director Robert Siodmak contributed to the project and the conviction that Lon Chaney Jr., then in his prime, brought to the role, the film failed to perform at the box office, and plans to continue the Dracula series were summarily scrapped. This decision was particularly unfortunate, given that the films were, in many ways, the most successful and original work of the entire group, with moody cinematography by George Robinson, Hans J. Salter's evocative music (Salter composed the scores for many of the Universal horror films, and sections from his scores were often used as "cues" in Universal non-horror films, especially the long-running Sherlock Holmes series with Basil Rathbone and Nigel Bruce), and John P. Fulton's stunning special effects, particularly in the bat-to-man transformation sequences, as well

as in an eerie courtship scene in a swamp, where Dracula materializes from a stream of mist issuing from a partly submerged coffin.

The plot of *Son of Dracula* also bears mentioning. Based on a story by Curt Siodmak (Robert Siodmak's brother), Eric Taylor's script centers on a young woman who falls under Dracula's spell so that she, too, can become a vampire—and then, in a surprise twist, turn her fiancé into a vampire as well, so that both can gain immortality. With this accomplished, the pair intends to destroy the Count. Needless to say, the lovers' plan is derailed by circumstance and outside intervention, but *Son of Dracula* (which Robert Siodmak directed for a mere $150 a week as an "apprenticeship" task at the studio—both Siodmaks, Curt and Robert, were refugees from Hitler's Germany) resonates in the memory as a hypnotic tale of the supernatural, a successful film in every respect.

The Frankenstein series had more continuity, and not only because Boris Karloff agreed to play the monster in the first three consecutive films of the series. James Whale directed not only the original *Frankenstein* but also the first sequel, *The Bride of Frankenstein,* in 1935. With a framing story that depicts the genesis of the novel in Byron's lakeside villa, featuring Elsa Lanchester in a cameo as Mary Shelley (she also appeared, unforgettably, as the "bride" in the final moments of the film), *Bride* is a fairly straightforward narrative with superior production values, economically paced at a crisp seventy-five minutes. The plot has Colin Clive, reprising his role as Baron Henry von Frankenstein, deciding that the monster's problems really stem from the lack of an appropriate mate—if only one can be whipped up in his laboratory, all will be well.

Bride is more directly satirical than the original film, with a decidedly "camp" air to the proceedings, helped along by Whale's florid direction and Ernest Thesiger's flamboyant turn as Dr. Pretorius, Frankenstein's co-conspirator in this new, ultimately ill-advised venture. When, at length, the intended bride is unveiled, with a lightning-bolt beehive hairdo and short, jerky gestures that befit an entirely constructed being, she immediately rejects the monster's advances, much to the creature's chagrin. "She hate me, like others," the monster intones before pulling a switch that brings the doctor's laboratory down around them in a cataclysmic explosion, supposedly killing the monster, the bride, and Frankenstein himself.

In 1939 Basil Rathbone appeared in *Son of Frankenstein* and, as Baron Wolf von Frankenstein, immediately pressed on with his father's work, though under the decidedly less-inspired direction of Rowland V. Lee. Eager to get the film to the public, Universal started shooting with an unfinished script, although a series of highly stylized and striking sets had been built especially for the production, harking back to the German Expressionist production design of the original 1932 film.

But despite Karloff's authoritative presence and the capable assistance of Rathbone, Bela Lugosi as Ygor, the monster's protector, and Lionel Atwill as the one-armed Inspector Krogh ("One does not soon forget an arm torn out by its roots," he comments, remembering an earlier confrontation with the monster), the film seems stillborn, as if everyone involved is straining to do their best with the material at hand. Above all, the film lacks energy. Despite the luxurious sets (or perhaps because of them), *Son* emerges as a rather ornate set piece that very rarely engages the viewer.

The Ghost of Frankenstein, in which Lon Chaney Jr. played the monster for the first time, was directed by Erle C. Kenton in 1942 and features a convoluted plot involving brain transplantation. Buoyed by an excellent cast, including Sir Cedric Hardwicke, Lionel Atwill, Bela Lugosi, Ralph Bellamy, and Dwight Frye (as the village lunatic and rabble-rouser), *Ghost* blazes through its brief sixty-eight-minute running time with smooth assurance and comes to a suitably monstrous conclusion when Ygor's brain is transferred into the monster's skull, thus giving the audience a truly bizarre visual and aural construct to deal with: Chaney's shambling physique coupled with Lugosi's urgent, insistent voice. Due to a mismatch in blood types, however, the monster soon becomes blind and, in a rage, destroys the laboratory in a cataclysmic outburst as the film comes to an abrupt conclusion.

It is at this juncture that Universal began "teaming up" its monsters to boost box-office receipts in what was rapidly becoming a less lucrative enterprise. *Frankenstein Meets the Wolf Man,* stylishly directed in 1943 by Roy William Neill, was the first result. Originally conceived as a joke by Curt Siodmak in the Universal cafeteria during a long lunch break as he and his fellow writers struggled to come up with a new angle for the Frankenstein saga (Siodmak wryly suggested that the film should more properly be titled *Frankenstein Wolfs the Meat Man,* a reference to wartime

rationing), the script for *Frankenstein Meets the Wolf Man* was duly presented by Siodmak to Universal's executives.

Immediately taken with the notion, Universal rushed the film into production, this time with Lugosi in the role of the monster and Lon Chaney Jr. as the Wolf Man. The film opens promisingly with an extended, atmospheric grave-robbing sequence shot in a studio graveyard; two resurrectionists choose the grave of the Wolf Man, Lawrence Talbot, as their latest target and are summarily torn to shreds by the now immortal lycanthrope. As the full moon recedes and Talbot returns to human form, his first and seemingly only thought is a wish to die—to be free of the curse of the Pentagram (the mark of the werewolf) forever.

His search for release leads him to the office of Dr. Mannering (Patric Knowles), who soon becomes involved in resuscitating the Frankenstein monster and attempting to bring an end to Talbot's sinister affliction. But what makes the film truly interesting is that, as originally scripted by Siodmak, the monster still retained Ygor's brain, and thus Lugosi's voice, and was given reams of dialogue to deliver—all in Lugosi's distinctive Transylvanian accent. The final scene in *Ghost of Frankenstein* had laid the groundwork for this conceit, and since Lugosi was now actually playing the role, no dubbing would be needed.

But a rough cut of the film convinced Universal's management that what had been effective for one gripping scene in *Ghost* rapidly became risible in *Frankenstein Meets the Wolf Man*; it was as if Dracula himself were now somehow inhabiting the body of the Frankenstein monster. By building up a romantic subplot and lengthening a tedious musical sequence, the studio was able to excise all of the monster's dialogue, leaving the creature as a hissing, malevolent force of destruction, devoid of both voice and reason. What is left of Lugosi's performance is both credible and savage, and Chaney is both tragic and dangerous as the Wolf Man. Despite its contrived origins, the film is a worthy entry in the series, and it did extremely well at the box office.

Sensing that wartime audiences demanded ever-increasing doses of shock and violence, Universal took nearly all of its monsters and put them into the two final "straight" films of the series, Erle C. Kenton's *House of Frankenstein* (1944) and *House of Dracula* (1945), combining the Wolf Man, the Frankenstein monster, and Dracula (now portrayed in a very different manner by the sonorous yet suitably gaunt John Carradine).

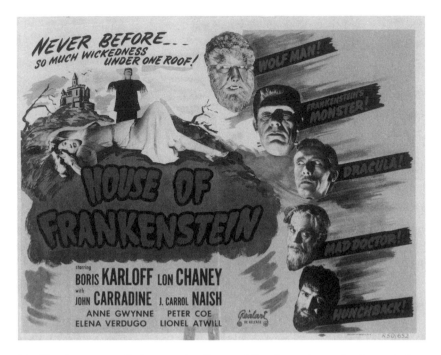

11. The "monster rally" poster for *House of Frankenstein* marks the end of an era. Courtesy: Jerry Ohlinger Archive.

Although entertaining to watch, these "monster rally" films defy credulity on almost every level.

House of Frankenstein, at least, had the services of Boris Karloff as Dr. Gustav Neiman, a truly mad scientist who is first seen in the dungeon of a rotting castle, along with his hunchbacked assistant Daniel (J. Carrol Naish), imprisoned for his "crimes against nature" in the laboratory. When a chance lightning bolt knocks out a section of their jail cell and allows Neiman and Daniel to escape, they find shelter in the wagon of a traveling horror show run by Professor Lampini (George Zucco), who, among his other exhibits, boasts a coffin containing the "actual skeleton of Count Dracula."

Summarily disposing of Lampini and his driver, Neiman impersonates Lampini, with Daniel as his assistant, and picks up a dancing girl along the way (Elena Verdugo). Hiding in plain sight, they take the horror show on the road, intending to arrive at Neiman's native village to settle old scores with the officials who imprisoned him. One night,

during a performance, Neiman accidentally removes the stake from Dracula's skeleton, which had been strategically placed through the vampire's heart. In short order, Dracula rematerializes, agrees to do Neiman's bidding, but becomes interested in a local ingénue and attempts to abduct her for his bride. The townspeople give chase and apprehend Dracula (who immediately crumbles to dust with the first rays of the morning sun), but Neiman and Daniel escape and return to Neiman's laboratory.

There, in one of the film's most sublimely preposterous moments, Neiman discovers the Frankenstein monster (now played by former cowboy actor Glenn Strange) and the Wolf Man (Chaney Jr.) frozen in gigantic blocks of ice. Believing, for some unfathomable reason, that either the Wolf Man or the monster will help him locate the records of the original Dr. Frankenstein, Neiman thaws the two monsters out of their frosty prisons and begins a search for the records. Though Neiman promises to free Lawrence Talbot from the curse of his affliction, he soon becomes more interested in the monster, and the film ends with a maelstrom of violence. The young Gypsy dancer kills Talbot with a silver bullet and is murdered by him in the process; Daniel revolts against his master and tries to kill Neiman, but the monster intervenes and throws Daniel through a window. As the inevitable crowd of angry villagers closes in on the castle, the monster carries the injured Neiman into some conveniently located quicksand, where both are swallowed up in the film's last scene.

At seventy minutes, there's little time for boredom with such a convoluted scenario. What ultimately saves the entire enterprise is that, no matter how ridiculous the film becomes, everyone plays it absolutely straight, led by Karloff's assured performance. We are thus swept along in an utterly illogical universe without having time to think about the *logic* of such events, which, all things considered, is the only way to deal with such a bizarre, almost surrealistic narrative.

Kenton's *House of Dracula* is a more somber film—indeed, it would be difficult *not* to be—in which the reclusive Dr. Franz Edelman (Onslow Stevens) takes on both Dracula (Carradine) and the Wolf Man (Chaney Jr.) as patients in a spectacularly ill-conceived attempt to cure them of their respective maladies. In the case of the Wolf Man, Dr. Edelman theorizes that his skull is pressing on certain portions of his

brain, causing it to speed up "like a steam engine without a balance wheel," resulting in unwanted growth of hair, fangs, claws, and other accoutrements. Edelman schedules him for surgery.

Dracula's "condition" is attributed by the doctor to a "peculiar parasite" in his blood, and Edelman begins a series of transfusions to correct the condition. But Dracula, true to his nature, infects the doctor with his own blood. In the meantime, the Frankenstein monster has been discovered in a grotto beneath Edelman's estate, once again ready for resurrection. Turned into a homicidal vampire by Dracula's treachery, Dr. Edelman recovers himself long enough to perform a brain operation on Lawrence Talbot that successfully cures him—a first for the series— as Talbot faces the full moon and miraculously does not revert to his usual bestial form. But Dr. Edelman, now too far gone to help anyone, even himself, is shot to death by Talbot just as the monster springs back to life with a massive jolt of electricity and destroys Edelman's laboratory (in footage lifted from the climactic scenes of *Ghost of Frankenstein*).

Dracula, the Frankenstein monster, and the Wolf Man would appear together just one more time, in Charles T. Barton's *Abbott and Costello Meet Frankenstein* (1948), a labored parody in which Universal seemingly abandoned its creations. The film's penultimate sequence depicts Lugosi transforming into a bat, only to be seized by Lon Chaney Jr.'s Wolf Man as both topple over the parapet of an enormous Gothic castle and are dashed to bits on the rocks hundreds of feet below. It was an ignominious end for a series of films that had started out entirely in earnest.

While the Frankenstein and Dracula films were in production in the early 1930s, Boris Karloff inaugurated yet another franchise with Karl Freund's superbly atmospheric film *The Mummy* (1932), featuring Karloff as Im-ho-tep, an undying mummy who seeks vengeance on his victims across the centuries. As in most of his films, Karloff's convincing performance dominates the proceedings, but Freund's direction (as a cinematographer, he had photographed numerous films in his native Germany, including Fritz Lang's *Metropolis*) is mesmerically hypnotic and, along with Jack Pierce's superb makeup, makes this easily the best of the *Mummy* series.

Subsequent entries, including Christy Cabanne's *The Mummy's Hand* (1940), Harold Young's *The Mummy's Tomb* (1942), Reginald Le Borg's *The Mummy's Ghost* (1944), and Leslie Goodwins's *The Mummy's*

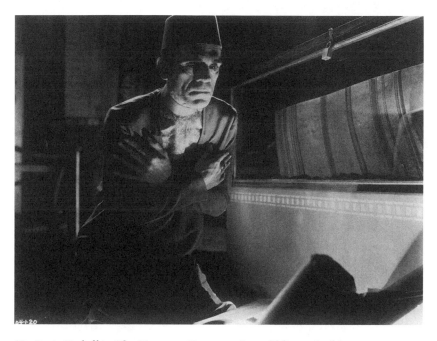

12. Boris Karloff in *The Mummy*. Courtesy: Jerry Ohlinger Archive.

Curse (1945), were without exception cheap and shoddy affairs. In *The Mummy's Hand,* cowboy star Tom Tyler unconvincingly portrayed the title character; in *The Mummy's Ghost* and *The Mummy's Curse,* Lon Chaney Jr. was pressed into service. The results were deeply uneven, poorly acted, and staged with an almost complete indifference to either production values or audience interest. Interspersed with clips from Freund's original film, these threadbare sequels, barely sixty minutes each, were mercifully suspended in 1945, until the Mummy returned for one last time at Universal—in Charles Lamont's *Abbott and Costello Meet the Mummy* (1955).

Much the same trajectory befell the unfortunate figure of *The Invisible Man* (1933), originally portrayed with great distinction by Claude Rains and directed with style and panache by James Whale. But Joe May's *The Invisible Man Returns* (1940) is a stolid affair at best, despite the presence (in voice only, until the film's final moments) of a young Vincent Price. A. Edward Sutherland's comedy *The Invisible Woman* (1940), with John Barrymore in one of his last roles, is tedious in the extreme. Edwin L. Mann's *Invisible Agent* (1942) was a wartime entry in

the series, with Jon Hall taking over the central role to little effect. Although Ford Beebe's *The Invisible Man's Revenge* (1944), once again with Jon Hall in the lead, has more energy and style than the other entries in the series, it still falls far short of the original H. G. Wells source material. With Charles Lamont's *Abbott and Costello Meet the Invisible Man* (1950), what had begun, once again, as a straightforward horror character was reduced to parody in a cost-conscious film that did little to enhance the Universal legacy.

While Universal was busy recycling its stable of monsters in the 1940s, at RKO Radio Pictures an altogether unexpected series of events conspired to create some of the most memorable and original horror films of the era. One of the first of these films was Ernest B. Schoedsack and Irving Pichel's *The Most Dangerous Game* (1932), the first screen adaptation of Richard Connell's short story *The Hounds of Zaroff*. British actor Leslie Banks plays Count Zaroff, a mad Russian aristocrat who lives in isolated splendor on a lonely island, where he spends his time in his luxurious castle, waiting for passing ships to crash onto the reefs that conveniently surround his miniature kingdom. Zaroff has rearranged the warning buoys to give the impression of safe passage around the island where there is none, so shipwrecks are a common occurrence. After the dazed survivors wash ashore, Zaroff feeds them, lets them rest a while, and then hunts them like animals, as the most "dangerous game" a hunter can track.

When famous big-game hunter Robert Rainsford (Joel McCrea) is washed up on the beach, Zaroff is ecstatic: at last, a *real* challenge to his skills. Already on the island are Eve Trowbridge (Fay Wray) and her brother Martin (Robert Armstrong). Eve, aware that something is amiss, furtively warns Rainsford during dinner that Zaroff's hospitality is not all that it seems. Her brother, however, is a hopeless drunk, and late that night Zaroff takes Martin down to his "trophy room," where he keeps the heads of his past victims mounted on the wall. Zaroff gives Martin a head start, a knife, and some food, and then hunts him down and kills him with a bow and arrow.

Eve knows none of this, but when Martin doesn't appear the next morning, Rainsford demands an explanation, which is shortly forthcoming. Taking Eve with him, Rainsford heads out from the castle as night falls, with Zaroff in hot pursuit. Zaroff's wager is simple: survive until sunrise, and you "win" the game; otherwise, you die. Through the use

of a variety of exotic tricks—including an improvised Burmese tiger trap—Rainsford and Eve manage to elude Zaroff until dawn. But, predictably, the count has no intention of obeying his own rules, and he sets his hounds on Rainsford, who falls off a cliff under a waterfall, presumably to his death. Elated, Zaroff forces Eve back to the castle, intent on raping her as a celebratory "ritual" to mark the success of his hunt.

But Rainsford, against all odds, has survived, and he returns to the castle to kill Zaroff. As the two men struggle, Zaroff falls off a ledge into the kennel, where his hunting dogs tear him to bits. Eve and Rainsford are thus free to leave the island, and Rainsford, heretofore an enthusiastic hunter, finds he has no more appetite for the "sport"—now he *knows* what it's like to be the prey of a merciless opponent. Schoedsack and Pichel cram the entire story into a compact sixty-three minutes, and many of the film's sets, as well as the actors, would be recycled in Schoedsack and Merian Cooper's masterpiece *King Kong* one year later.

As Zaroff, Leslie Banks is marvelously theatrical and yet deeply sinister, stroking a long scar on his head absentmindedly whenever the excitement of the hunt overtakes him; and McCrea, Wray, and Armstrong are reliably efficient with their roles. But the real star of *The Most Dangerous Game* is Zaroff's treacherous island itself, thick with fog, filled with swamps, a jungle hell fit only for a monster like Zaroff. The film would subsequently be remade many times after this first, and best, version: Robert Wise's *A Game of Death* (1946) tries hard, but fails to deliver; Roy Boulting's *Run for the Sun* (1956), with Trevor Howard as the mad hunter, is much more effective. More recently, Ernest Dickerson's *Surviving the Game* (1994) cast Ice-T as the prey of a group of bored, rich, racist "hunters," and even Hong Kong action director John Woo took a shot at the story line with his film *Hard Target* (1993), featuring Jean-Claude van Damme as the potential victim of the psychotic Lance Henriksen. Still, none of these versions approaches the menace and power of the 1932 original.

As the 1940s dawned, RKO decided to take a stab at emulating Universal's success with the horror genre under the auspices of producer Val Lewton, a former employee of producer David O. Selznick. In a mere four years, from 1942 to 1946, Lewton brought a singular vision to the screen in nine Gothic thrillers before RKO abandoned him and his unit. Lewton himself succumbed to a heart attack at the age of forty-six

on March 14, 1951, exhausted by years of battling with myopic production executives who didn't understand the bleak, desperate uniqueness of his approach to the genre.

RKO's method of dealing with Lewton was both simple and pragmatic: give him a pre-sold title, a minuscule budget, and a short shooting schedule, and then take whatever he came up with and sell it on the bottom half of a double bill. Budgets ran in the $100, 000 range, and the average production schedule allowed for just three weeks of shooting. But starting with his very first film as a producer, *Cat People* (1942), masterfully directed by Jacques Tourneur, Lewton created—in sharp contrast to Universal's Carpathian never-never land—a modern world with people who had passions, loves, hates, jobs, hobbies, and sometimes fatal character flaws, and he set his films in locales that audiences could identify with.

Cat People takes place in New York City, where Lewton had spent considerable time in his formative years, especially in Greenwich Village. The film's plot is simple: Irena (Simone Simon) falls in love with Oliver Reed (the always stolid Kent Smith), and the couple is married. But Irena labors under a terrible curse: at the first sign of intimacy, she fears she will turn into a leopard and kill the man she loves. Faced with an unconsummated marriage, Oliver drifts into a relationship with co-worker Alice (Jane Randolph), which arouses Irena's jealousy. In one of the film's most memorable sequences, Irena stalks Alice when she takes a late-night dip in a Midtown swimming pool, ripping her bathrobe to shreds as a sign of her displeasure. Alice, alone in the darkened pool area, screams with terror as she senses Irena closing in for the kill, only to be saved at the last possible moment by the indifferent desk attendant, who rouses herself to investigate.

What makes the scene all the more remarkable is that we never *see* the leopard at all—the whole sequence is composed of light and shadow, with only the *sense* that something is moving in the darkness. "We're great ones for dark patches," Lewton observed, and indeed, this power of suggestion, rather than direct representation, is what makes the film all the more effective.

RKO expected nothing more from the film than a return on its minuscule investment; instead, the film was a box-office sensation, far outstripping RKO's earnings projections. Lewton was suddenly the

13. Simone Simon in *Cat People*, the film that brought horror into the twentieth century. Courtesy: Jerry Ohlinger Archive.

golden boy of the B unit, and RKO rushed him and Tourneur into the equally ambitious and mesmeric *I Walked with a Zombie* (1943), a version of *Jane Eyre* set in the West Indies. Saddled with a title he despised, Lewton attempted to dispose of it in the opening line of the film's voice-over, as Betsy (Frances Dee), a Canadian nurse hired to look after the catatonic Jessica Holland (Christine Gordon), soon finds herself enmeshed in the Holland family's internal power struggles, even as she finds herself drawn to Paul Holland (Tom Conway), Jessica's husband.

The entire production was created on the RKO back lot, using a variety of recycled sets, costumes, and lighting effects to create a vision

14. The voodoo dance sequence in Jacques Tourneur's *I Walked with a Zombie*. Courtesy: Jerry Ohlinger Archive.

of the island of St. Sebastian as a land of both wonder and fear. The film's highlight is a wordless, ten-minute sequence in which Betsy, by now convinced that voodoo magic is perhaps the only chance to lift Jessica out of her trance, ventures into the jungle. In a series of gorgeously designed tracking shots, Tourneur takes us deep into the heart of the tropical jungle to observe a voodoo ritual that is strikingly authentic in its presentation; indeed, the hallmarks of Lewton's films are always a meticulous attention to detail and a commitment to accuracy insofar as the constraints of time and budget would allow. This film, too, was a substantial hit and offered the public something other than the standard-issue bogeymen Universal persisted in reviving in sequel after sequel.

The Leopard Man (1943), an atypically sadistic film set in New Mexico, in which an insane serial killer uses the escape of a real leopard from a nightclub act to cover his crimes, was Lewton and Tourneur's next effort. A somewhat uneven film, it lacks the cohesive vision Lewton usually brought to his projects. It was at this point that RKO

stepped in and separated Lewton and Tourneur, feeling that both men were soon to move on to A status at the studio, a decision that seems, in retrospect, extremely short-sighted.

Thus, Mark Robson was brought in by Lewton to take the helm of his next and perhaps most deeply personal effort, *The Seventh Victim,* shot in twenty-four days in May 1943. Set in a studio re-creation of Greenwich Village, *The Seventh Victim* traces the activities of a group of Satanists who have abducted one of their members, Jacqueline Gibson (Jean Brooks), and taken over her cosmetics business to subsidize their activities. Jacqueline's sister Mary (a young Kim Hunter) leaves her boarding school to investigate Jacqueline's disappearance and soon finds herself caught up in a web of murder, intrigue, and deceit. This remarkable film, Lewton's most radical and unconventional production, perfectly reflects the producer's own feelings on the tenuousness of existence. Framed with a quotation from John Donne's Holy Sonnets ("I run to Death and Death meets me as fast, and all my pleasures are like yesterday"), *The Seventh Victim* sketches a world of bleak desperation in which evil is a potent force and those who would defeat it weaken in their resolve.

Lewton's next effort, *The Ghost Ship* (1943), also directed by Robson, was tied up for years in a plagiarism suit and unavailable for general viewing. Now that the dust has settled, audiences can see that the film is one of Lewton and Robson's finest achievements. The tale focuses on a pathologically insane commander, Captain Stone (Richard Dix), whose "spit and polish" brusqueness is a disguise for his homicidal mania, as he methodically dispatches the members of his crew on the doomed ship *Altair.* A young seaman, Tom Merriam (Russell Wade), tries to warn the other members of the ship's crew about Stone's true nature, but only the mute deckhand Finn (Skelton Knaggs) believes Tom's accusations.

At length, Stone's capacity for evil is revealed, but only after Tom's faith in humanity has been sorely tested. As Stone warns Tom when the young man tells the captain that he plans to expose him, no one will give any credence to the charges because of Stone's rank and reputation. The abuse of power presented in the film resonates far beyond the series of gruesome murders on the ship. Stone stands for every petty bureaucrat who thinks that by blending in with the dominant order, his brutal nature will be both concealed and even encouraged.

In 1944 Lewton's small unit was assigned to create a sequel to his biggest hit, *Cat People,* and given the distinctly unpromising title of *The Curse of the Cat People.* Lewton promptly created a film that, although it recycled many of the cast members and characters of the original production (Simon, Smith, and Randolph all reprised their respective roles), had absolutely nothing to do with the first film and was instead a haunting allegory about the fantasy world of childhood.

The film centers on young Amy Reed (Ann Carter), the daughter of Oliver and Alice, who are now happily married and living in a suburban dream house. Irena still haunts the Reed family, but in a most peculiar way. Bereft of friends because of her fanciful imagination, Amy chances upon a picture of Irena and summons her up in the backyard of the house as a sort of phantasmal playmate. In this film, Simone Simon is a gentle companion for the lonely Amy, not the menacing figure of the first film, but Oliver and Alice are disturbed by Amy's flights of fancy and punish her for insisting that Irena is "real," as indeed she is to Amy. During this time, Amy has also been visiting the home of a lonely old recluse, Julia Farren (Julia Dean, in a stunning performance), unaware that Julia's daughter Barbara (Elizabeth Russell) is jealous of her mother's attentions to Amy and plots to kill the child.

In the film's final moments, as Barbara is about to strangle the young girl, she finds herself unable to commit the murder when confronted with Amy's trusting, compassionate innocence. Oliver, who has been searching for Amy, arrives just at this moment and, taking Amy in his arms, agrees to let her have her "imaginary friend," feeling he has been too strict with the child. Thus, Irena no longer has a hold over Amy or her family, and she disappears from their lives forever.

The film had a troubled genesis. The original director, Gunther von Fritsch, was dismissed after several weeks of shooting because he kept falling behind schedule. Midway through the shoot, Robert Wise took over, in his first job as director after a long apprenticeship in the cutting room working as editor on, among many other films, Orson Welles's 1941 masterpiece *Citizen Kane.* Thus, the shooting schedule for *The Curse of the Cat People* stretched from August 26 to October 4, 1943, and the film came in slightly over budget and over schedule. Although it is now regarded as one of the finest in the series, at the time it was a resounding commercial failure.

James Agee, the prescient film critic who was an admirer of Lewton's work from *Cat People* onward, was especially taken with the film, but Lewton had strayed too far from the source material to satisfy the typical horror fan, and so he was put on notice to create more "conventionally horrific" offerings in the future. Lewton's unit rounded out 1944 with two non-genre projects, Robson's *Youth Runs Wild,* about wartime juvenile delinquency, and Wise's *Mademoiselle Fifi,* a period drama based on two short stories by Guy de Maupassant. Neither did especially well at the box office, and Lewton was beginning to feel pressured by his superiors. Then something extraordinary happened. RKO decided to strike a deal with Boris Karloff to appear in Lewton's forthcoming slate of films, and the two men hit it off immediately, with Karloff recognizing in Lewton a man of style, taste, and culture, interested in making films of a nature altogether different from Karloff's films of that period at Universal.

This affinity, of course, was something that the RKO brass had not counted on, but with Karloff's name and presence as box-office insurance, Lewton was allowed to proceed with *Isle of the Dead* (1945), one of the most unusual films of the series. Karloff plays an imperious Greek general who is stranded with a ragtag group of soldiers, a diplomat and his wife, and an American reporter on a small island off the coast of Greece in 1912. When a plague sweeps the island, the members of the group rapidly fall victim to the disease, but Kyra (Helene Thimig), an old peasant woman, persuades the superstitious general that, in fact, the deaths are the work of Greek vampires, or "vorvolakas," and that only the general's firm hand can bring an end to their reign of terror.

Karloff was enthusiastic about the role, but a long-neglected severe back injury left him in nearly intolerable pain, and he was forced to do his scenes in brief sections before collapsing into a wheelchair. The shooting began on July 14, 1944, but was halted on July 22 when it became apparent that Karloff could not continue. The actor immediately entered the hospital for spinal surgery to relieve the pressure on his sciatic nerve. Though primitive by modern standards, the surgery was successful enough that Karloff was able to rejoin the cast and crew on December 1, and the entire film was completed in twenty-one days. In some ways, *Isle of the Dead* is disjointed because of this rupture during production, but the doom-laden scenario is quintessentially Lewtonesque,

and Karloff's authoritative performance gives the completed work an air of hermetic, fatalistic realism.

In 1945 Lewton and Wise teamed with Karloff for an adaptation of Robert Louis Stevenson's *The Body Snatcher,* with Bela Lugosi thrown in for marquee value in a small, inconsequential role. The real stars of this Burke and Hare tale of grave robbers run amok are Karloff and the superb, cold British actor Henry Daniell. One of the screen's greatest heavies, Daniell plays Dr. MacFarlane, a surgeon possessing great medical gifts but little patience or humanity, who runs a cutting-edge medical school in early nineteenth-century Edinburgh. The cabman and grave robber Gray (Karloff) keeps "Toddy" (Gray's nickname for MacFarlane) supplied with fresh corpses for his research, until MacFarlane can stand Gray's blackmailing and needling no more and resolves to be rid of him once and for all.

Although shot with Lewton's customary speed from October 25 to November 17, 1944—a mere twenty-three days—the film is arguably one of the finest of his RKO productions. Karloff and Daniell firmly seized the reins of the production, adroitly guided by Wise, who was rapidly becoming an accomplished auteur. But sadly, the Lewton/Karloff partnership was about to come to an end with the production of *Bedlam* (1945), perhaps the least successful film of the series. Karloff plays Master Sims, the keeper of Bedlam, the infamous British insane asylum of the late eighteenth century. Although Karloff tackles the villainous role with his customary skill and aplomb, the film as a whole is dull and predictable. As James Agee noted, it was more "literary" than Lewton's other works, as if the script, rather than the action, dominated the end product in a deadening, unsatisfactory manner.

Bedlam was not a commercial success, and after four years and nine genre films, RKO closed down the Lewton unit after Lewton suffered a heart attack in November 1946. Lewton left RKO for Paramount, where in 1947 he was assigned to produce a romantic drama entitled *My Own True Love,* directed by Compton Bennett, which became such an ordeal due to script changes and studio interference that despite "wrapping" in September 1947, it was not screened for the public until one year later, when it was met with total indifference by audiences. Moving to MGM, Lewton produced a tepid romantic comedy, Norman Taurog's *Please Believe Me* (1950), but that, too, was a failure. Lewton's

interests, like it or not, were in films that dealt with a serious, fatalistic sense of life; these light-hearted projects were wholly unsuited to him, and it showed. Lewton's final film as a producer was Hugo Fregonese's *Apache Drums* (1950), a routine western. His time had run out.

An independent production company Lewton had set up with his two protégés, Mark Robson and Robert Wise, collapsed when the two directors backed out of the arrangement, leaving Lewton feeling both betrayed and abandoned. Producer Stanley Kramer then entered the picture. Lewton was just starting work for the Kramer Company when he suffered a second heart attack and, a few days later, a third and more severe heart attack, brought on by a combination of overwork, worry, and exhaustion. After a week in the hospital, Lewton died in an oxygen tent.

At the funeral, it was Lewton's RKO colleagues who attended in the greatest number—the technicians, actors, writers, and other artists with whom he had made his best films. Lewton's reputation is now absolutely secure as the most individualistic and ultimately influential figure in 1940s horror, and his complete horror films have been collected in two DVD box sets. Numerous books and at least two feature-length documentaries have been made about Lewton's work, and yet one wonders what more he might have accomplished if he had not been so constrained by the Hollywood studio system's mercantile demands. Lewton was a genuine original but lacked, in many respects, the toughness needed to survive in the film business; an artist first and a businessman second, Lewton always led with his heart, which was predestined to be broken.

While Val Lewton and his team were revisualizing the possibilities of the Gothic horror film at RKO in the 1940s, other studios were also at work on genre films, with varying degrees of success. Twentieth Century Fox, headed by Darryl F. Zanuck, immediately saw the possibilities of a B horror unit after the resounding success of *Cat People* and rapidly commissioned two Lewtonesque thrillers. Harry Lachman's *Dr. Renault's Secret* (1942), a rather conventional film in which a mad scientist (George Zucco) transforms a gorilla into a humanoid ape, was followed in quick succession by the far superior werewolf drama *The Undying Monster,* directed in 1942 by the gifted stylist John Brahm. The latter film is superbly crafted and conceals its surprise ending up to the

last; like Lewton's films, it makes excellent use of existing sets and costumes, enhanced by Brahm's skillful sense of composition and lighting.

The Undying Monster, though not as big a hit as *Cat People,* persuaded Zanuck that Brahm was destined to become a force within the horror genre, and he promoted Brahm to the A unit—something that never happened to Lewton at RKO—to direct one of the screen's most effective versions of the Jack the Ripper tale, 1944's *The Lodger,* starring the tragic figure of Laird Cregar in the title role. An openly gay man of immense bulk, Cregar rose to prominence playing a variety of loathsome villains, breaking through as a character actor of memorable viciousness in H. Bruce Humberstone's "Pygmalion-in-Manhattan" murder mystery *I Wake Up Screaming* (1941). There he plays the obsessive homicide detective Ed Cornell, intent on framing boxing promoter Frankie Christopher (Victor Mature) for a murder that Cornell *knows* Christopher has not committed. Cornell, in fact, is the real killer.

The film was a sensation, as was *The Lodger,* but Cregar was tired of being typecast as a heavy (in every sense of the word) and went on a crash diet in the hope of becoming a conventional matinee idol. He made one more film with Brahm, the dark *Hangover Square* (1945), in which he played a homicidal concert pianist, before dying of a heart attack at the age of thirty-one, a victim of amphetamine abuse, struck down by his vanity and his desire to fit in. With Cregar's death, Fox abandoned its schedule of horror films—by 1945, the genre was in decline anyway—and sought greener pastures in film noir and musicals.

MGM was never a horror studio, nor did it want to be, but at least one film from the studio with "more stars than there are in heaven" qualifies as one. Tod Browning's 1932 *Freaks* is one of the most sympathetic and original of the early 1930s horror films, although MGM almost immediately disowned it. *Freaks* centers on a rich, gullible circus dwarf, Hans (Harry Earles), who is lured into a romance-for-money by the duplicitous aerialist Cleopatra (Olga Baclanova). Cleopatra wants to marry Hans, but only so she can almost immediately poison him, inherit his money, and run off with her real paramour, Hercules (Henry Victor), the troupe's strong man. The other circus freaks discover her plot and, in the film's appalling climax, track her down in a raging mud storm and carve her up into a monstrosity—part woman, part ostrich—that soon goes on display on the midway.

15. A collection of the actual circus performers with director Tod Browning on the set of *Freaks*. Courtesy: Jerry Ohlinger Archive.

Browning, who had his roots in the circus early in his career, cast the film with genuine circus "freaks" of the era, and audiences found the finished film impossible to take: here was true human monstrosity, without makeup. MGM sold the film to Dwain Esper, one of the most marginal distributors in the film business, for a series of semi-clandestine exploitational screenings in the United States; in England, *Freaks* was banned outright until 1963. Browning's career never really recovered, although he made two more effective horror films for MGM in the mid-1930s: *Mark of the Vampire* (1935), starring Lugosi in a remake of Browning's lost *London after Midnight*; and *The Devil Doll* (1936), a compelling horror film involving a race of miniature people who are telepathically commanded to commit murder.

In the 1940s MGM offered Albert Lewin's literate adaptation of Oscar Wilde's *The Picture of Dorian Gray* (1945), with Hurd Hatfield as the doomed aristocrat who pursues a life of debauchery without apparent consequence, while his portrait in the attic decays into an image of loathsome putrescence. Directed in suitably detached fashion, the film is

both understated and menacing, highlighted not only by Hatfield's suit-
ably emotionless performance, but also by brief color sequences in which
the painting in the attic, in all its ghastly glory, is revealed to the viewer
as an object of totemic revulsion. Paramount also dabbled in the super-
natural with such films as 1943's *The Uninvited*, a ghost story directed by
Lewis Allen. The film received strong critical and commercial acclaim,
but Paramount soon returned to the tried-and-true formula of the Bob
Hope–Bing Crosby "Road pictures," leaving the scare tactics to others.

The bottom rung of 1940s horror was occupied by two Hollywood
studios that toiled in the film capital's Poverty Row, Monogram and
Producers Releasing Corporation (PRC). Monogram's horror films
were produced, for the most part, by the notoriously impecunious Sam
Katzman (in association with his then-partner, Jack Dietz, as Banner
Productions), shot on schedules of a week to ten days, budgeted as
tightly as possible, and conceived with an utter lack of imagination, orig-
inality, or ambition. Monogram had one major star who was willing to
appear in its films, Bela Lugosi.

Always in need of money, driven by his drug addiction and his mat-
rimonial difficulties—he was married five times—Lugosi was willing to
appear in almost anything, so long as he received star billing. And thus
we have the pathetic spectacle of Lugosi lumbering through Joseph H.
Lewis's *Invisible Ghost* (1941) as a homicidal maniac; William Nigh's
Black Dragons (1942), a bizarre tale of wartime espionage and plastic sur-
gery; Wallace Fox's *The Corpse Vanishes* (1942), featuring Lugosi as a sci-
entist who kidnaps young brides so that his aging wife may remain
eternally young; Fox's *Bowery at Midnight* (1942), with Lugosi cast as an
insane criminology professor who also operates a Bowery soup kitchen
and moonlights as the head of a ruthless criminal gang engaged in a ram-
page of murder and mayhem; and William Beaudine's *The Ape Man*
(1943), of which the title tells all. Perhaps the most interesting of these
impoverished films is Beaudine's *Voodoo Man* (1944), presenting Lugosi
as a practitioner of black magic who kidnaps young women to drain
their life energy and restore his wife to the living.

In these films, Lugosi is supported by a group of excellent actors,
including George Zucco and John Carradine, yet Monogram's produc-
tion values are so fatally compromised as to render the films almost
impossible to watch in their entirety. The photography is flat, the

direction sticks to master shots and close-ups, the sound recording is poor, and the stock music is endlessly recycled. A generation of television viewers grew up on these films in the 1950s, when they were among the first to be released to television following Monogram's "evolution" into Allied Artists. Although they retain some small measure of entertainment value, the Monogram films are solely commercial enterprises, designed for the bottom half of undiscriminating double bills and destined to be forgotten.

PRC (which was known almost universally in Hollywood not as Producers Releasing Corporation but as "Poverty Row Crap") was the absolute bottom rung of the studio system—once you worked at PRC, unless you were a young star on your way up (Alan Ladd's first credit, Sam Newfield's Nazi exploitation film *Beasts of Berlin* [aka *Goose Step* and *Hell's Devils,* 1939] was a PRC film), you were pretty much finished in the industry. Newfield, PRC's house director, was *so* prolific that he used two aliases to cover his tracks—Sherman Scott and Peter Stewart— and routinely knocked out a finished film in five days or less on budgets as low as $20, 000 to final print. Even in the 1940s this was difficult to accomplish, but Newfield cranked out feature films for PRC and, later, other companies at such a rapid pace that he holds the distinction of being the most prolific feature film director in Hollywood history—a record unlikely to be broken anytime soon. But most of Newfield's films are so sloppy and dashed off that it is almost impossible to care about what happens to his protagonists.

Newfield's *Dead Men Walk* (1943) offered George Zucco as a vampire and his human twin brother, with Dwight Frye still cast as the vampire's faithful retainer, twelve years after he appeared as Renfield in *Dracula.* The *Mad Monster* (1942) is another tale of science gone awry by Newfield. In Newfield's *The Monster Maker* (1944), J. Carrol Naish stars as demented scientist Dr. Igor Markoff, who infects concert pianist Anthony Lawrence (Ralph Morgan) with the disease acromegaly, which distorts Lawrence's features hideously, so that Markoff can seduce Lawrence's daughter without undue interference. In *The Black Raven* (1943), George Zucco presides over a rundown roadside inn frequented by gangsters; for a change, in Terry Morse's *Fog Island* (1945), Zucco and Lionel Atwill are involved in a complex tale of murder and intrigue in an isolated manor house.

Bela Lugosi worked at PRC in Jean Yarbrough's *Devil Bat* (1940), playing a mad scientist working for a cosmetics company who raises a race of gigantic killer bats to attack his employer's family, homing in on their prey by following the scent of a special after-shave lotion. In 1946 Frank Wysbar (aka Franz Wysbar, another émigré from Hitler's Germany) was pressed into service to direct a sequel, *Devil Bat's Daughter,* and *Strangler of the Swamp,* a supernatural tale of violence and murder in the Louisiana swampland.

Edgar G. Ulmer, also a refugee from Nazi Germany, was PRC's most talented director by a wide margin and directed a number of films for the studio, including *Bluebeard* (1944), with John Carradine cast as the infamous serial killer. Ulmer's most famous film for PRC is the classic film noir *Detour* (1945), not the province of this book, but a brilliant film nonetheless. Ulmer also directed the interesting *Strange Illusion* (1945), a modern-dress version of *Hamlet* shot in six days for $40,000, in which a young man's dead father warns him from beyond the grave of a potential threat to his mother's life, one of PRC's few really distinctive efforts.

Columbia Pictures, which had started out as a Poverty Row company until its president, the indomitable Harry Cohn, lifted it out of the depths of Gower Gulch with Frank Capra's *It Happened One Night* (1934), also took a bet on horror films, engaging Boris Karloff to star in a series of interesting, mid-range horror films, most with a scientific bent. Efficiently directed by Nick Grinde, *The Man They Could Not Hang* (1939) features Karloff as Dr. Henryk Savaard, a generally benevolent scientist who invents an artificial heart; however, when his assistant agrees to be put to death in order to be revived by the device, Savaard is prevented by the police from resurrecting him. Subsequently executed for murder, Savaard is revived by another assistant, Dr. Lang (Byron Foulger), but his return to life is marked by a fatal dementia, which sets Savaard on a killing spree as he attempts to eliminate the authorities who fatally interfered with his work. In Grinde's similarly themed *The Man with Nine Lives* (1940), Karloff is Dr. Leon Kravaal, involved in cryogenic research, and in Grinde's *Before I Hang* (1940), Karloff, as Dr. John Garth, is an advocate for euthanasia. Once again, the authorities take a dim view of his activities.

Most interesting of all the Columbia horror films is Edward Dmytryk's *The Devil Commands* (1941), easily the best film of the series.

Dmytryk, who would soon go on to prominence as an A list director on such films as *Murder, My Sweet* (1944) and *The Caine Mutiny* (1954), to name just a few of his many films, spins a complex and surprisingly emotional tale of Dr. Julian Blair (Karloff), whose wife is killed in a hit-and-run accident in the first few minutes of the film. Blinded by grief, Blair begins a series of grisly experiments in an attempt to contact his wife's spirit, aided by an unscrupulous medium, Mrs. Walters (Anne Revere, in a typically authoritative performance), using the corpses of the recent dead as "amplifiers" to boost the signal of his wife's attempts to contact him from the afterlife. At a brisk sixty-five minutes, the film never condescends to the audience, and yet it delivers the requisite shocks the genre requires.

Karloff was impressed with Dmytryk's finished film, but the Columbia contract was for five films only, and after that, Karloff was a free agent. Karloff's Columbia films were, on the whole, quite limited, both in budget and ambition. But Karloff could hardly claim to be surprised by this, given the guiding philosophy of Columbia's chief Harry Cohn, one of the most brutal and vulgar Hollywood moguls of the classical studio era. As Cohn once told one of his numerous minions, "let me give you some facts of life. Every Friday, the front door of this studio opens and I spit a movie out onto Gower Street . . . if that door opens and I spit and nothing comes out, it means a lot of people are out of work—drivers, distributors, exhibitors, projectionists, ushers, and a lot of other pricks . . . I want one good picture a year, and I won't let an exhibitor have it unless he takes the bread-and-butter product, the *Boston Blackies*, the *Blondies*, the low-budget westerns and the rest of the junk we make." With an attitude like that, Karloff knew precisely where he stood in Columbia's pecking order; he was part of "the rest of the junk." Karloff's hopes for a quality horror film would come true only a few years later, in his work for producer Val Lewton at RKO. But at Columbia, Karloff was just a commodity, and nothing more.

During this period in England, true horror films were rare, with the exception of a long succession of Edgar Wallace thrillers. Many of these had a strong horror element, most notably Walter Summers's *Dark Eyes of London* (aka *The Human Monster,* 1940), in which Bela Lugosi appears as an unscrupulous moneylender who takes out life insurance policies on his customers and then murders them. As a cover for his activities, he

also masquerades as the director of a home for the blind, assisted by a hulking brute who drowns and electrocutes his unfortunate victims.

Lugosi's name, of course, was what gave the project box-office clout. In similar fashion, shortly after his success in *Frankenstein,* Boris Karloff returned to his native England to appear in T. Hayes Hunter's *The Ghoul* (1933), in which he plays an archaeologist who rises from the dead to seek vengeance when a priceless jewel, promising eternal life, is stolen from his grave. With a cast that included Sir Cedric Hardwicke, Ernest Thesiger, and Ralph Richardson (in his film debut), this seventy-three-minute film was a distinct change of pace for British audiences.

Even more brutal were the films of the aptly named Tod Slaughter, who had been treading the boards in Victorian horror melodramas for several decades before producer George King, one of Britain's most cost-conscious impresarios, realized that he could film several of Slaughter's stage productions on a "quickie" basis and market them profitably throughout the empire, where they found a wide and enthusiastic audience among less discriminating viewers. Slaughter was fifty years old when he made his first screen appearance, and subtlety was never his forte. In such films as King's *The Crimes of Stephen Hawke* (1937), Slaughter appears as a fiendish criminal known only as "the Spine Breaker," and indeed, in the first scene in the film, we see him sneak up behind an unsuspecting child in a public park and neatly snap its back into two pieces. This was strong stuff for audiences of the period and remains so today. Slaughter's innumerable villains never for a moment command a vestige of sympathy from the audience; they are purely evil and beyond redemption. Slaughter also starred in the first sound version of *Sweeney Todd, the Demon Barber of Fleet Street* (George King, 1936) as the crazed barber who kills his customers with a flick of his straight razor and then bakes their entrails into hot meat pies.

Slaughter made eight films for King between 1935 and 1940, and then returned to the stage, appearing around the country in the same violent plays King had adapted for the screen. Slaughter never had any pretensions about his work and died in harness, right after the performance of one of his more violent plays in front of a provincial audience. As Slaughter noted in the prologue to *The Crimes of Stephen Hawke,* "in my career I've murdered hundreds and hundreds of people, and come to a sticky end more times than I care to remember. I keep a perfectly open

mind on the matter. I murder by strangulation, shooting, stabbing—or with a razor."

The British Film censor's office, however, was not so open-minded on the subject of cinematic mayhem, and in 1940 it banned all horror films, foreign and domestic, as detrimental to the war effort. The ban was not lifted until 1945, when Ealing Studios, best known for its comedies, produced the classic omnibus horror film *Dead of Night,* a five-part masterpiece directed by Alberto Cavalcanti, Basil Dearden, Robert Hamer, and Charles Crichton, with a cast including Sir Michael Redgrave, Mervyn Johns, Miles Malleson, Sally Ann Howes, and many other luminaries of the British screen.

As *Dead of Night* opens, Walter Craig, an architect (Mervyn Johns), arrives at a country house for the weekend, ostensibly to look over the house for renovation. Almost immediately, however, he has the feeling that he's been to the house before, that he's met the owners and their guests before, and that, as the evening progresses, he will be forced to murder someone against his wishes, unless he leaves immediately. A psychiatrist (Frederick Valk), one of the guests, persuades Craig to stay, to demonstrate that his fears have no foundation.

To pass the time, the members of the group take turns telling ghost stories. The first, "The Hearse Driver," tells of a racing driver who has a presentiment of death that saves him from a fatal bus accident; the second, "The Christmas Story," centers on a crying boy in a deserted mansion who had been murdered a century earlier by his sister and returns as a ghost. The third section, "The Haunted Mirror," is one of he strongest stories of the group. A young man, Peter (Ralph Michael), buys a mirror that belonged to a man who strangled his wife before killing himself in the 1840s. Slowly, the mirror takes possession of Peter, and the spell is broken only when his wife, Joan (Googie Withers), smashes the mirror and destroys its curse. The fourth segment, "Golfing Story," is a comic ghost story about two rival golfers who are competing for the affections of the same woman. One cheats to win her, and the loser kills himself, but then returns from the dead to haunt his rival, having been apprised in the afterlife of his friend's cheating. The film's final segment, "The Ventriloquist's Dummy," tells the tale of Maxwell Frere (Sir Michael Redgrave), a ventriloquist with an unruly dummy, Hugo, who eventually subsumes Frere's personality.

16. Michael Redgrave (right) and his demonic dummy Hugo in *Dead of Night*. Courtesy: Jerry Ohlinger Archive.

In the film's horrific climax, all of the stories combine into one nightmarish whirlpool of propulsive narrative, as Craig does indeed murder an innocent victim (the psychiatrist) and is tormented by the characters in the tales we've just witnessed. Suddenly, Craig wakes up. The whole thing has been a dream. But he has to go to the country to inspect a house that needs renovations, and when he arrives, he feels that he's been there before. The film ends with the same images and dialogue shown at the beginning, as the credits roll, and the horror of Craig's dream becomes endless, circular, and inescapable.

The horror film, which had been truly international in the silent era, became centered in Hollywood, which in the 1930s and '40s set the standards for narrative pacing, production values, star power, and iconic and thematic structure. The horror film had been a potent genre in the German silent era, but when Hitler seized power in 1933, Joseph Goebbels, his minister of propaganda, declared that the horror film was "decadent," and he embarked on the production of a series of vile

anti-Semitic films much more horrific than any imaginary scenario could ever be, such as Fritz Hippler's repugnant libel *Der ewige Jude* (*The Eternal Jew,* 1940) and Veit Harlan's equally odious *Jud Süss* (*Jew Süss,* 1940), along with a series of newsreels, comedies, war films, and frankly escapist fare—but no fictional horror films. All of the talented artists who had created the German classic silent horror films fled almost immediately to America—Fritz Lang, Franz Wysbar, Robert and Curt Siodmak, G. W. Pabst, Hans J. Salter, and many others—to create the Universal series of horror films that defined the horror film in the early sound era.

Nearly every European country had stopped production of films altogether for the duration of World War I, creating a perfect export climate for American products. By 1918, when the Armistice was declared, American films dominated the international box office, as they continue to do to this day. And yet, there was still a foreign audience for horror films, both foreign-language versions of American hits and homegrown horror films, which appeared throughout the world on a sporadic basis. In the early sound era, films were often photographed in multiple languages. For example, at Universal, George Melford (who didn't speak a word of Spanish) directed, through an interpreter, the Spanish-language version of *Dracula* in 1931 on the same sets as the English-language version; Browning shot during the day, and Melford shot at night, using Carlos Villarías and Lupita Tovar as his two leads in what many consider a more sensual and explicit version of the classic vampire tale.

Although he is certainly not considered a horror auteur, the Danish director Carl Theodor Dreyer contributed an early and remarkable entry to the genre with the dreamlike *Vampyr, Der Traum des Allan Grey* (*Vampire: The Dream of Allan Grey,* 1932), the director's first film shot with a synchronized soundtrack after his final silent masterpiece, *La passion de Jeanne d'Arc* (*The Passion of Joan of Arc,* 1928). To achieve maximum distribution potential in an era in which dubbing was all but impossible, Dreyer shot the film simultaneously in German, English, and French with the private financing of Baron Nicolas de Gunzberg, who also served as *Vampyr*'s key protagonist, Allan Grey, under the pseudonym of Julian West.

Immaculately photographed by Rudolph Maté, later a director himself, with a deliberately diffuse camera style, *Vampyr,* despite its pedigree, was a complete commercial failure and only began to be appreciated for

17. The ghostly funeral in Dreyer's *Vampyr*. Courtesy: Jerry Ohlinger Archive.

the eerie, otherworldly masterpiece that it is in the early 1960s, when screenings of the film at universities and museums around the world offered a new generation of more perceptive viewers the chance to re-evaluate a classic. In particular, the dream sequence in *Vampyr,* in which Grey imagines that he is being buried alive—shot entirely from his point of view as he lies in the coffin, unable to move or speak—is a horrific tour de force that effectively brings home the sense of dread inherent in the entire enterprise.

With the commercial failure of *Vampyr,* however, Dreyer was unable to find backing for another film until 1942, when he directed a documentary short film about motherhood for the Danish government. Then, in 1943, he turned to *Vredens Dag (Day of Wrath),* a parable of the Nazi occupation, which was then at its peak in Denmark. In 1629 the aged Herlofs Marte (Anna Svierkier) is accused of being a witch. At the same time, the seemingly innocent Anne (Lizbeth Movin) is married to Absalon Pedersson (Thorkild Roose), an old pastor who presides over the witch trials that are sweeping the region. Anne and Absalon live

together in a house dominated by Absalon's mother, Merete (Sigrid Neiiendam), a forbidding matriarch who distrusts Anne and is suspicious of her relationship with Absalon.

In a complex series of intertwined relationships, Anne gradually falls in love with Martin (Preben Lerdorff Rye), Absalon's son from his first marriage. As the two young people become more intimate, Anne suddenly realizes that she wishes that Absalon were dead so that she could marry Martin. Herlofs Marte, in the meantime, is tortured until she "admits" that she is a witch, and she is burned at the stake. Under torture, she had cursed Absalon, predicting that he would soon die. This happens all too soon when Anne confronts Absalon and tells him of her love for Martin and of her wish that he might die so she can be free to remarry. Stunned, Absalon collapses on the spot and expires. At the funeral, Merete attacks Anne, calling her a witch, a charge that Anne initially denies but then finally admits is true.

Day of Wrath thus ends on an unresolved note, but what is most peculiar about the film is, perhaps, our comprehension of it both in 1943, when it was first released, and today. Because we start, presumably, with the convictions that witches do not exist and that witch trials are merely a sham allowing one group to persecute another, we are loath to believe that either Anne or Herlofs Marte is a witch. Surely, this is a matter of ignorance and intolerance, easily explained by jealousy, fear, and the conflict of the old versus the new. But Anne really *is* a witch, which only gradually dawns on us, and Dreyer, that most stern and sensible of directors, has led us down the path of disbelief only to confront us with genuine evil—Anne *does* have the power of life or death.

But American films still ruled the box office. Dubbing became a routine process, and American films were dubbed or subtitled for foreign audiences. The market was vast, the competition was non-existent, and thus the Hollywood horror film reigned supreme at the box office from 1930 to 1948, when Universal, in the aforementioned *Abbott and Costello Meet Frankenstein,* seemingly gave up on the genre. Horror films had been killed by a plethora of poorly made sequels betraying a lack of both care and inspiration, as well as the all-too-real events of World War II.

The classic monsters were truly dead. They had been recycled, teamed with other of their brethren, and finally relegated to foils for burlesque comedians, and no one seemed to have any idea of how to restore

them to "life." But in England a revival was underway; it would change the shape of the horror film forever and present to the public a new version of the Gothic replete with color and increased doses of sex and violence. Perhaps most surprisingly, this renaissance would occur at a manor house in the British countryside, which in the early 1950s was occupied by a small, thinly capitalized studio then cranking out monotonous B noirs: Hammer Films. Soon Hammer would abandon these pseudo-America knockoffs and, starting with Mary Shelley's seminal creation, reinvent the horror film from the ground up. But first, there were some intriguing Cold War iterations of the horror film in 1950s America, as Universal's classic monsters stepped out of the spotlight and a new series of nightmares, quite different from those of the Depression and World War II, gripped the nation's consciousness.

CHAPTER 3

Rebirth

1949–1970

IN AMERICA, HORROR FILMS in the 1950s were trying to find a new audience. The genre had yet to recover from the predations of Abbott and Costello's burlesques of Universal's classic monsters (*Meet the Mummy* and so on). The rise of television, too, was another "monster" that the studios faced during this period, and one of the tools they used to counter the ubiquitous onslaught and hang on to their audiences was 3-D technology. The "shock" aspect of 3-D seemed to lend itself to horror films, and in short order the major studios obliged with various offerings.

Although several cheap 3-D films were made in the early 1950s, notably Arch Oboler's jungle melodrama *Bwana Devil* (1952), Warner Brothers was the first studio to mount a lavishly budgeted 3-D production, André de Toth's horror film *House of Wax* (1953), a remake of Michael Curtiz's *Mystery of the Wax Museum* (1933) and one of the rare cases in which the remake is superior in every way to the original. Henry Jarrod (Vincent Price) is the creator and proprietor of a wax museum in turn-of-the-century New York, which has fallen on hard times. Jarrod's partner, Matthew Burke (Roy Roberts), demands that Jarrod "sensationalize" the museum with depictions of famous murderers, torturers, and tyrants, and when Jarrod refuses, Burke splashes kerosene on the wax exhibits and sets the museum on fire to collect the insurance. Jarrod tries to stop him, but Burke knocks Jarrod out and flees, leaving his partner to burn to death along with his beloved exhibits.

However, Jarrod survives, albeit in a wheelchair, and with the aid of his mute assistant Igor (Charles Bronson), he sets up a new museum dedicated to precisely the sort of violent, lurid exhibitions that Burke had

demanded. But while the museum prospers, a mysterious cloaked figure in a wide-brimmed hat is simultaneously stalking the streets, murdering Burke, then Burke's fiancée, Cathy Gray (Carolyn Jones), and other victims. The killer, of course, is none other than Jarrod himself, hideously disfigured as a result of the fire, but hiding his distorted visage beneath a wax mask that gives him the appearance of normalcy when in public.

At length, Cathy's friend Sue Allen (Phyllis Kirk) discovers Jarrod's secret: all of the "models" in Jarrod's wax museum are really his victims, covered in a thin coating of wax. Jarrod becomes obsessed with Sue Allen's beauty and imagines her as "my Marie Antoinette." In a panic, Sue hits Jarrod repeatedly in the face, shattering the wax mask, and then faints at the sight of his disfigured visage. She is spirited away to the basement of the wax museum, where Jarrod keeps an enormous apparatus to scald his victims to death with molten wax while encasing them in a thick coat of pink paraffin. At the last possible moment, the police break into Jarrod's workroom and save Sue from a violent death, while Jarrod himself falls into a huge vat of liquid wax and is immediately killed.

De Toth's *House of Wax* is a slick, efficient thriller, produced on an assembly-line basis in narrative order so that it could beat the first 3-D films of Warners' competitors into theaters. *House of Wax* was shot in the impractical but technically superior Natural Vision process created by Julian and Milton Gunzberg, which used two "slaved" cameras locked in frame-for-frame synchronization in an enormous blimp to achieve the 3-D effect, which was viewed by audiences through specially polarized glasses. Perhaps the most peculiar aspect of the film was that de Toth himself, blind in one eye, had no depth perception at all and thus would seem to be unsuited for directing a 3-D film. But precisely because of this handicap, de Toth concentrated on the film's narrative line; by eliminating the tedious comedy interludes of the 1933 version and choosing not to rely on shock effects, he delivered a tight, violent film.

House of Wax also marked the beginning of Vincent Price's inextricable link with horror films and set him firmly on the path that would see him profitably through the 1950s, '60s, and '70s. As for 3-D, the fad fizzled out after two years, although even Alfred Hitchcock used it in one of his least interesting films, *Dial M for Murder* (1954); the director later admitted he had turned to it because of "a creative lapse" in his work. Although the 3-D version of *Dial M for Murder* exists and has been

revived in its original dual-projection format from time to time (most notably at New York City's Film Forum, one of only two theaters in the United States that can accommodate the cumbersome process; the other is the Los Angeles Cinematheque at the Egyptian Theatre in Hollywood, which regularly showcases classic 3-D festivals), Hitchcock released the film in the conventional 2-D format only. Begun in 1952, the 3-D craze was passé by 1954.

Many of the most innovative and unusual horror films of the 1950s came from independent producers who were attempting to break away from the pantheon of Universal's classic monsters. Albert Band's hypnotic and underrated *I Bury the Living* (1958) stars Richard Boone as Robert Kraft, the manager of an upscale cemetery where all the plots are marked out on a large map that dominates Kraft's small, on-site office. One day, Kraft accidentally puts a black pin into the map (designating an occupied grave) where a white one (indicating an empty grave) should have been; much to his shock, the owner of the plot suddenly dies. Soon, one death follows after another, as Kraft begins to believe that the map, which gradually grows larger and larger in size like some phantasmal prop from *The Cabinet of Dr. Caligari,* has the power of life and death (the film's visual design was created by the gifted film montage expert Slavko Vorkapich). If the black pins bring death, what will happen when Kraft removes them? Will the dead return to life?

Shot on a minuscule budget and with a brief running time of roughly seventy-five minutes, *I Bury the Living* fuses Frederick Gately's effective cinematography and Gerald Fried's propulsive musical score with a convincingly anguished performance by Boone in the leading role, while Theodore Bikel provides capable support as Andy McKee, the cemetery's enigmatic groundskeeper. Guided by Louis Garfinkle's literate script and Band's intelligent execution (Garfinkle and Band also produced the film, which was ultimately released through United Artists), *I Bury the Living* reminds one of the best of Val Lewton's horror films in the 1940s. Like them, this film evokes a mounting sense of dread in everyday existence, as Kraft's life, seemingly quite placid at the start of the film, rapidly spins out of control.

As the 1950s progressed, a number of interesting films managed to sneak through the cracks of the country's postwar complacency, all of them sharing an air of claustrophobic fatalism. Edward L. Cahn's *The Four*

Skulls of Jonathan Drake (1958) is one of a group of very curious horror films made in the late 1950s by Cahn, a director of longstanding Hollywood reputation, with a career going back to the 1930s. In *The Four Skulls of Jonathan Drake,* Drake (Eduard Franz), a psychic researcher working at an unnamed university, fights back against a centuries-old colonialist curse visited upon all the male descendents of the Drake family by the resuscitated figure of Dr. Emil Zurich (Henry Daniell), who is in reality an undead construct: the head of an ancient white slave trader, who was murdered some two hundred years earlier by Drake's ancestors, sewn onto the body of a South American native.

Now, with his assistant Zutai (Paul Wexler), Zurich seeks to avenge himself on all the members of the Drake family. His favored method of retribution is decapitation. As the film opens, Jonathan's brother Kenneth (Paul Cavanaugh) is beheaded by Zutai, and his head is subsequently shrunken by Dr. Zurich and preserved as a trophy. For the balance of the film, which was shot in moody black and white on a few spartan sets, Jonathan Drake must strive to convince both the authorities and his own daughter of the reality of the curse, which threatens to destroy them all.

What sets *Four Skulls* apart is Cahn's absolute seriousness in the film's execution. It is just one of a series he pounded out on short schedules with minimal budgets, some for producer Robert E. Kent (who also worked as a screenwriter), some for Sam Katzman's Clover Productions, and some for American International Pictures, usually when Roger Corman was busy on another project. These films include *Invisible Invaders* (1959), *Curse of the Faceless Man* (1958), *It! The Terror from Beyond Space* (1958), *Invasion of the Saucer Men* (1957), *Zombies of Mora Tau* (1957), *Voodoo Woman* (1957), *The She-Creature* (1956), and the extraordinarily violent *Creature with the Atom Brain* (1955), in which marauding zombies murder their victims by literally lifting them in the air and snapping their spines in two.

Cahn's films during this period prefigure the more violent films that would appear in the early 1970s; they are fast, brutal, and unapologetic. Cahn, who died in 1963, directed an average of ten films per year in the late 1950s and early '60s. His last film, one of his few in color, was an odd retelling of the classic fairy tale *Beauty and the Beast* (1962).

Another prolific and gifted contract director in the 1950s was Fred F. Sears. He made a series of inexpensive but effective horror films for the

Katzman unit at Columbia, most notably *The Werewolf* (1956), in which an unsuspecting Duncan Marsh (Stephen Ritch) is transformed into a werewolf by two unscrupulous scientists as a sort of experiment, with disastrous consequences. Shot in low-key black and white, *The Werewolf* is one of the most effective and understated modern-day horror films of the era.

Another curious artifact of late 1950s horror is Howard W. Koch's *Frankenstein 1970* (1958), in which Boris Karloff plays Baron Victor von Frankenstein, a hideously scarred victim of Nazi "experimentation" during World War II. He has escaped to continue his work in a lonely mountain castle but finds that his funds are running short. To raise the needed cash to continue his experiments, he grudgingly allows a television crew to use his castle as a set for a grisly "docudrama" on his infamous ancestors, and he even agrees to appear in the television show as himself, narrating the family legend. All the while, he is building yet another monster in a secret laboratory in the castle's basement.

When human "spare parts" prove to be in short supply, Baron Frankenstein starts killing off crew members one by one for their organs, only to be thwarted at the last minute by the crew's mounting suspicions. As a link between the original Universal *Frankenstein* films and the films that would follow during the 1960s horror renaissance, *Frankenstein 1970* is a straightforward, brutal film, and Karloff completely dominates in every scene. Shot in CinemaScope on a modest budget, the film sustains a genuine aura of menace throughout its compact running time of eighty-three minutes and closes with a neat touch: the monster Frankenstein is building would have had Karloff's own face, circa 1958, that of an urbane, sophisticated gentleman.

Reginald Le Borg's *The Black Sleep* (1956) also deserves mention during this era as one of the genre's last "class reunion" films. Basil Rathbone, a mainstay of 1930s and '40s horror, now in his declining years, plays Sir Joel Cadman, a demented scientist with a cellar full of experiments gone wrong. Akim Tamiroff, Lon Chaney Jr., Bela Lugosi, and John Carradine round out the cast. Sadly, the film is a rather cheap and shoddy affair, designed solely to wring the last possible dollar out of whatever marquee value these aging horror stars had left with the public.

Other odd 1950s horror films include Edward Dein's *Curse of the Undead* (1959), a vampire western; Will Cowan's bleakly convincing

The Thing That Couldn't Die (1958), in which the decapitated head of a centuries-old warlock is reunited with its long-buried body to wreak havoc upon the living; Alfred Shaughnessy's *Cat Girl* (1957), in which a young woman turns into a monstrous feline and goes on a murderous rampage; and John Parker's almost impossible to describe "nightmare film" *Dementia* (1955). A dreamlike independent production that sketches an endless hell of murder, corruption, and death, *Dementia* was shot on a non-existent budget and given an atonal score by George Antheil, who began his career working with the French surrealist movement, composing the score for Fernand Léger and Dudley Murphy's *Ballet mécanique* (1924).

One might also mention Francis D. "Pete" Lyon's *Cult of the Cobra* (1955), one of the last of the Universal horror films of the 1950s, made on the cheap with former Howard Hughes protégé Faith Domergue in the lead; John Brahm's campy *The Mad Magician* (1954), a sort of black-and-white 3-D knockoff of the infinitely superior *House of Wax*, again with Vincent Price in the lead; Felix Feist's *Donovan's Brain* (1953), in which the mind of a dead, ruthless industrialist gradually takes over the body of an overly ambitious research scientist; and Seymour Friedman's interesting twist on the Jekyll/Hyde saga, *The Son of Dr. Jekyll* (1951), starring Louis Hayward as Jekyll's progeny, with a suitably understated performance by Alexander Knox as the film's villain. Director Nathan Juran (aka Nathan Hertz) took Lon Chaney Jr. and Boris Karloff through the appropriately doom-laden scenario of *The Black Castle* (1952); Charles Laughton's sole film as a director, *Night of the Hunter* (1955), showcased Robert Mitchum as a psychotic preacher on the trail of two young children; and Jacques Tourneur, late of the Val Lewton films, directed the brilliant British production of *Night of the Demon* (1958), a frighteningly commonplace film about black magic that treats it as an everyday occurrence, with a deft performance by Niall McGinnis as the chief Satanist.

In France, Georges Franju, whose *Le sang des bêtes* (*Blood of the Beasts,* 1949) offered an unsparing look at a Parisian slaughterhouse, continued making equally disquieting fictional feature films, starting with *La tête contre les murs* (*Head against the Wall,* 1959), in which the director of an insane asylum thwarts the inmates' attempts to recover their sanity. His masterpiece was *Les yeux sans visage* (*Eyes Without a Face,* 1960), which

18. The "faceless woman" is comforted in Georges Franju's *Eyes Without a Face*.
Courtesy: Jerry Ohlinger Archive.

centers on a crazed surgeon's attempts to keep his disfigured daughter
eternally youthful by transplanting the faces of a series of young women
over her scarred visage. Henri-Georges Clouzot's tale of four desperate
men struggling to truck two loads of unstable nitroglycerine over treach-
erous mountain roads in a South American jungle, *Le salaire de la peur* (*The
Wages of Fear,* 1953), is a film of almost unbearable tension and unremit-
ting humanist despair, a real-life horror story with capitalism as the
film's clearly defined villain. Several years later Clouzot's *Les diaboliques*
(*Diabolique,* 1955), a tale of murder, betrayal, and intrigue at a provincial
French boarding school with distinctly supernatural overtones, became
one of the 1950s' most critically acclaimed films in the horror genre.

Another deeply peculiar film of this transitional period is Joseph Green's independent production, *The Brain That Wouldn't Die* (1963), in which Dr. Bill Cortner (Jason Evers), an unscrupulous scientist, takes his fiancée, Jan Compton (Virginia Leith), for an evening car ride that results in her decapitation in a horrific accident. Cortner grabs Jan's head, wraps it in a towel, and spirits it off to his basement laboratory, where he keeps the still talking, conscious head alive until he can find a suitable body to replace Jan's own, which was destroyed in the wreck. Cruising the strip clubs, Dr. Cortner lures a variety of young women back to his house with his oily charms, sure that Jan will approve of what he is doing. But Jan wants none of it. She wants only to die and thinks (quite rightly) that Cortner is insane.

It transpires that this is not Dr. Cortner's first questionable experiment; in fact, he has been working on creating a synthetic human for quite some time and keeps a monstrous "thing" locked up in his laboratory closet, representing the sum total of all his mistakes. Jan develops a telepathic connection with the wretched being, and in the film's climax, it breaks out of its closet prison and kills Dr. Cortner while the lab explodes in flames. The film ends with the monster destroying Jan's head, wrecking all of Cortner's work, and escaping with a young woman whose body was to have been used as a replacement for Jan's.

What is most remarkable about *The Brain That Wouldn't Die* is the film's sheer amorality, as well as its flat, unapologetic presentation of the world. Cortner's assistant in the project, Kurt (Leslie Daniels), continually expresses his disapproval of the entire enterprise but does little to stop Cortner's homicidal mania. Instead, he mouths meaningless platitudes, such as "The paths of experimentation twist and turn through mountains of miscalculations and often lose themselves in error and darkness," which indeed in this film they do. For her part, Jan sees her disembodied head as a thing of revulsion and disgust. "Nothing you can be is more terrible than what I am," she tells Cortner as he heads off on yet another mission to secure a less-than-willing victim for his experiment.

Throughout the film Cortner continually lies to Jan, Kurt, and anyone else unfortunate enough to come into contact with him about the true nature of his quest. Or, as he puts it, trying to lull one of his potential victims into a false sense of security, "Do I look like a maniac who goes around killing girls?" Actually, with his sleazy bachelor pad and his

19. Virginia Leith's head awaits transplantation in *The Brain That Wouldn't Die*. Courtesy: Jerry Ohlinger Archive.

insistence on physical appearance over all other attributes, Cortner seems a sort of forerunner of Patrick Bateman (Christian Bale) in Mary Harron's *American Psycho* (2000). Women are nothing more than objects of desire for Cortner, and his infatuation with Jan before her decapitation is nothing more than that; he wants Jan for her physical beauty alone. For Cortner, Jan's body is something that can easily be replaced by picking out the right stripper for the part. If any film ever testified to the sexism that pervaded horror films of the era, *The Brain That Wouldn't Die* is that film.

One of the most violent films of the era was a rather lavishly budgeted British film that was screened at children's matinees throughout the United States during the early 1960s: Arthur Crabtree's remarkably sadistic *Horrors of the Black Museum* (1959). Produced by Herman Cohen, the man behind *I Was a Teenage Werewolf* and *I Was a Teenage Frankenstein*, *Horrors of the Black Museum* is a virtual catalogue of murders, presented without a shred of conscience or commentary. In the film's justly infamous opening, a bright red delivery van pulls up to the

apartment house of an attractive young woman, who is surprised to receive an expensive pair of binoculars as a gift from an anonymous admirer. As she puts the binoculars over her eyes and tries to focus them, a sharp spike pops out of each lens, killing her instantly.

The killer is almost immediately revealed to the audience (but not the police) as crime reporter Edmond Bancroft (Michael Gough), who realizes that his readers are hungry for the gory details of violent crimes and consequently arranges incidents like this to keep his public satisfied. In addition to writing a daily column for one of the sleazier London tabloids, Bancroft also bangs out lurid, best-selling books on brutal sex crimes, including his newest project, entitled *The Poetry of Murder.* Bancroft proudly keeps his own private "Black Museum," showcasing the savage crimes he's committed, and he is a thoroughgoing misogynist. At one point he blurts out to Rick (Graham Curnow), his young assistant, that "no woman can hold her tongue. They're a vicious, unreliable breed!"

To generate new thrills for his readers, Bancroft injects Rick with drugs that destroy the young man's will and sends him out to commit a series of grisly murders, including the decapitation of a young prostitute using a portable guillotine. When Rick falls in love with pretty Angela Banks (Shirley Ann Field) and brings her to Bancroft's private lair so they can be alone, Bancroft discovers them and flies into a jealous rage. Recovering his composure, Bancroft pretends to approve of their relationship, but as soon as Angela leaves, Bancroft injects Rick with another dose of drugs and orders him to kill her. Rick obediently stabs Angela to death in an amusement park "Tunnel of Love," but then turns on Bancroft, who has trailed him to the murder scene. Jumping off a Ferris wheel, Rick stabs Bancroft to death before a group of startled onlookers.

Equally disturbing was Michael Powell's 1960 *Peeping Tom,* which centered on mild-mannered film assistant Mark Lewis (Carl Boehm), who in his spare time murders a series of young women with a specially built "spike camera" and records their deaths on film. *Peeping Tom* was almost universally reviled upon its initial release and brought an end to the long and distinguished career of director Powell, who, with his partner Emeric Pressburger, co-directed such classics as *The Red Shoes* (1948), *A Canterbury Tale* (1944), and *A Matter of Life and Death* (aka

20. A disturbing scene from Michael Powell's *Peeping Tom*; Carl Boehm with his "killer camera." Courtesy: Jerry Ohlinger Archive.

Stairway to Heaven, 1946). *Peeping Tom* was Powell's first foray into the horror genre, and it was crafted with his customary panache and daring, but the subject matter was too radical for the era. Powell was singularly unapologetic about his work on the film; he even went so far as to play Mark's manipulative father in "home movies" within the film.

The film that truly put an end to the 1950s and opened up a new era for the horror film was Alfred Hitchcock's *Psycho* (1960), a surprisingly brutal film with significant horror elements (violent death, an old dark house) from a filmmaker best known as a purveyor of sleek suspense. Basing his film on a novel by Robert Bloch, which in turn was based on the real-life crimes of the Wisconsin fetishistic murderer Ed Gein, Hitchcock created one of his most memorable and deadly protagonists in the character of Norman Bates (Tony Perkins), a split personality dominated by the will of his dead mother, who kills anyone he is attracted to as a means of maintaining his closed, claustrophobic little world. As the proprietor of the Bates Motel, Norman Bates is the psychopath in our

21. Tony Perkins in his signature role of Norman Bates in *Psycho*. Courtesy: Jerry Ohlinger Archive.

midst, the person we would never suspect, the evil that hides in plain sight. In terms of both graphic specificity (the justly famous shower murder sequence) and originality, *Psycho* is unsettling, riveting, and mesmerizing. You can't look away from the screen, no matter how much you might want to. *Psycho* changed the conventions of the horror film forever, to say nothing of helping to topple the outdated production code, and it became the biggest hit of Hitchcock's long career, something entirely unexpected and absolutely disruptive.

Other similarly themed films followed in rapid succession. Robert Aldrich's Gothic thriller *Whatever Happened to Baby Jane?* (1962) managed

to resurrect the declining careers of both Bette Davis and Joan Crawford; as two elderly sisters locked in a battle to the death over the memories of past stardom, they became horror stars for a new generation of viewers. The film was a surprise hit for Warner Brothers, which quickly ordered a sequel from Aldrich, who began shooting almost immediately on *Hush . . . Hush, Sweet Charlotte* (1964). However, it had been apparent to all on the set of *Whatever Happened to Baby Jane?* that Davis and Crawford openly despised each other. Their continued collaboration as a "horror duo" was thus problematic at best, and almost immediately after the start of shooting *Hush . . . Hush, Sweet Charlotte,* Crawford bowed out of the film, leaving Davis to battle it out with the less capricious Olivia de Havilland.

Moving on from the success of *Psycho,* Hitchcock scared audiences with *The Birds* (1963), an unsettling vision of nature in revolt. Two years later William Wyler's *The Collector* (1965) starred Terence Stamp as a disturbed young man who kidnaps a young woman (Samantha Eggar) as his unwilling companion; the film's dark conclusion is at once entirely appropriate and yet deeply unsettling. Around the same time, Francis Ford Coppola got his first real chance to direct with *Dementia 13* (1963), a psychological horror film centering on a series of brutal murders in an Irish castle, photographed for a little more than $40,000 to final print. During this same period, the Japanese director Ishirô Honda directed a long series of epic monster films, beginning with 1954's *Gojira* (released in the West, with dubbing and additional scenes featuring Raymond Burr, as *Godzilla* in 1956). Honda's films are really not horror films, but rather films in which gigantic monsters, including Mothra (a giant moth), Ghidra (a three-headed dragon), and Rodan (an enormous prehistoric pterodactyl accidentally brought back to life), repeatedly devastate Tokyo and its environs in sequences of spectacular destruction.

In America, another small, independent, and hard-nosed company was making a mark of its own in the horror field. American International Pictures (AIP), founded in the late 1950s by James H. Nicholson and Samuel Z. Arkoff, first specialized in cheap black-and-white double bills with such films as Herbert L. Strock's *I Was a Teenage Frankenstein* and Gene Fowler Jr.'s *I Was a Teenage Werewolf* (both 1957), which cost about $100,000 apiece to make and wound up grossing millions. From the first, AIP aimed at the newly emerging teen market almost exclusively; as

22. A moody Michael Landon in *I Was a Teenage Werewolf.* Courtesy: Jerry Ohlinger Archive.

mom and dad sat at home watching the television, the kids sought escape at the movies, especially the drive-ins.

But AIP's executives rapidly realized that the black-and-white second features they were churning out at a torrid pace would not be sufficient to sustain the company in the long run, even if it controlled both halves of the double bill—a practice that by the late 1950s was beginning to fade out. Accordingly, AIP took what was for it a huge gamble and spent roughly three weeks and $300,000 on a color, CinemaScope version of Poe's *The Fall of the House of Usher,* entitled *House of Usher* (1960). As director, Nicholson and Arkoff chose AIP's most innovative and individual maverick, who had been with them from the beginning: the wildly prolific, speed-obsessed auteur Roger Corman.

Born in Los Angeles, Corman attended Beverly Hills High School, graduating in 1943. He then went on to Stanford University and completed his degree in engineering in 1947 before pulling a three-year hitch in the U.S. Navy. Upon his discharge from the service, Corman abandoned all thoughts of an engineering career and instead became a "runner" for 20th Century Fox, where he rapidly rose to the position of story analyst. Leaving Fox, he spent one semester at Oxford studying modern English literature and then returned to Hollywood, set himself up as a literary agent, and wrote screenplays on the side. His first produced screenplay was the crime film *Highway Dragnet,* directed by Nathan Juran in 1953, which Corman also co-produced.

Corman then moved on to produce Wyatt Ordung's *The Monster from the Ocean Floor,* an underwater horror film shot in six days for a total of $12,000 and released in 1954. In 1955 Corman tried his hand at directing and made five films that year, including the science-fiction/horror thriller *The Day the World Ended,* with a young Mike "Touch" Connors in the lead, all released through AIP. But this was just the beginning. In 1956 Corman directed no fewer than eight films for AIP, including the intergalactic vampire saga *Not of This Earth,* featuring Paul Birch as an alien vampire intent on conquering the planet, and *The Undead,* a tale of witchcraft and hypnosis that succeeded admirably on a minuscule budget.

By 1957 Corman was turning out a torrent of films for AIP; but he soon realized that these short-schedule films would never advance his career and so convinced AIP to produce *House of Usher.* Obtaining the services of genre icon Vincent Price for the leading role and a literate script from horror specialist Richard Matheson, Corman shot the film in color and CinemaScope in (for him) a relatively leisurely three weeks. For his cinematographer, Corman chose the gifted Floyd Crosby, who had won an Academy Award for his work on F. W. Murnau's *Tabu* in 1932. Crosby's atmospheric and confident camerawork, coupled with Daniel Haller's suitably Gothic sets and Edgar Allan Poe's doom-laden short story as the inspiration for the piece, made the film a breakout hit for AIP and established the company at a single stroke as a major competitor in the cinematic marketplace.

In that same year, Corman directed the classic comedy/horror film *Little Shop of Horrors* in two days and a night. The story involves a giant

23. Vincent Price's mind snaps in *The Pit and the Pendulum*. Courtesy: Jerry Ohlinger Archive.

man-eating plant and its unwilling assistant, Seymour Krelboin (Jonathan Haze), who soon turns to murdering skid-row bums as food for the plant, which Seymour nicknames Audrey Jr. after his long-suffering girl-friend Audrey Fulquard (Jackie Joseph). The film also offered an early and memorable role for Jack Nicholson as Wilbur Force, a dental patient who insists, "No novocaine. It dulls the senses," during a particularly invasive session of oral surgery.

Returning to Poe, Corman directed perhaps his most impressive film in the series, the period piece *The Pit and the Pendulum* (1961), which fea-tures a complex plot involving murder, betrayal, and ultimately insanity. Once again Vincent Price took the leading role, this time as Nicholas Medina, a tormented man driven insane by the blood-soaked legacy of his father, the depraved Sebastian Medina, one of the most infamous torturers of the Spanish Inquisition. Corman collaborated with Crosby, Haller, and Matheson to fashion an imaginative, thrillingly compact hor-ror film that moves swiftly and efficiently through its grisly material.

The two Poe projects were followed by three more: *The Premature Burial* (1961), with Ray Milland stepping in for Price in the leading role; the three-part *Tales of Terror* (1962), which toplined Price, Peter Lorre, and Basil Rathbone in three adaptations of Poe's short stories; and the horror spoof *The Raven* (1963), which combined the talents of Lorre, Price, a young Jack Nicholson, and Boris Karloff in a lavish send-up of the series. When Corman completed *The Raven* two days ahead of schedule, he convinced Karloff to stick around for a few extra days and quickly whipped up the script for *The Terror* (1963) with his associates Leo Gordon and Jack Hill. The bulk of the film was shot in two days, with Jack Nicholson taking the other leading role in the film as an officer in Napoleon's army who seeks shelter at the castle of Baron von Leppe (Karloff).

By this time, Corman had built up a sizable group of protégés, including Francis Ford Coppola, Dennis Hopper, Monte Hellman, Jack Nicholson, Charles Bronson, William Shatner, Robert Vaughn, and others, and he used this group of actors and technicians as a talent pool to complete *The Terror,* as well as a number of other films during this period, creating a stock company of actors and technical artists whose skills he would repeatedly employ in his subsequent productions. In *X— The Man with the X-Ray Eyes* (1963), Ray Milland plays a scientist who expands his vision beyond the conventional human spectrum until he can literally see infinity. In the same year *The Haunted Palace* was based on H. P. Lovecraft's novella *The Case of Charles Dexter Ward.*

In 1964 Corman traveled to England, where he shot his most sumptuous film, *The Masque of the Red Death,* with Price heading a cast that included British horror heroine Hazel Court and a young Jane Asher. Cinematography was by the gifted Nicholas Roeg, who would later become a director in his own right. A final Poe horror effort, *The Tomb of Ligeia* (1964), was shot on location in England rather than on one of Daniel Haller's impressive sets, and it provided an effectively understated conclusion to the Poe series. Corman essentially retired from direction in 1970 in favor of producing for his own company, New World Pictures (and later Concorde), but returned to the director's chair one last time for *Frankenstein Unbound* (1990), which, despite promising source material and an excellent cast, failed to catch fire with critics or audiences.

Another curiously complex figure in horror films during this period was William Castle. Born William Schloss on April 24, 1914, Castle had been knocking around in the New York theater scene since the late 1930s before moving to Hollywood, where he directed a low-budget but interesting "sleeper" for Monogram, *When Strangers Marry* (1944), with Robert Mitchum, Kim Hunter, and Dean Jagger, in which Mitchum effectively portrays a homicidal bridegroom. A string of well-crafted suspense thrillers for Columbia followed, including *Voice of the Whistler* (1945), *Crime Doctor's Warning* (1945), and *The Mark of the Whistler* (1944), as well as an apprenticeship to Orson Welles for second-unit work on Welles's *Lady from Shanghai* (1948).

Many of Castle's efforts in the early 1950s were routine program pictures until, going out to the movies one night with his wife, Castle was intrigued by a line of teenagers waiting to get in to a screening of Henri-Georges Clouzot's *Diabolique* (1955), which had just been imported to the United States. Featuring one of the most famous "twist" endings of any horror film, *Diabolique* was a sensation not only at art houses, but also at regular neighborhood theaters (in a dubbed version, of course), and Castle was naturally curious.

Informally polling the teenagers, Castle learned that it was the horror aspect that attracted them to the film above all other elements, and he soon resolved to leave Columbia and set up shop on his own. His debut as a producer/director was *Macabre* (1958), which centered on Doctor Rodney Barrett (William Prince), whose daughter has been kidnapped and buried alive; Barrett has just five hours to find and rescue her. Castle mortgaged his house to finance the film, which cost little more than $100,000 and was released through Allied Artists. As a promotional gimmick, Castle arranged with Lloyd's of London to insure all his patrons against "death by fright" during each screening. The film was an instant box-office success, and Castle had found his métier: the horror film.

Macabre was followed almost immediately by the superbly atmospheric supernatural thriller *House on Haunted Hill* (1959), again released through Allied Artists. It features Vincent Price as eccentric millionaire Frederick Loren, who throws a "haunted house party" for his wife, Annabelle (Carol Ohmart), and a group of strangers in a mansion notorious for its grisly history. Again working on a modest budget, Castle

24. William Castle on the set of *13 Ghosts*. Courtesy: Jerry Ohlinger Archive.

shot the exteriors for *House on Haunted Hill* at the futuristic Ennis-Brown House, still located at 2655 Glendower Avenue in Los Angeles, which was designed by Frank Lloyd Wright in 1924; the house fits the film's plot perfectly as a simulacric coffin. As Frederick Loren tells his guests in the film, "the windows have bars the jail would be proud of, and the only door to the outside locks like a vault." As he did for *Macabre,* Castle arranged a gimmick for screenings of *House on Haunted Hill*; at a certain point in the film, a large plastic skeleton flew out from the theater wings over the heads of the audience. Castle dubbed the process "Emergo," promising that a "ghost would actually emerge right off the screen."

House on Haunted Hill was even more successful than *Macabre,* and Castle returned to Columbia to direct and produce a string of successful horror/suspense films, most notably *The Tingler* (1959), *13 Ghosts* (1960), *Straitjacket* (one of Joan Crawford's last starring roles, 1964), and perhaps his most successful film, *Homicidal* (1961), inspired by the success of *Psycho.* Working with his long-time scenarist, Robb White, Castle created a peculiar and disturbing film in *Homicidal,* in which two of the leading characters, Emily (a woman) and Warren (a man), are both played by Jean Arless (aka Joan Marshall), a woman. Throughout much of the film, Emily has center stage as a rampaging, psychotic, bleached-blond murderer who kills without compunction. Warren, on the other hand, is presented as a reasonable, if somewhat unattractive, young man, whom everyone in the film's narrative accepts as male.

What ultimately makes *Homicidal* so compelling is its careful rehearsal and construction of early 1960s gender tropes. Dressed in a business suit, with tie and suspenders, hands habitually thrust into trouser pockets, Warren, as portrayed by Arless, is every bit the assured and aggressive masculine stereotype ubiquitous in the heterocentric cinema of the 1900s to the present. As Emily, clad in a white gown—complete with gloves—flirting with men and warming milk in a saucepan for her paralyzed caregiver (a neat switch in itself), Arless projects the servitude and "femme" persona of a Donna Reed or a Jane Wyatt, the homemaker with murder in her heart.

One of Castle's last films of real consequence was *The Night Walker* (1964), from a screenplay by Robert Bloch. Irene Trent (Barbara Stanwyck) is married to the blind and insanely possessive millionaire inventor Howard Trent (Hayden Rorke, in a superb performance). Howard makes Irene's life a living hell, shadowing her every movement and recording her every word with an elaborate, hidden system of microphones situated strategically throughout the house. Obsessed with the idea that Irene is being unfaithful to him, Howard summons his attorney, Barry Moreland (Robert Taylor), to his home and demands that he put a "tail" on Irene to discover the identity of her lover. Against all odds, however, Irene *is* faithful to Howard, and the surveillance comes to naught. But one night, working late in his laboratory, Howard is killed in an explosion, and Irene inherits his entire fortune.

Yet Irene's sleep is troubled by a series of recurring nightmares in which Howard's hideous visage, burned almost beyond recognition, alternates with the phantasmal vision of "The Dream" (Lloyd Bochner), a smooth-talking young man who spirits Irene away on a series of nocturnal adventures. Castle handles the material with great assurance, and Vic Mizzy's score adds considerably to the proceedings.

Castle continued to make films, though with considerably less success. He died of a heart attack at home while editing his one-hundredth film as a producer in 1977. Since then, several of his best films have been remade, including *House on Haunted Hill* (1999, directed by William Malone) and *Thir13en Ghosts* (2001, directed by Steve Beck); none has approached the power of Castle's original films.

As we've seen, British horror films in the first fifty years of the cinema were relatively few and far between, but when Hammer Films finally decided to enter the horror field in 1957, it took decisive hold of the field with its first feature-length color Gothic, *The Curse of Frankenstein*. The film was directed by Terence Fisher, who almost single-handedly reinvented the horror film in the second half of the twentieth century, revisualizing such classic British creations as the Frankenstein monster and Dracula in a manner that was both contemporary and utterly original.

In many ways, Hammer came almost out of nowhere to spearhead this revolution in the horror film. The studio had been around since the mid-1930s, making second-string films based on pre-sold properties, although it did import Bela Lugosi for Denison Clift's *The Mystery of the Marie Celeste* in 1935 and also cast the African-American activist and actor Paul Robeson in J. Elder Wills's *Song of Freedom* (1936), two fairly ambitious productions for the fledgling company. Partnered with Exclusive Films, a distribution outfit that had secured the release rights to Alexander Korda's early films, Hammer seemed destined for modest, yet solid success. In 1937, however, a general downturn in the British film business and some bad business decisions forced Hammer into bankruptcy. Exclusive soldiered on, reissuing existing product, until 1947, when it struck a deal with Jack Goodlatte, the booking manager for the ABC theater chain, for new low-budget product.

Accordingly, Hammer was back in business with a string of small-budget features, including Godfrey Grayson's *Dick Barton at Bay* and

Dick Barton Strikes Back (both 1948), based on a popular radio serial of the era. During this period, too, Hammer rented its first "house studio," a large mansion named Dial Close, near the river Thames; the facility became a studio and served as lodging for technicians between projects. These early Hammer films were successful, and the company began to churn out "support programming" on a regular basis, eventually moving from Dial Close to Oakley Court, another enormous country house, as its new base of operations.

Hammer continued its policy of low-cost, low-risk filmmaking at Oakley Court, with such productions as Francis Searle's *Someone at the Door* (1949), and still concentrated on second-string features after it moved to Gilston Park. From 1952 through 1966 the palatial manor Down Place served as Hammer's base of operations; renamed Bray Studios, the facility was purchased outright by Hammer as a permanent home. It was at this time, too, that Hammer struck its first truly international deal with American producer Robert L. Lippert, who specialized in low-cost features for a chain of theaters he owned in the States. Lippert would provide a fading American star to topline a film, which Hammer would shoot at minimal expense; the resulting film would then be shown in both the United States and the United Kingdom, offering something salable for each market.

It was also during this period that Hammer's key production staff coalesced into a harmonious working unit. Sir James Carreras, son of Hammer founder Enrique Carreras, was the driving force behind the company—a superb salesman and entrepreneur who knew instinctively what would sell and what would not. Anthony Nelson-Keys served as the studio's executive producer. Tony Hinds was the company's line producer and later a writer under the pseudonym of James Elder (and still later, the somewhat tongue-in-cheek *nom de plume* of Henry Younger). A cost-conscious professional, he kept an eye on the budget and made sure that a film *never* fell behind schedule.

Gifted individuals were also working their way up the system. Michael Carreras, James Carreras's son, was another driving force behind Hammer, functioning as a producer and later as a director during the studio's golden era. Bernard Robinson was the studio's innovative production designer; Jimmy Sangster, the key scriptwriter; James Bernard, the most prolific musical composer; and Terence Fisher, Freddie Francis,

John Gilling, Don Sharp, and Val Guest, the key Hammer directors. For the moment, however, someone had to pay the rent.

Thus, in the early 1950s, such down-on-their-luck American stars as George Brent (for Terence Fisher's *The Last Page,* aka *Man Bait* in the United States, 1951), Zachary Scott (for Fisher's *Wings of Danger,* 1951), and Paul Henreid (for Fisher's *Stolen Face,* 1951) were brought over as part of the Lippert deal and gave Hammer its first taste of the American market. Although the studio was certainly busy, it lacked an identity of its own and seemed destined to remain a second-rate production facility, clinging to the Lippert deal as a lifeline to inject some spark of originality into its admittedly routine productions.

But in 1953 there came an unexpected turning point. Hammer purchased the rights to the BBC television serial *The Quatermass Experiment,* a science-fiction thriller written by Nigel Kneale, which had been a substantial hit and naturally interested Hammer as a pre-sold property, just as the Dick Barton series had several years earlier. At the time, it seemed like just another project for the busy studio, but as directed in 1956 by Val Guest on a budget of a mere £42,000, *The Quatermass Xperiment* (the "*Xperiment*" tag was a reference to the "X" British censor's certificate the film was certain to obtain) emerged as a rather violent, occasionally horrific thriller.

Robert Lippert contributed the services of actor Brian Donlevy as Professor Quatermass, a scientist obsessed with sending a manned rocket into space (the film was released in the States as *The Creeping Unknown*). Although the serial's original author, Nigel Kneale, thought little of Donlevy's brusque approach to the role, Guest was taken with the actor's no-nonsense approach, and the film surprised everyone—especially Hammer's chief executive James Carreras—by becoming a massive box-office hit and putting the studio firmly on the path to success as the preeminent purveyor of cinematic horror for the next two decades. But Hammer's management had one question to ask of its audiences, much as William Castle had done when he queried a group of young filmgoers about their affection for *Diabolique*: Which aspect of *The Quatermass Xperiment* had appealed to them more, the horror aspect (when a group of astronauts are shot into space, only one comes back alive, and he soon mutates into a massive blob of jelly, lethal to the touch, which eventually invades Westminster Abbey), or the straight science-fiction angle?

Back came the answer: 1950s British audiences wanted horror, not science fiction. So Hammer set itself the task of making a full-blooded Gothic horror film and settled on a new color version of Mary Shelley's *Frankenstein,* the studio's first foray into feature-length color film production. Before *The Curse of Frankenstein* could go before the cameras, Hammer quickly whipped together two sequels to *The Quatermass Xperiment.* Leslie Norman's *X the Unknown* (1956) was an "unofficial" sequel in that it borrowed freely from Kneale's basic themes; it featured a distinguished Professor Quatermass, one "Dr. Adam Royston" (American actor Dean Jagger) in the lead. A sanctioned sequel, Val Guest's *Quatermass 2* (aka *Enemy from Space* in the States, 1957), again starred Brian Donlevy as Professor Quatermass and, with a bigger budget, put an increased emphasis on the horrific aspects of the film.

Both were successful at the box office, but Hammer now turned all its energy toward *The Curse of Frankenstein,* to be directed by Terence Fisher. The project somewhat ironically found its way to the studio through the auspices of two American producers, Max J. Rosenberg and Milton Subotsky, who with one previous film to their credit, Will Price's musical *Rock Rock Rock* (1956), tried to convince producer Eliot Hyman, chief of Associated Artists Productions, to back the *Frankenstein* project as that studio's next film. Hyman passed, but sent the script along to James Carreras, with whom he was friendly, and Hammer was indeed interested in pursuing the idea.

Subotsky's script was far too short for a feature and required extensive revisions; indeed, Hammer felt that it was too close to the Universal series in both theme and approach, and asked Jimmy Sangster, who had started at Hammer as an assistant director and gradually moved up the ladder to the position of story editor, then screenwriter, and much later, director and producer, to try his hand at a new draft of the *Frankenstein* script, now unimaginatively titled *Frankenstein—The Monster!* Sangster's script was a distinct improvement on the Subotsky version, and the project went forward, going into production on November 19, 1956. Subotsky, who with Rosenberg would form the highly successful horror production company Amicus Films in the early 1960s, was paid off with a flat fee of $5,000 for his work on the project, plus a percentage of the film's potential profits; he got no screen credit, and Sangster's script became the template for the ambitious production.

Meanwhile, in the United States, Universal was watching with distinct misgivings as the Hammer project unfolded. Frankenstein was *its* signature creation—at least in its view—and the studio took a dim view of Hammer's plans to move in on its territory, even though Universal had run out of creative possibilities for the monster and his maker more than a decade earlier. All through the pre-production of the film, Universal kept sending a series of "lawyer letters" to Hammer, warning it of an intention to sue if any aspect of Universal's version of Mary Shelley's tale was used in Hammer's version.

Noting that the work was firmly in the public domain, Hammer proceeded with casting the film, even as its legal department scrupulously viewed all of the titles in the Universal series to make certain that not one scrap of dialogue or thematic material not found in the novel had accidentally crept into Sangster's screenplay. Even at the last moment, however, Hammer, which had decided that the film would constitute a break from the "borrowed American star" format used in its co-productions with Robert Lippert, was fighting against the idea of casting an American star as Dr. Frankenstein. Further, it was only at the last minute that the film was upgraded to a color production—Tony Hinds originally planned to shoot it as a black-and-white "quickie" with a three-week schedule, until James Carreras intervened and allotted the film six weeks in production and a relatively lavish budget of £65,000.

The film was a landmark for all involved. Terence Fisher, then fifty-two, had been making program pictures his entire life and got the job only because he owed Hammer one more film as a director on his contract. Jack Asher, the cinematographer, was assisted by Len Harris as camera operator, with Bernard Robinson designing the sets, James Needs editing the scenes, and James Bernard composing the score. The two stars of the film, Peter Cushing and Christopher Lee, literally became horror icons overnight.

Peter Cushing, then forty-three, had been a journeyman actor for decades, working in everything from a Laurel and Hardy film to Sir Laurence Olivier's 1948 production of *Hamlet,* as well as acting in numerous BBC television productions. Cushing landed the role because most British film companies considered him merely a television actor and thus beneath them. Cushing, however, read about Hammer's forthcoming project in the trades and actively campaigned for the role of

Baron Frankenstein. At length, Hammer overcame the objection of
Warner Brothers/Seven Arts, the film's American distributors, and
signed him to the role.

Christopher Lee, in much the same fashion, had been a minor player
in the business since Terence Young's *Corridor of Mirrors* in 1947. At
thirty-four, he was a relative unknown, although he had racked up a
considerable number of credits as a character actor, as well as serving as
Stewart Granger's stunt double on Compton Bennett's 1950 version of
King Solomon's Mines and appearing in bits in Olivier's *Hamlet* and John
Huston's *Moulin Rouge* (1952—this last film, oddly enough, employed
the services of future Hammer director Freddie Francis as camera opera-
tor). Lee got the part because he was tall, had some experience in mime,
and needed the work. It was a series of fortuitous "accidents," then, that
led to the creation of one key cast and crew of the Hammer series,
though, of course, no one knew it at the time.

Although Universal continued to protest up to the last possible
minute, filing a formal objection to the registration of the film's final
title, *The Curse of Frankenstein,* Hammer knew it was on to something
and proceeded with the shooting through January 3, 1957. The film
moved swiftly through post-production for a May 2, 1957, premiere,
followed by a May 20, 1957, general release in both the United
Kingdom and the United States. The reaction was immediate. Sangster's
literate script, along with Cushing's crisply aristocratic Baron, Lee's
original and deeply sympathetic interpretation of the creature, and
Hammer's deft use of color and production design, combined with
Fisher's committed direction, made the film an instantaneous hit on
both sides of the Atlantic.

The die was cast. Hammer had, in a single stroke, found its identity
as a studio, created its two signature stars, established its principal direc-
tor, found its key scenarist, and conjured a new look and feel for the
Gothic cinema, rooted firmly in the genre's English heritage. Though
Curse was a quintessentially British film, usually anathema to American
distributors, it soon was in the top ten of box-office grosses in both
England and America and did repeat business in engagements not only in
these two main markets, but also throughout the world.

International audiences embraced Hammer's revisualization of the
classic Universal monsters. Seeing the writing on the wall, Universal

25. Peter Cushing and Robert Urquhart discuss anatomy in *The Curse of Frankenstein*. Courtesy: Jerry Ohlinger Archive.

made a pact with Hammer to distribute Hammer's next major project, *Dracula* (*Horror of Dracula* in the United States, 1958), with Christopher Lee, now a major star, as the ravenous Count. Peter Cushing signed on as Dr. Van Helsing, with Terence Fisher directing, Bernard Robinson creating the sets, James Bernard composing the music, and Jimmy Sangster producing a script from Stoker's novel. *Dracula* was an even bigger success than *Curse of Frankenstein* and remains for many observers not only the finest film Hammer ever made, but also the definitive screen adaptation of *Dracula* and one of the most successful Gothic films ever.

Suddenly, at age fifty-three and after years of apprenticeship, Terence Fisher became a "hot" director, and Cushing and Lee were vaulted into permanent genre stardom. One of the keys of Fisher's fresh approach to the material was his refusal to screen the old Universal films at all. As he put it, "You can't go back and remake a film; you can remake a *subject,* but that's different." Indeed, Fisher's deeply Christian approach to the material, despite the contemporary complaints of both the censor's office and mainstream critics, ensured that the subject matter

would be treated, with the utmost sincerity, as a battle between good and evil on a decidedly human scale.

As Dracula, Lee was smooth, charming, and aristocratic, as long as it served his purposes; when the situation demanded, he was transformed into a ravening beast. Bernard Robinson's sets are particularly striking, devoid of the musty, cobwebbed feeling of the Universal films; Dracula's castle is immaculate, well appointed, even luxurious. In addition, Fisher introduced another element to the Dracula mythos: the sexual dynamism of the vampire. Lugosi had hinted at this in his 1944 *Return of the Vampire,* in a haze of mist for an illicit rendezvous, but Fisher found Dracula to be "basically sexual . . . Dracula preyed upon the sexual frustrations of his [female] victims."

Further, Fisher insisted on graphic close-ups of the staking sequences, because "it was a release for the victim tainted with vampirism." In short, Fisher's *Dracula* inhabits an entirely moral universe, as do all of the director's films, in which life is a struggle between temptation and redemption, perseverance and acquiescence. At one point in the film, Van Helsing compares vampirism to drug addiction, as Dracula is compelled by his very nature to constantly seek new blood, night after night. Sangster's script also dispensed with Dracula's supposed transformative powers, having Van Helsing dismiss them as "a common fallacy" to avoid special effects that would look inherently unrealistic, and also to ground Dracula's world more firmly in the Victorian era in which the narrative is set.

Following the success of *Dracula,* Hammer decided that the horror genre was going to be its main focus and began producing a torrent of films, just as Universal had, but now with Universal's blessing. As Hammer's top director, Fisher was immediately assigned to the first *Frankenstein* sequel, *The Revenge of Frankenstein* (1958), a bold and witty variation upon the original. But Hammer then began to lose interest in the monster, letting the creature rest until Freddie Francis's *The Evil of Frankenstein* in 1964, one of the weaker entries in the series. In addition to reverting to the original Universal design for the monster, the film has a script that seems cobbled together from a number of plot strands in Universal's Frankenstein sequels. Francis, who lacked the commitment to the material that Fisher so clearly evidenced, directed the film with a great deal of visual style and panache, but his disinterest was all too evident.

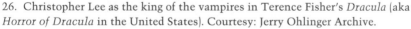

26. Christopher Lee as the king of the vampires in Terence Fisher's *Dracula* (aka *Horror of Dracula* in the United States). Courtesy: Jerry Ohlinger Archive.

Francis had been a lighting cameraman for many years before breaking into direction in the early 1960s, and he became a horror auteur only because Hammer kept offering him one film after another. He was sharp and efficient, with a no-nonsense professionalism that ensured an economical use of the resources at hand. As Francis himself said, rather dismissively, of the project, "This was just more or less 'here is the monster, here is the mad lab and away we go,' so to speak. I just try to keep people interested." The casting of an ex-wrestler, Kiwi Kingston, as the monster also was of little help to the finished film; Kingston certainly had the right physique for the role, but little, if any, ability to project emotion.

Frankenstein Created Woman (1966) marked a welcome return to form for the series, with Fisher back in the director's chair and Peter Cushing returning as the resourceful Baron. The plot, involving a young woman who drowns herself after her lover is guillotined for a murder he did not commit and Frankenstein's subsequent transplantation of the young man's brain into the young woman's body, is an unusual twist to say the least. The recombinant Christina (model-turned-actress Susan Denberg) has but one aim: to avenge her/himself on those who framed her/him. The rest of the film is Grand Guignol on a rather epic scale, as Christina lures a series of men to isolated locations with the promise of a passionate liaison, but instead chops the would-be paramours to death with a meat cleaver.

Frankenstein Must Be Destroyed (1969), the fifth entry in the series, presents Baron Frankenstein as more determined and ruthless than ever. It also features a rape scene that was added at the last minute over the strenuous objections of the cast and crew, as part of management's attempt to revive what was by then clearly a troubled franchise. The sixth and final film in the series, *Frankenstein and the Monster from Hell*

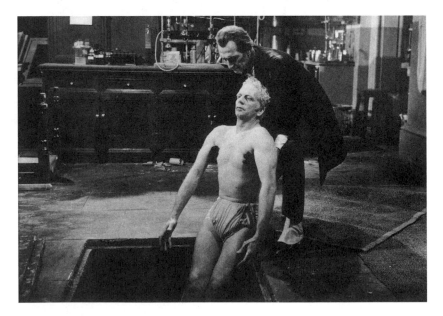

27. Peter Cushing cleans up his lab in *Frankenstein Must Be Destroyed*. Courtesy: Jerry Ohlinger Archive.

(1974), which was Fisher's last film as a director, is easily the poorest film of the lot, despite the now-aging Peter Cushing's spirited attempts to breathe some new life into the character of the Baron. Made on a few cramped sets at Elstree Studios (Hammer permanently moved from Bray for a variety of cost-cutting and space reasons in late 1966), the film lacks both vision and focus, and it is littered with shock effects of the kind that Fisher so disliked in his work, once again inserted over his objections.

The later entries in the *Dracula* series fared slightly better after the superb first film, starting with Fisher's *The Brides of Dracula* (1960), with David Peel stepping in for Christopher Lee, who, afraid of being hopelessly typecast in the role, refused to play the Count again until *Dracula: Prince of Darkness* (1965). Before that film was produced, Don Sharp directed one of Hammer's most exquisitely savage vampire tales, *Kiss of the Vampire,* shot in 1962, but released in 1963 in the United States and in 1964 in the United Kingdom. It follows a coven of vampires sequestered in a secluded castle, led by the unscrupulous Ravna (Noel Willman), who welcomes new initiates into their circle with a grand ball of grotesque splendor. The film's famous finale, in which thousands of bats are summoned from the depths of Hell, break into the castle, and literally devour the members of the coven, was heavily censored at the time. Later, for American television, much of this final sequence was cut out, entire scenes were reshot with a completely different cast of performers, and the film was retitled *Kiss of Evil.*

Dracula: Prince of Darkness, adroitly helmed by Fisher, is an impressive film in many ways, but considerably weakened by Lee's refusal to speak a single line of dialogue because he was so disenchanted with the script. "Give me some of Stoker's lines!" he repeatedly complained during the production. When direct quotations from the novel were not forthcoming, Lee contented himself (if not Hammer) with a series of hisses and guttural noises as the reincarnated lord of the undead. The film picks up precisely where the 1958 original ended, and indeed begins with the justly famous climax from that film, in which Dracula, after a violent fight with the implacable Van Helsing, disintegrates in the rays of the morning sun filtering through a castle window. With Dracula little more than a pile of dust, it falls to Dracula's servant Klove (Philip Latham) to lure a group of unsuspecting tourists to Castle Dracula, slaughter one of the men, the smug Alan (Charles Tingwell), and use his

blood to resurrect Dracula in an elaborate ceremony. Unfortunately, this sequence is the highlight of the film.

For *Dracula Has Risen from the Grave* (1968), Hammer turned to Freddie Francis to bring a more commercial hand to the proceedings. Although the film was marginally successful, it has a mechanical, methodical feel to it and never really catches fire. Peter Sasdy's *Taste the Blood of Dracula* (1969) is certainly more energetic, following the activities of a group of sensation seekers who once again revive the Count as an antidote to their perpetual sense of ennui, and it contains a sense of visual daring and contemporaneity in its execution that offers some excitement. *The Scars of Dracula* (1970), on the other hand, cheaply mounted at Elstree and indifferently executed by director Roy Ward Baker, shows that the series was rapidly losing its edge.

Dracula A.D. 1972, directed by Alan Gibson, is an altogether unsuccessful attempt to transport the Count to "Swinging London," with embarrassing dialogue and scant motivation. The final gasp of the series, *The Satanic Rites of Dracula* (1973), once again directed by Alan Gibson, presents Dracula as a shadowy business tycoon who presides over a far-flung corporate empire with but one aim in mind: the destruction of mankind with a viral plague. Cushing and Lee, astoundingly still on board for this abysmal film, do little more than walk through their roles, as well they might.

Hammer also produced its own series of Mummy films, of which the first, *The Mummy* (1959), is easily the best, with Christopher Lee as the titular character and inspired direction by Terence Fisher. Lee's interpretation of the Mummy is radically different in one key respect; possessed of enormous strength, Lee's creation also moves through the film very quickly, unlike Karloff's lumbering terror in the original Universal film. In all respects, the film offers an entirely original revisualization of the character and remains one of Hammer's most sumptuous films.

The same cannot be said for subsequent entries in the series, Michael Carreras's *The Curse of the Mummy's Tomb* (1964), John Gilling's *The Mummy's Shroud* (1966), and Seth Holt's *Blood from the Mummy's Tomb* (1971; Holt died during production, and the film was completed by Michael Carreras). These failed to deliver on the promise of the first film, although Holt's is easily the best of the lot, with a curiously claustrophobic air about it that entirely suits the project. Indeed, when

Michael Carreras took over the final weeks of shooting after Holt's death, he was surprised to discover that Holt, an experienced genre film-maker, had neglected to film any entrances or exits for the characters, thus giving them the distinct feeling of being trapped within the frames of the production for eternity. This melancholy and understated production, modest in its scope and ambition, was thus a gentle postscript to the series, absolutely serious and imbued with a genuine feeling of death.

Perhaps the most infamous of the Hammer horror films is Fisher's unusual *Stranglers of Bombay* (1960), a historical period piece concerning the cult of the Thuggees in British colonial India, a group of religious fanatics who killed literally thousands of victims as a sacrifice to the goddess Kali. Based on authentic records of the cult's activities in the 1820s, the film documents the attempts of Captain Lewis (Guy Rolfe) to stamp out the group and its adherents. Shot quickly and cheaply in black-and-white CinemaScope, the film is remarkable for its sustained level of graphic violence, including numerous sequences of strangulation and torture, many of them observed by the mysterious figure of Karim (Marie Devereux), a buxom young woman who says not a word in the film, but watches impassively as eyes are gouged out, ritual murders are performed, and various acts of barbarism are committed. As the person-ification of Kali, as well as a simulacrum for the audience, Karim is the silent spectator who watches, but never interferes. When the final film was assembled, Fisher all but disowned it, finding the level of brutality unacceptable. *Stranglers of Bombay* gestures toward the splatter films of the early 1970s with a clear-eyed gaze and is ample proof that, at least at the time, Hammer was willing to push the envelope of graphic realism to its then absolute extreme.

Numerous other unusual films followed, including Fisher's *The Two Faces of Dr. Jekyll* (1960), in which Dr. Jekyll (Paul Massie), instead of becoming a repulsive figure of debauched desire in his transformation to Mr. Hyde, takes on the persona of an immaculate, if villainous aristocrat who is more than willing to plot the downfall of Jekyll's dissolute "friend" Paul Allen (Christopher Lee), who, unaware of Jekyll's dual nature, is also the illicit love of Jekyll's feckless wife, Kitty (Dawn Addams). Fisher's *The Curse of the Werewolf* (1961) offered Oliver Reed his breakthrough role as Leon, a young man of noble Spanish birth who is born with the curse of lycanthropy. Shot on sets that originally

had been created for a never-filmed production about the Spanish Inquisition, the film, like *Stranglers of Bombay,* suffered severe cuts at the hands of the censors for blending sexuality with horror in a way that was even more explicit than *Dracula,* and more unsettling. Leon's condition is the result of the rape of his mother in a dungeon by a deranged tramp, who infects her, and thus Leon, with his corrupt blood.

Hammer also worked with director Joseph Losey on a prescient science-fiction horror film, *The Damned* (shot in 1961, but not released until 1963), which again toplined Oliver Reed as the leader of a gang of violent teenage thugs who terrorize a quiet seaside resort and then come across a group of radioactive children who have been sequestered in a cave by the authorities to hide the results of a nuclear experiment gone wrong. Fisher even tried his hand at *The Phantom of the Opera* (1962), with Herbert Lom as the Phantom, but the film was one of his less successful works and a commercial and critical failure. Fisher's moody *The Gorgon* (1964), with Christopher Lee and Peter Cushing toplined in a screenplay by John Gilling, was an updating of the ancient myth of Medusa and her two sisters, whose gaze alone is sufficient to turn humans into stone. Despite some disappointing special effects at the conclusion of the film, which robbed the climax of much of its shock impact, the film remained a personal favorite of Fisher's, who commented later that it "emphasiz[ed] the poetics of the fantastic, rather than the horror." The lackluster box-office returns were perhaps due to the film's understated complexity.

Late 1961 saw an interesting new development at Hammer: the advent of psychological horror, obviously inspired by the success of *Psycho.* The first Hammer project out of the gate was in many ways the best, Jimmy Sangster's complex thriller *Taste of Fear* (1961), directed by Seth Holt. In this effort, unscrupulous fortune hunters conspire to drive young Penny Appleby (Susan Strasberg, in an excellent performance) mad to claim an inheritance. Next came Freddie Francis's *Paranoiac* (shot in 1962, released in 1963), with Oliver Reed in the lead as the dissolute aristocrat Simon Ashby; another complex tale of murder from the pen of the prolific Sangster and adroitly directed by Freddie Francis, it was a substantial commercial and critical success.

Michael Carreras directed the deftly atmospheric thriller *Maniac,* shot in 1962, released in 1963), centering on an amoral drifter, Geoff

Farrell (Kerwin Matthews), who helps a madman break out of an insane asylum. Freddie Francis's *Nightmare* (shot in 1962/63, released in 1964) was another complex psychological horror film scripted by Jimmy Sangster, in which a scheming couple plan to drive a young woman mad to claim her inheritance. The last of the psychological horror films, *Hysteria,* directed by Freddie Francis, rolled off the assembly line in 1964. By this time, however, Sangster's twist endings were becoming more predictable, and character actor Robert Webber was unconvincing in the lead as the amnesiac "Christopher Smith."

By far the most lavish Hammer film of the era was *She,* a remake of the 1935 original (directed by Irving Pichel and Lansing C. Holden). Hammer's new version, directed by Robert Day and starring Ursula Andress, as well as Cushing and Lee, was yet another retelling of Sir H. Rider Haggard's novel of an immortal woman who rules a lost civilization with an iron hand until she falls in love with a young adventurer who stumbles into her forbidden domain. Boasting sumptuous production values and one of James Bernard's most haunting scores, the film, shot in 1964 but released in 1965, was a blockbuster for the studio and demonstrated once again that Hammer was willing to take on projects outside the conventional horror mainstream.

And yet, although Hammer was busier than ever, the end was in sight for this tightly knit, intrinsically cost-conscious studio, whose output was now screened around the world for enthusiastic audiences and revered by the more astute critics of the era, in particular the young firebrands at the French journal *Cahiers du cinéma. Fanatic* (aka *Die, Die, My Darling* in the United States; shot in 1964, released in 1965) was screen legend Tallulah Bankhead's swan song as Mrs. Trefoile, a possessive, jealous old woman who imprisons her late son's fiancée, Patricia (Stephanie Powers), when the young woman pays a condolence call. Future star Donald Sutherland appeared in the film as Mrs. Trefoile's addled gardener. As directed by Silvio Narrizano, the film was a solid commercial success. But 1965 saw the first signs that draconian cost-cutting was beginning to hurt the look of Hammer films, which had always boasted lavish settings and high production values.

To save money on a slate of forthcoming features, producer Anthony Nelson-Keys decided that for the first time two films, *Dracula: Prince of Darkness* and *Rasputin the Mad Monk,* would be shot back-to-back on the

same sets with almost the same casts (Christopher Lee played the title character in both), and that two other films, *The Plague of the Zombies* and *The Reptile,* would immediately follow, shot back-to-back using the same sets and many of the same cast members. Fisher directed *Dracula: Prince of Darkness*; Don Sharp handled the *Rasputin* project; and John Gilling pulled double duty on *Plague of the Zombies* and *The Reptile.*

When Hammer said "back-to-back," it was no exaggeration. *Dracula: Prince of Darkness* wrapped on June 4, 1965; four days later, on June 8, *Rasputin* went on the floor on the same, minimally re-propped sets. Likewise, *Plague of the Zombies* completed shooting on September 6, 1965, and a week later *The Reptile* began filming. There was another cost-cutting factor at work, too: shooting schedules were being cut to the bone. The *Dracula* project, the most prestigious of the group, was shot in little over a month instead of the usual six weeks; *The Reptile* was shot in *less* than a month—and it showed.

While these four films were being pushed through production, Hammer was involved in post-production on one of its last prestige projects, Seth Holt's *The Nanny* (1965), in which Bette Davis may or may not be a homicidal maniac intent on killing her charge, Joey (young William Dix). Holt's typically restrained direction and his judicious use of black and white, coupled with an unusually nontheatrical performance from the usually flamboyant Davis, combined to make the film a "sleeper hit" with critics and audiences. It seemed that all was well. But then the four back-to-back features were released, in pairs, so that Hammer and the distributors, ABC in the United Kingdom and 20th Century Fox in the United States, could control both halves of the double bill, still a common practice at the time. Sadly, the lack of care in production and presentation was all too evident, and the films did only modest business.

John Gilling's *The Mummy's Shroud* was the last Hammer film to be made at Bray Studios. With the move to MGM Elstree, Hammer became less of a family operation, in which actors, technicians, writers, and directors all took personal pride in their work, and more of a straightforward business. Hammer had always kept a firm eye on the bottom line, but the company was so small that lines of communication were open and individual enterprise was rewarded and encouraged. Suddenly, all that changed.

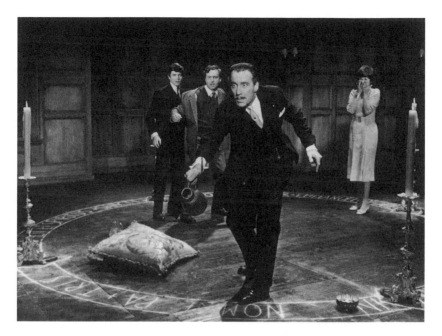

28. Christopher Lee casts out evil spirits in *The Devil Rides Out* (aka *The Devil's Bride* in the United States). Courtesy: Jerry Ohlinger Archive.

The Elstree years would see a few interesting films from Hammer. Among them were Terence Fisher's late masterpiece *The Devil Rides Out* (aka *The Devil's Bride* in the United States, 1967), which was actually shot at MGM's studios at Boreharmwood. Despite the popularity of Dennis Wheatley's source novel and a remarkable performance by Christopher Lee in the leading role of the Duc de Richelieu, as well as a suitably sinister turn by Charles Gray as his opposing force, the Satanist Mocata, the film was only a modest success, owing in part to some unfortunate special effects during the climax of the film, when the "Angel of Death" comes to claim the lives of the Duc and the family he is protecting.

In a desperate attempt to pump up public interest in its films, Hammer offered lesbian vampires in Roy Ward Baker's *The Vampire Lovers* (1970); a transsexual version of the classic Jekyll/Hyde story, Baker's *Dr. Jekyll and Sister Hyde* (1971); and increased doses of sex and violence in John Hough's *Twins of Evil* (1971). But everyone seemed tired now. Peter Cushing had lost his beloved wife, Helen, and to

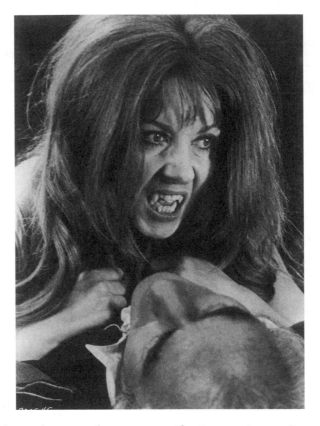

29. Ingrid Pitt claims another victim in *The Vampire Lovers*. Courtesy: Jerry Ohlinger Archive.

assuage his grief, he threw himself into one film after another, in which he seemed grim, gaunt, and disinterested. After the failure of *Frankenstein and the Monster from Hell* and *The Satanic Rites of Dracula* in 1972, Hammer cut back on its horror production for the first time since 1958. An exception was Roy Ward Baker's *Legend of the Seven Golden Vampires* (1974), a dubious co-production with Hong Kong's Shaw Brothers studio, which starred Peter Cushing for one last time as Van Helsing in an uneasy mixture of vampirism and kung fu.

The end of the studio was tragic. In 1968 Hammer received the Queen's Award for Industry for bringing in more than £3 million in box-office receipts since 1965, and *Dracula Has Risen from the Grave,* under Francis's brisk and somewhat tongue-in-cheek direction, was

breaking domestic box-office records. Just five years later, Hammer was reduced to co-production deals with the Shaw Brothers studio, whose Hong Kong soundstages were, to say the least, primitive. Hammer's technicians, for one example, were deeply surprised when they discovered that Shaw Brothers intended to shoot the entire film without sound and then dub in all the dialogue later.

One by one, the key personnel who had built up Hammer and its reputation died or left. Relations between Sir James Carreras and his son Michael became deeply strained. At length, Michael bought out his father's interest in the studio and became the new chief executive. Hammer's last horror film, Peter Sykes's *To the Devil a Daughter* (1976), a German/United Kingdom co-production toplined by Christopher Lee and an extremely irascible Richard Widmark, who refused to perform certain scenes on the grounds that he found them personally offensive, failed miserably at the box office.

Michael Carreras then began spending his own money to fund a variety of projects that never got off the ground. Finally, he set up a co-production deal for an unlikely project, a remake of Alfred Hitchcock's *The Lady Vanishes,* which went before the cameras in 1978 with Anthony Page directing, just ten short years after Hammer's *annus mirabilis*. The film went over budget, Michael Carreras was removed from the production, and in 1979 the firm officially went bankrupt. Michael Carreras resigned from Hammer, the company his father had built, the following spring. His father watched from the sidelines, but did nothing; Sir James died of a heart attack on January 9, 1990, at age eighty-one. Michael Carreras died of cancer only four years later, a broken man, at the relatively young age of sixty-six.

Thus, a variety of forces brought about the end of Hammer: not enough interest in new ideas; mistaken notions that sex and nudity would automatically bring in more customers; and a failure to develop new talent behind or in front of the camera. Since the late 1950s, Hammer had relied heavily on the services of Peter Cushing and Christopher Lee as its major stars. Twenty years later, both were old, and no one had stepped forward to take their places. Hammer also failed to develop a new talent pool of directors; while such American auteurs as John Carpenter, George Romero, Tobe Hooper, Wes Craven, and others were staking out new territory for the horror film, Hammer seemed stuck in the past.

Meanwhile, also working in England were Max J. Rosenberg and Milton Subotsky, who formed Amicus Films following Hammer's example and used the talents of Freddie Francis as the director of their best efforts. Amicus created a series of "portmanteau" films, each composed of several short stories (usually by horror author Robert Bloch, the author of the novel *Psycho,* on which Hitchcock's 1960 film was based), to create an effective alternative to Hammer's output.

Dr. Terror's House of Horrors (1965) starred Peter Cushing as the mysterious Dr. Schreck, or Terror (a nod to actor Max Schreck in Murnau's 1922 version of *Nosferatu*), who meets a group of travelers on a train and forecasts their decidedly macabre futures with a deck of Tarot cards. The most effective stories in the film revolve around an arrogant art critic, Franklin Marsh (Christopher Lee at his most imperious), who is blinded in a road accident; a killer plant with the ability to "take over the world"; and Donald Sutherland in the final segment as a young doctor who unknowingly marries a flirtatious female vampire, Nicolle (Jennifer Jayne). The entire affair, of course, was patterned after Ealing's groundbreaking *Dead of Night*; but the film was effective in its own way, and the use of Hammer's two top stars guaranteed a solid showing at the box office.

Other films from Amicus followed in quick succession, but only one can be considered a true masterwork: Francis's 1965 production of *The Skull,* based on a short story by Robert Bloch, "The Skull of the Marquis de Sade." It featured a superb cast: Lee, Cushing, Patrick Wymark, Nigel Green, Jill Bennett, Michael Gough, George Coulouris, and Patrick Magee. The film opens with an effectively atmospheric grave-robbing sequence set in nineteenth-century France in a highly stylized studio graveyard, immaculately photographed by John Wilcox, in which the titular skull is retrieved from the Marquis's grave and then ritually cleansed with acid to gleaming perfection.

But the skull has a life of its own and soon kills the man who has stolen it. The film then flashes forward to present-day London, where Professor Christopher Maitland (Cushing) is an authority on black magic and the supernatural, with a well-stocked library of archaic books on the subject and an apparently limitless bankroll to fund his research. Maitland's friend, Sir Matthew Phillips (Lee), is also interested in the occult, and we first see the two men spiritedly bidding against each other

at an auction for a group of four demonic figurines, which Sir Matthew, seemingly in a trance, purchases for a ridiculously high sum.

Sir Matthew has been acting under the influence of the skull, which he now owns; nevertheless, he is afraid of the skull's malign powers and wishes to be rid of it. When Marco (Patrick Wymark), a sleazy dealer in antiquities, steals the skull, Sir Matthew makes no attempt to reclaim it, pleased that he is now free of its power. But to his shock, he discovers that Marco has sold the skull to Professor Maitland, who soon falls under the spell of the sinister talisman. The final thirty minutes of the film, in which the skull takes possession of Maitland's soul and drives him to murder, is a nearly wordless tour de force that recalls the best of Lewton and Tourneur, particularly the "zombie walk" sequence from *I Walked with a Zombie.*

In the midst of this trancelike final section there is also a bizarre dream sequence in which two ominous plainclothesmen appear at Maitland's palatial estate without explanation and drag him away to a sinister courtroom, where a sadistic judge forces him to play Russian roulette repeatedly with a handgun. Maitland awakes from this nightmare only to find that his real existence is now utterly controlled by the skull's power. The film's fatalistic end, in which the skull murders Maitland but remains undetected, suggests that the skull's influence will continue long after the film has ended.

Francis subsequently left Amicus and went back to Hammer, only to return in 1972 with the surprisingly successful *Tales from the Crypt* (1972). Yet another Amicus anthology film, this one was based on stories taken from the pages of 1950s EC horror comics and featured no less a star than Sir Ralph Richardson as the crypt keeper who, as in *Dr. Terror's House of Horrors,* predicts disaster for a group of strangers who wander into his domain. One of the weaker entries in the series—by this time Francis was losing interest in directing horror films, having become hopelessly typecast as a horror auteur—the film nevertheless surprised everyone by making a fortune at the box office. More than two decades later, it served as the inspiration for the long-running HBO series of the same name.

One other figure in British horror during this period merits attention, although his career was cut far too short by an accidental overdose of sleeping pills in his early twenties. Michael Reeves, a born filmmaker,

was perhaps less successful in navigating the business side of filmmaking and completed work on only four films before his untimely death in 1969: *Witchfinder General* (aka *The Conqueror Worm* in the United States, 1968); *The Sorcerers* (1967), one of Boris Karloff's last roles of any substance; the Italian film *La sorella di Satana* (*Revenge of the Blood Beast,* 1966); and uncredited work on *Il castello dei morti vivi* (*Castle of the Living Dead,* 1964). Reeves was a true renaissance figure: he wrote the screenplay for *Castle of the Living Dead* (as Michael Byron) and for *The Sorcerers* and *Witchfinder General.*

Though his output was slight, Reeves's reputation rests chiefly on his last film, which concerns Matthew Hopkins, a real-life figure who roamed the British countryside in the early 1600s, zealously searching out "witches" for violent persecution and death. As portrayed with uncharacteristic vigor by Vincent Price (in perhaps his most restrained performance), Hopkins is a figure of unmitigated evil, which is exactly what Reeves was after. Price and Reeves clashed continually through the making of *Witchfinder General.* Price referred to Reeves as "a very troubled young man" (which, indeed, he was to some extent), while Reeves was determined not to let Price "camp it up" and insisted that the actor stay in character throughout the film. The result is a production of unremitting violence and horror, one that prefigured what was to come in the cinema of the early 1970s and beyond.

Roman Polanski, born in France but raised in Poland, had a far more naturalistic approach to the horror genre, which he had honed in numerous short films, as well as in his Polish psychological thriller *Nóz w wodzie* (*Knife in the Water,* 1962), in which a young drifter engages in a disturbing game of cat-and-mouse with an older married couple on a small sailboat. That feature was followed in short order by his disturbing film *Repulsion,* shot in Britain in 1964 and released in 1965, starring Catherine Deneuve as Carole Ledoux, a young woman who descends into madness in a deserted, shabby London flat. This film, which is generally overlooked in Polanski's oeuvre, remains one of his most effective thrillers. Carole's isolation from the rest of society is sharply outlined by her interactions (or lack thereof) with those around her; at one point, she imagines that the main corridor in the flat has come alive with human hands, groping her mindlessly as she tries to resist their anonymous advances. Another of the film's most memorable set pieces occurs

when the nameless, seedy landlord (Patrick Wymark) comes to collect the rent and is slashed to ribbons by the deranged Carole in a fit of desperation and loneliness. The film was a major success in the West, both in England and in the United States, and further consolidated Polanski's reputation as a director to watch.

Polanski brought this same stripped-down style to *Rosemary's Baby* (1968), the tale of Rosemary Woodhouse (Mia Farrow), a young woman whose husband, Guy Woodhouse (John Cassavetes), is part of a coven of witches and warlocks who gather at a seemingly nondescript Manhattan apartment building. With a supporting cast that included Ruth Gordon, Sidney Blackmer, Maurice Evans, and Ralph Bellamy, the film paints a disturbingly convincing picture of sophisticated evil, akin to the Val Lewton production of *The Seventh Victim,* released more than two decades earlier. *Rosemary's Baby* made even the most innocent aspects of modern Manhattan life seem sinister, in much the same manner that Lewton did. Only John Cassavetes as Guy seems a bit too over-the-top; reportedly, Robert Wagner was seriously considered for the role but lost out to Cassavetes. Yet, what remains most interesting about *Rosemary's Baby* is the fact that Polanski almost didn't get to direct it. Director William Castle, entranced by Ira Levin's source novel, bought the rights but stepped back at the last moment to produce the film. Under his direction, the film would have been a very different project all around.

Rosemary's Baby followed in the wake of Polanski's generally unsuccessful horror spoof, *The Fearless Vampire Killers, or Pardon Me, But Your Teeth Are in My Neck* (1967). Polanski also starred in the film opposite his young wife, Sharon Tate, whose life was not long thereafter cut short by the real-life horror of Charles Manson and his followers. That event marked a change in the public's attitude toward violence, which is arguably, and sadly, reflected in the plethora of slasher films released in the 1970s and through to the present day.

In other countries around the world, the horror film was also undergoing a creative renaissance in the cold war era. Kenji Mizoguchi's transcendent and trancelike *Ugetsu Monogatari* (*Tales of the Moon and Rain,* 1953; released in the United States as *Ugetsu*) is a haunting, poetic ghost story of two men in sixteenth-century Japan who go off to seek their fortunes during wartime. One, Genjurô (Masayuki Mori), leaves his

wife, Miyagi (Kinuyo Tanaka), to sell pottery in a bustling market place, but soon falls under the spell of Lady Wakasa (Machiko Kyô), a noblewoman who is in reality a ghost who seeks to seduce Genjurô and marry him. Meanwhile, Genjurô's partner, Tobei (Sakae Ozawa), dreams of becoming a samurai; he leaves his wife, Ohama (Mitsuko Mito), who is later raped by a gang of renegade soldiers and falls into a life of prostitution as a result. Confronted by his wife, Tobei at last comes to his senses, and the two are reunited as Tobei casts off his dreams of warrior glory.

For Genjurô, the result of his misadventures is even more tragic. Returning home after escaping the clutches of Lady Wakasa, Genjurô discovers his wife, Miyagi, still in their house. Unwilling to criticize Genjurô's actions, Miyagi makes him a cup of tea, and, after Genjurô plays with their young son, watches as Genjurô drifts contentedly off to sleep, secure in the knowledge that he is home and safe at last. But Genjurô's happy homecoming is another illusion. When he awakes the next morning, Miyagi is gone, and a passing neighbor, finding Genjurô in the house with his son, tells Genjurô that Miyagi is dead—murdered by soldiers in another rape. Stunned by his loss, Genjurô takes up pottery again with a renewed dedication, seeking self-expression in his work rather than commercial gain, as his wife's spirit (heard on the film's soundtrack) watches over him and approves of his new, more humble attitude toward life. On this note of possible regeneration, the film ends.

Mizoguchi, one of the masters of the Japanese cinema, created in *Ugetsu* one of the screen's most delicate and evocative tales of the supernatural, based on stories by Ueda Akinari and (surprisingly) Guy de Maupassant. One of the first Japanese films of any genre to break through to the West on theater screens, *Ugetsu* is not only a classic ghost story, but also a classic of the international cinema.

In 1964 Masaki Kobayashi directed the memorable portmanteau film *Kaidan* (*Ghost Stories*; released in the United States as *Kwaidan*), composed of four stories by Lafcadio Hearn, as adapted for the screen by Yôko Mizuki, each with a supernatural overtone. In "Black Hair," a samurai warrior (Rentaro Mikuni) returns to his wife after deserting her for many years; they spend the night together, but the next morning he discovers only her skeleton and her long black hair by his side. "The Woman of the Snow" concerns a young carpenter (Tatsuya Nakadai) whose life is saved by a phantasmal snow goddess who swears him to

secrecy, upon pain of death, if he ever reveals to anyone that she intervened on his behalf. "Hoichi, the Earless" follows the adventures of a blind musician (Katsuo Nakamura), who finds himself tricked into singing to the members of a deceased clan each night. To thwart further congress with the spirits, Hoichi's master sees to it that he is covered from head to toe with prayers, but neglects to mark his ears with the holy symbols. When Hoichi subsequently tries to escape from the clan's hold on him, one of the members follows him to his home and, seeing only his ears, cuts them off as an act of retribution. "In a Cup of Tea," perhaps the most curious episode of the group, centers on a household guard, Kannai (Kanemon Nakamura), who is haunted by the spirit of a samurai whose face inhabits Kannai's teacup.

Lavishly designed by Shigemasa Toda, *Kaidan* runs 183 minutes in its complete version. (In many U.S. prints, "The Woman of the Snow" was cut, reducing the running time to 125 minutes and seriously diminishing the impact of the film.) Photographed in sumptuous color and CinemaScope by Yoshio Miyajima, *Kaidan* is perhaps Kobayashi's best-known film and another effective horror tale in which the presence of evil is implied rather than directly shown.

In Italy, director Mario Bava was making a name for himself with his stylishly violent *giallo* horror films, the word *giallo* being Italian for "yellow," from a series of cheap paperback novels with yellow covers that defined the subgenre in its literary format. Breaking through to international audiences with *La maschera del demonio* (*Mask of the Demon*, 1960), which AIP picked up, dubbed into English, and released in 1961 as *Black Sunday*, Bava almost immediately became the most important figure in Italian horror during the period.

Black Sunday made an instant star out of Barbara Steele, cast in the film as Asa Vajda, a witch executed in a particularly gruesome fashion by seventeenth-century clergy of Moldavia, as a mask lined with steel spikes is driven into her face with a sledgehammer. Lushly photographed in bold black and white, the film established Bava as a stylist of the first rank and led to a long list of similarly violent thrillers, including *I tre volti della paura* (*The Three Faces of Fear,* 1963), released by AIP in the United States as *Black Sabbath* (1964). The film took advantage of the inestimable talents of Boris Karloff as host to three stories of the supernatural, as well as star of the final tale, "The Wurdalak," a vampire story by Tolstoy.

30. Barbara Steele comes back from the dead in Mario Bava's *Black Sunday.*
Courtesy: Jerry Ohlinger Archive.

Working in color this time, Bava cemented his reputation as a bold, striking director with a knack for unsettling compositions (since Bava had started his career as a cameraman, this came quite naturally to the fledgling director) and rich, saturated color. The slick *Ercole al centro della terra* (*Hercules at the Center of the Earth,* 1961; released in the United States as *Hercules in the Haunted World*) had Christopher Lee as a lord of the underworld, with whom Hercules must do battle to save his beloved (in the U.S., with additional sound-track dubbing, Lee's character also became, without further explanation, a vampire). It was another lavishly designed exercise in dime-store mysticism created out of nothing, with a combination of fabrics, lighting, and the flimsiest of sets to support the domain of Hell.

Sei donne per l'assassino (*Six Women for the Murder,* 1964) was released by rival distributor Woolner Brothers in a dubbed U.S. version entitled

31. Mario Bava's stylish thriller *Blood and Black Lace*. Courtesy: Jerry Ohlinger
Archive.

Blood and Black Lace in 1965. The film demonstrated that, although Bava's
eye for arresting compositions hadn't faltered, his interest in plot was
easily superseded by his increased emphasis on brutal violence, atmos-
pheric sets, and lighting design. *Terrore nello spazio,* released in the United
States as *Planet of the Vampires* in 1965, used aging noir star Barry Sullivan
in a nearly plotless tale of otherworldly vampirism; reportedly, the film
was begun without a completed script, and long sections consist entirely
of wordless, yet undeniably striking visuals, as astronauts land on a cursed

planet and are forced to deal with its malevolent inhabitants. *Planet of the Vampires* is also notable for its visual resemblance to Ridley Scott's much later *Alien* (1979), particularly in the design of the interior of an alien spaceship, which seems to prefigure the giant, wrecked spacecraft discovered by the crew of the *Nostromo* in *Alien* almost to the last detail.

Later films by Bava trailed off into slasher territory, with the exception of the interesting spy thriller *Diabolik* (*Danger: Diabolik,* 1968), which starred John Philip Law and which Bava typically finished in high style for a fraction of the film's original budget in a matter of weeks. Another, *Gli orrori del castello di Norimberga,* released by AIP in the United States in 1972 as *Baron Blood,* featured Joseph Cotten in one of his final leading roles.

Numerous other Italian horror films followed in Bava's footsteps. Indeed, in the 1960s, Cinecittà (Rome's biggest film studio) and its numerous competitors were hotbeds of genre filmmaking, with westerns, costume dramas, sword and sandal films, and horror movies being cranked out for a cost of as little as $20,000 a film. Many of them were shot in Techniscope and Technicolor, which breathed new life into the various genres, as evidenced, for one example, by Sergio Leone's remarkably successful series of so-called "spaghetti westerns" starring a then relatively unknown television actor named Clint Eastwood.

Anton Giulio Majano's lurid *Seddok, l'erede di Satana* (*Seddok: The Heir of Satan,* released in the United States under the much more marketable title of *Atom Age Vampire,* 1963), was produced by Bava and has a suitably gruesome scenario. A mad scientist transforms himself into a vampire to obtain bodily fluids to aid in his research. Massimo Pupillo's *Il boia scarlatto* (*The Scarlet Hangman,* released in the United States as *The Crimson Executioner* [aka *The Bloody Pit of Horror*] in 1966) stars Jayne Mansfield's husband at the time, muscleman Mickey Hargitay, in a violent saga of murder and revenge that has a strong and unpleasant streak of misogyny.

Vincent Price was lured to Italy to star in the first version of Richard Matheson's *I Am Legend* (in Italy, *L'ultimo uomo della terra; The Last Man on Earth,* 1964), a Robert Lippert/AIP co-production co-directed by American genre specialist Sidney Salkow and Ubaldo Ragona. The deserted streets of Rome stand in for modern-day Los Angeles, not altogether convincingly, in this tale of one man struggling to survive in

a world of the walking dead. Although the film has moments, the 2007 remake, *I Am Legend,* directed by Francis Lawrence, with Will Smith in the title role, as well as the Charlton Heston version, *The Omega Man,* directed by Boris Sagal in 1971, make much more effective use of the material.

Perhaps the most "distinguished" Italian horror film of the era was the three-story *Histoires extraordinaires (Extraordinary Stories),* released in the United States by AIP in 1969 as *Spirits of the Dead,* with segments directed by Louis Malle, Roger Vadim, and Federico Fellini. Billed by AIP as another film in its long-running Edgar Allan Poe series, *Spirits of the Dead* was really an Italian-French co-production, with Brigitte Bardot, Alain Delon, Terence Stamp, Jane Fonda, and Peter Fonda heading the large cast.

Vadim's entry in the film, "Metzengerstein," features Jane Fonda as a decadent aristocrat who is responsible for the death of her cousin (Peter Fonda), with whom she is, despite her protestations to the contrary, infatuated. Louis Malle's rendition of Poe's "William Wilson," about a man (Alain Delon) whose doppelganger causes him eventually to take his own life, is equally effective. But Fellini's "Toby Dammit, or Never Bet the Devil Your Head," is clearly the outstanding entry in the three-part film, casting Terence Stamp as an alcoholic film star, Toby Dammit, adrift in the Italian film capital. He agrees to star in an offbeat western with religious overtones and becomes entranced with the image of Satan as a young girl, playing with a white ball, who invites Toby to join her in her games. Interestingly, Clint Eastwood was originally considered for the role of Toby, but Stamp's dissolute nonchalance seems much better suited to the project. In the end, it is Toby's weakness that leads to his destruction, and Stamp's angelic countenance makes it all the more effective when, at the film's conclusion, his head is neatly lopped off by a razor-sharp wire.

In Mexico, a large number of low-budget horror films were being made with distinctly less ambition than Italian ones, but they still attained a certain degree of savage utilitarianism. Chano Urueta's *El barón del terror (The Baron of Terror;* released in the United States in 1961 by AIP under the bizarre title *The Brainiac)* deals with Baron Vitelius d'Estera (Abel Salazar), a three-hundred-year-old warlock burned at the stake in 1661. He returns to 1960s Mexico City as a suave aristocrat and

occasionally metamorphoses into a monstrous ogre with a huge, pro-
truding tongue, which he uses to suck out the brains of his victims.
Fernando Méndez's *El ataúd del Vampiro* (*The Vampire's Coffin*, 1958), a
sequel to his 1957 film *El vampiro* (*The Vampire*), stars Germán Robles as
Count Karol de Lavud, who has a penchant for the blood of young
women.

As if to demonstrate that Mexican filmmakers were determined to
plow through the entire stable of Universal monsters, with enough vari-
ation to avoid a lawsuit, Rafael López Portillo's *La momia azteca* (*The
Aztec Mummy*, 1957) offers a rather uninspired retread of the 1932 orig-
inal. The film's sequel, Portillo's *La maldición de la momia azteca* (*Curse of
the Aztec Mummy*, 1957), finds the Mummy in search of treasure buried
in a pyramid. Portillo's pleasingly bizarre *La momia azteca contra el robot
humano* (*The Robot vs. the Aztec Mummy*), released in 1958, offers the
spectacle of the Mummy fighting off the unwelcome advances of a
humanoid robot. All of these films were hastily shot in black and white,
with minimal production values, yet attracted large audiences in both the
United States and Mexico in original-language and dubbed versions.

As the new decade dawned, just as with the Universal films of the
mid-1940s, something new had to be added, so René Cardona's *Las
luchadoras contra la momia* (*The Wrestling Women vs. the Aztec Mummy*,
1964) features a new female mummy, Xochiti. Capable of transforming
herself into a snake, or even a bat, she joins a group of, well, wrestling
women, headed by Lorena Velázquez as Gloria Venus, in a battle against
the evil Prince Fujiyata's (Ramón Bugarini) band of female wrestlers,
which certainly gets a few points for originality.

Even Lon Chaney Jr. got involved in the wave of Mexican horror
films that flooded theater screens in the late 1950s and early '60s. In
Gilberto Martínez Solares's *La casa del terror* (*House of Terror*, 1960) an
unnamed mad doctor (Yerye Beirute) revives an ancient mummy
(Chaney, naturally), who, when the moon is full, also turns into a
werewolf—again, an interesting combination. An even more peculiar
variation on these films emerged when notorious American low-budget
impresario Jerry Warren bought the U.S. rights to the film, cut it
together with some footage from *La momia azteca*, shot some new
sequences, dubbed the whole thing into English, and released it as *Face*

of the Screaming Werewolf in 1964, creating a truly incomprehensible cinematic mash-up completely devoid of logic, narrative or otherwise.

The American director Al Adamson is a peculiar figure in cinema history and a controversial one for many reasons. Like Sam Newfield at PRC in the 1940s, Adamson was remarkably prolific, but his work is so slapdash and threadbare as to be fatally compromised in every respect, even though he employed a number of gifted actors (usually on their way down the ladder of fame), such as John Carradine, Lon Chaney Jr., Russ Tamblyn, Reed Hadley, Kent Taylor, and other Hollywood veterans. Scripts in Adamson films are often negligible to nonexistent. His films, all made for the micro-budgeted production company Independent International, were routinely re-released and re-edited into "new" films under different titles and displayed an almost complete lack of care in their production.

Adamson's films were also often extremely violent, especially *Satan's Sadists* (1969), a brutal biker film notable for its nihilism. Indeed, all of Adamson's films have a fatalistic, foredoomed feel in their hasty construction. Thus, such films as *Blood of Dracula's Castle* (1969), *Hell's Bloody Devils* (1970), *Horror of the Blood Monsters* (1970), *Dracula vs. Frankenstein* (1971), *Brain of Blood* (1972), *Blood of Ghastly Horror* (1972), and others are interesting solely as cultural artifacts of a bygone era in low-budget filmmaking; they are otherwise nearly devoid of initiative, talent, or craftsmanship. Adamson stopped directing in 1983 and went into real estate; he made a good living at it with his wife and former star, Regina Carrol, whom he married in 1972. After Carrol died in 1992, Adamson married actress Stevee Ashlock.

By 1995, Adamson's films had become cult items with the "so bad it's good" crowd (he even had a retrospective at the Nederlands Filmmuseum in Amsterdam in the early 1990s), and he seemed poised to return to the director's chair. Abruptly, however, Adamson disappeared. Following a five-week search, his body was found encased in cement under a newly installed whirlpool bath in his home. Adamson's handyman, one Fred Fulford, was arrested, tried, and convicted of murder, and sentenced to twenty-five years in prison. Adamson's career as a horror director thus had a grisly conclusion, as odd and as violent as many of his films.

Working in the depths of filmdom's poverty row, the Manhattan-based filmmaker Andy Milligan—of whom critic Michael Weldon once remarked, "If you're an Andy Milligan fan, there's no hope for you"—used a variety of pseudonyms (Dick Fox, Gerald Jackson, Joi Gogan) to create perhaps the most poverty-stricken films considered in this entire volume. Entirely self-taught, Milligan broke in with the "underground" film scene in New York with his short film *Vapors* (1965), one of his best films, in which two strangers meet in a gay bathhouse. Simple, direct, and surprisingly poetic, the film is unusually restrained for Milligan, who soon after joined forces with William Mishkin, a producer of soft-core exploitation and horror films, to create (often in 16mm) such films as *Torture Dungeon* (1969), *Guru, the Mad Monk* (1970), *The Rats Are Coming! The Werewolves Are Here!* (1972), *Legacy of Blood* (1978), and *Monstrosity* (1989). After a long illness, Milligan died of AIDS in 1991 at the age of sixty-two.

Yet all of these films, no matter how violent, belong to an era of relative innocence, with the exception, perhaps, of *Witchfinder General*'s Matthew Hopkins, who rapes and tortures in the name of Christianity, and Fisher's oddly prescient *Stranglers of Bombay*. This was all about to change forever. In 1968 a director of television commercials in Pittsburgh gathered a group of friends and technicians and shot, over the course of several weekends, a film that was a complete departure from all that had come before it: *Night of the Living Dead*. George Romero, the director, used nonprofessional actors in many of the roles, shot the film in almost documentary-style black and white, and cast an African American (Duane Jones) as Ben, the resourceful leader of a group of strangers who find themselves trapped in a lonely house under assault from a phalanx of zombies intent on devouring their flesh. The group fractures into several opposing camps, children are transformed into flesh-eating monsters, a young couple attempting to escape is immolated when a pick-up truck explodes, and, having survived the nocturnal assault that has left all of his companions dead, Ben is shot the next morning by a deputy sheriff working with a "clean-up squad," having been mistaken for a zombie himself.

The film's scenario is brutal and unrelenting. The threadbare production values, for once, make the film all the more real, and when the zombies feed on the entrails of their victims, we see it in graphic,

32. The zombies attack in George Romero's *Night of the Living Dead*. Courtesy: Jerry Ohlinger Archive.

close-up detail. Romero toyed with the idea of cutting out the most explicit sequences (close-up after close-up of zombies eating entrails), but then decided that these scenes gave *Night of the Living Dead* the extra punch needed to distance it from the competition. Thus, a new level of cinematic violence was born, and the horror film was changed forever.

Several years later, Wes Craven would raise the bar still higher with *Last House on the Left* (1972), in which two young women are raped and murdered, leaving their families to take revenge upon the killers. Everything is shown in vicious, unsparing detail; there is not an ounce of sympathy, humanity, or compassion in the film's world of unrelenting cruelty. It was shot in 16mm for a total of $90,000 and was supposed to have a limited release, but when Samuel Z. Arkoff of AIP saw the film, he got behind it for a national rollout. The film's impact was sufficient to launch Craven on a prolific career as a director of horror films, especially the *Nightmare on Elm Street* and *Scream* series, which will be discussed in the next chapter.

33. A scene from Wes Craven's original version of *Last House on the Left*.
Courtesy: Jerry Ohlinger Archive.

At roughly the same time that Craven was putting audiences on trial
with *Last House,* Tobe Hooper was completing his own landmark film,
The Texas Chainsaw Massacre (1974), detailing the "family life" of a
group of bloodthirsty outsiders who butcher anyone who strays into
their territory and then cut up the bodies for nourishment. The people
who live in the isolated farmhouse where most of the film's action takes
place once worked in a slaughterhouse and have no more compunction
about killing a human being than they would a steer. Indeed, Leatherface
(Gunnar Hanson), the chainsaw-wielding leader of the group, is nothing
more than a brute killing machine who regards the world at large as one
giant abattoir.

Don Coscarelli's *Phantasm* series dispensed with plot in favor of a
series of violent, disconnected incidents centering around two young
boys and the mysterious "Tall Man" (Angus Scrimm), a small-town
mortician who is presumed to be responsible for a recent string of deaths.
The key iconic image of the film is a silver sphere that hurtles through
space of its own accord and uses retractable spikes and a drill to bore into
the heads of its victims. With zombie dwarfs, Cocteauesque mirrors that

34. Leatherface on the loose in Tobe Hooper's *The Texas Chainsaw Massacre.*
Courtesy: Jerry Ohlinger Archive.

serve as windows to another dimension, and a plot composed of incidents
rather than a coherent narrative, *Phantasm* is nothing so much as a violent
nightmare of death and pursuit. At the end of the film, we are told that
the entire narrative has been a dream—until the film's final sequence,
which once again questions the line between reality and fantasy.

An even more intriguing film was Calvin Floyd's *Terror of
Frankenstein* (aka *Victor Frankenstein,* 1975), a Swedish/Irish co-production
shot in Ireland in English on a minimal budget. Victor Frankenstein
(Leon Vitali), as in Shelley's novel, is determined to delve into the secrets
of life and death; his fiancée, Elizabeth (Stacy Dorning), opposes his
increasingly unhealthy preoccupation with playing God. Using the
bodies of the newly dead, after experimentation on animals proves
successful, Victor creates his first reconstituted man, played by the
Swedish actor Per Oscarsson in a moving, tragic performance. When
Frankenstein first brings his creation to life with the help of a bolt of
lightning, he is so appalled at what he has wrought that he flees his own

house. At length Frankenstein is brought home by his best friend, Henry Clerval (Nicholas Clay), but the monster is in no mood for rapprochement with its creator. The film makes extensive use of natural locations and employs available light whenever possible for a naturalistic, almost documentary look. The film is ultimately more faithful to Shelley's novel than any other version of the classic tale and ends, as does the original, with the monster alone in the Arctic, fully possessed of the power of speech, having made Victor's life a living nightmare.

Perhaps no figure in 1970s and '80s cinema more effectively sums up life at the margins of society than director David Lynch, whose student film *Eraserhead* (released in 1977) was made on a minuscule budget over a period of several years while Lynch attended the American Film Institute's conservatory program as a grant recipient. Shot in ghostly black and white in 16mm, the film documents the tedious and nihilistic existence of Henry Spencer (Jack Nance), his girlfriend, Mary X (Charlotte Stewart), and their monstrous offspring, a mutant baby who cries incessantly. The eighty-nine-minute film became a sensation when it was screened at the Elgin Theatre in New York, and Lynch's career was truly launched.

In 1980 Lynch made the jump to full-fledged feature films with *The Elephant Man,* which was photographed by Hammer horror director Freddie Francis, with whom Lynch developed a close relationship. Francis subsequently shot Lynch's adaptation of Frank Herbert's epic science-fiction novel *Dune* (1984) and the family drama *The Straight Story* (1999). *The Elephant Man,* a real-life horror story, considers the life of Joseph Merrick, a hideously deformed man born in Victorian England (superbly portrayed by John Hurt), who is exhibited as a circus freak until a sympathetic doctor, Frederick Treves (Anthony Hopkins), takes Merrick in and gives him a home and some sense of place in society. As time passes, Merrick becomes something of a celebrity in London and gains the sympathy and patronage of Dame Madge Kendal (Anne Bancroft), a famous actress of the period.

Produced by Mel Brooks, the film garnered eight Academy Award nominations and made Lynch so "hot" as a Hollywood director that even George Lucas approached him with an offer to direct *Return of the Jedi* (1983, ultimately directed by Richard Marquand). But Lynch had his eye on more personal projects, and when *Dune* failed at the box

office, he went straight into *Blue Velvet* (1986), one of his most accomplished and popular films. In this story young college student Jeffrey Beaumont (Kyle MacLachlan) and his squeaky-clean girlfriend, Sandy Williams (Laura Dern), find out that behind the white picket fences of their supposedly peaceful small town a world of violent eroticism awaits, as personified by Dennis Hopper in a "comeback" role as Frank Booth, a demented psychopath constantly seen inhaling *something* from an oxygen tank, and by Isabella Rossellini as Dorothy Vallens, a tragic torch singer who likes her sex with more than an edge of violence. Photographed by Frederick Elmes, who had also shot *Eraserhead, Blue Velvet* incorporates classic pop songs, "Donna Reed" iconography, and unsettling elements of paranoia and voyeurism to create a world in which nothing is as it seems and everything is open to question.

One of the more interesting supernatural thrillers of the early 1970s was John Hough's *The Legend of Hell House* (1973), based on the novel by Richard Matheson, who adapted it for the screen. The film was shot in England with a superb cast headed by Pamela Franklin, Roddy McDowall, and Clive Revill. Effectively paced by Hough, a veteran of British Gothics, the ninety-five-minute film follows a group of psychic researchers as they investigate the fictitious Belasco House, described in the film as the "Mt. Everest of haunted houses" because of the evil reputation attached to it. An intriguing variation on Robert Wise's *The Haunting* (1964), *The Legend of Hell House* is much more graphic in its violence and sexuality than many other films of the period. Sadly, it was the last film produced by James H. Nicholson after leaving American International Pictures and his partnership with Samuel Z. Arkoff. Nicholson and Arkoff had started AIP in 1954, but had come to a parting of the ways. Jim Nicholson died of a brain tumor in December 1972, just six months before *Legend of Hell House* was released.

Taken as a group, these films indicated a radical shift in horror iconography. No longer was it enough to depict a world of undead vampires, shuffling mummies, or lumbering Frankenstein monsters; now, the horror had come home to us, showing us that the real horror of life is everywhere. Even though Romero's film had a vague science-fiction premise (the bodies of the recently dead are somehow restored to life by an unknown force), the focus of the film was on the brutality both inside and outside the lonely farmhouse under siege.

Last House and *Texas Chainsaw* went even further. The monsters in both films are all too human, people who look like us, act like us, and for all intents and purposes could *be* us, bereft of hope or conscience or any sense of respect for human life. "Who will survive, and what will be left of them?" screamed the ads, and it was, at last, a valid question. The horror was real now, and it was all around us, not hidden in some remote castle in the Carpathian mountains or in a tomb in Egypt. It was grainy, realistic, and presented without preamble or apologies; audiences were as brutalized as the victims in the films.

By 1980, when the producer of *Last House,* Sean S. Cunningham, started his own horror franchise with the homicidal adventures of Jason Voorhees's *Friday the 13th,* the die had been irrevocably cast. The future of horror was violence, cruelty, and abundant quantities of gore. Nothing less would suffice to shock a generation that had watched the Vietnam war unfold nightly on television, with its grisly body count rising by the day and new recruits shipped off daily to kill or be killed. The new horror film presented a never-ending horizon of pain and fear—not an escape any more, but an indictment of the way things are now and what the future holds for all of us, both on-screen and in real life.

CHAPTER 4

New Blood

1970–1990

AND SO THE floodgates opened. The horror films released from the 1970s onward had little in common with their predecessors, save for one central aspect: they genuinely *horrified* viewers. It is hard to imagine audience members fainting dead away at the sight of Boris Karloff in *Frankenstein,* but it is so; Edward Van Sloan's "friendly warning" at the beginning of the film had been necessitated by Karloff's shocking countenance and, of course, by the subject matter. Living beings constructed from the corpses of the dead, hunchbacks, mad scientists, the drowning of a young girl—it was all too much for audiences to bear. Forty years later, *Frankenstein* was a venerable antique, a blueprint that had outlived its usefulness—unless, of course, one increased the level of violence and mayhem, with copious amounts of gore as window dressing.

This period also witnessed the decline and total collapse of the Hollywood studio system, allowing independent filmmakers with minuscule resources access to the marketplace. This trend, of course, would last for only a short time—perhaps ten years, fifteen at the most—before the conglomerates would once again hold unquestioned power over the new, anonymous multiplexes that sprang up in the late 1970s through the present era. But for a time, if you had $100,000 or so and enough talent, guts, and imagination to offer something that the majors were afraid to touch, you had a shot at breaking through to the mainstream audience. This strategy, of course, is how independent filmmakers have *always* competed against the majors, by offering the public a fresh, often outlaw vision that the bigger studios were either unwilling or unable to duplicate. One couldn't compete on budgets; the majors

would beat you every time. But you could, as AIP did, offer films that appealed directly to a younger, edgier audience and lure away a significant group of viewers.

In time, these "breakaway audiences" would become dominant, and the cycle would start all over again, with some new auteur on the block presenting a spectacle that, once again, pushed the outer edges of the envelope. And horror films, as we've seen, by definition operate on the cinematic margins, continually redefining what it is that truly horrifies us, frightens us, even repulses us—otherwise, they cease to be truly horrific. The splatter pioneer Herschell Gordon Lewis, whose *Blood Feast* (1963), shot in Miami on a budget of roughly $25,000, sensed this when he created the first truly ultra-violent film with copious amounts of gore and sadism, and was universally reviled for it. Yet nearly half a century later, the brutality and senseless slaughter of *Blood Feast* have been replicated by so many contemporary horror films that we can see, whether we like it or not, where the horror film was headed. Lewis, known as the "Wizard of Gore," went on to create a series of these ultra-low-budget, nearly plotless films with amateurish acting, inept direction, and seemingly endless scenes of graphic violence, each film more repellent than the last.

Two Thousand Maniacs (1964), which boasted a somewhat larger budget, features one scene in which a woman is ritually dismembered; in another sequence, a man is pushed down a hill inside a barrel with spikes driven through it, until all that remains is a bloodied corpse. Lewis correctly assessed that the film was "repulsive psychologically" and knew that he was appealing to the lowest common denominator in his audiences, but he simply didn't care. For Lewis, it was all about box-office receipts. As he put it, "If you cannot titillate [your audiences] with production value, you [must] titillate them with some type of edge."

Indeed, Lewis's imagination in this regard was limited solely by meager budgets; for years, he wanted to blow someone up on the screen with a swallowed stick of dynamite, but gave up because he couldn't figure out how to do it for a reasonable amount of money. And despite Lewis's renegade status, or perhaps because of it, French critics in *L'Observateur, Cahiers du cinéma,* and *Image et son* compared Lewis's audaciously violent films with Polanski's *Repulsion* and Hitchcock's *Psycho*. But, as Lewis knew, "That isn't the way you keep score. You keep score

through net film rentals." Thus, such later Lewis films as *A Taste of Blood* (1967) and *The Gore-Gore Girls* (aka *Blood Orgy,* 1972) kept up the same formula of terrible acting, miserable production values, and an arsenal of gore effects. All of Lewis's films made money, especially in the southern states, where they played at drive-ins and second-run houses to audiences who were eager to witness the depraved scenarios Lewis had concocted for their entertainment.

Lewis was a "hands-on" filmmaker who photographed, edited, and even composed the music for his films, in addition to creating the hyperviolent special effects on a dime-store budget. As he noted, "The only film an independent can make and survive with is a film that the majors cannot or will not make." An English professor at the University of Mississippi until he turned his hand to what he himself described bluntly as "gore" films, Lewis had a clear understanding of the aesthetic nullity of his films. Of *Blood Feast,* he asserted, "It's no good, but it's the first of its type and therefore it deserves a certain position."

In many ways, Lewis's films paved the way for many of the most lucrative franchises of the 1970s through the present era, films in which only violence matters. These became increasingly mechanical as audiences became progressively inured to watching pain and suffering on the screen as a means of escape from their own lives—an escape through indifference to the suffering of others. Lewis was using the Grand Guignol formula as his guide and was well aware of precisely what he was doing and how to go about it. The most popular horror franchises of the contemporary era—the *Friday the 13th* series, the *Nightmare on Elm Street* films, the *Saw, Scream,* and *Texas Chainsaw Massacre* films—all traffic in the same aesthetic of brutality and cynical distancing.

In all of these films, the victims line up for ritual slaughter, and the audience's interest resides solely in the manner, and the order, of their demise. All else is entirely dispensable. In addition, as we'll see, franchise filmmaking ruled the 1970s, '80s, and '90s in the horror genre, in a way that even Universal in the 1940s could never have imagined. One hit film would often generate six or seven sequels. Moreover, all of the major franchises of the era were strikingly similar—essentially slasher films in which a high body count was the chief prerequisite and character development and motivation were singularly unimportant. They offered more of the same with only minor variations, and audiences

apparently loved it. Then, too, when a franchise finally seemed exhausted, studios would "reboot" the entire series with a new "origin" film in hopes of starting the cycle all over again. Often enough, it actually worked.

The *A Nightmare on Elm Street* franchise, another invention of writer/director Wes Craven, chronicled the misadventures of Freddy Krueger (Robert Englund), a hideously scarred homicidal maniac possessed of long, razor-like fingernails, who pursues teenagers in their dreams in the hope of killing them. A "dream death" will then result in an actual death, as Freddy seeks revenge against the *parents* of the children who burned him to death many years earlier. The 1984 original was followed by a wave of sequels, beginning with *A Nightmare on Elm Street 2: Freddy's Revenge* (1985), directed by Jack Sholder, and then *A Nightmare on Elm Street 3: Dream Warriors* (1987), which was directed with a certain gory panache by Chuck Russell. The fourth film in the series, *A Nightmare on Elm Street 4: Dream Master* (1988), was directed by action specialist Renny Harlin, and the fifth, *A Nightmare on Elm Street 5: The Dream Child*, was helmed by Stephen Hopkins and featured more predictable mayhem.

Freddy's Dead: The Final Nightmare, directed in 1991 by Rachel Talalay, seemed to bring Freddy's misanthropic exploits to a close, but in 1994 Craven attempted to reboot the series as the writer and director of *Wes Craven's New Nightmare.* In this decidedly odd departure from the series, Wes Craven, Heather Langenkamp (the long-suffering "final girl" of the series), producer Robert Shaye, and others associated with the actual production of the *Elm Street* series discover that the fictional Freddy Krueger actually possesses an evil spirit, which is trapped in limbo and can be exorcised only by a final confrontation with Langenkamp, playing the series role of "Nancy" one last time.

This was a remarkably sophisticated entry in the series, which had degenerated into a mindless repetition of shocks and gimmicks; indeed, portions of *Freddy's Dead* were shot and exhibited in 3D to give some life to the nearly moribund series, but to no avail. The final entry in the series to date is Ronny Yu's sadly predictable *Freddy vs. Jason,* in which *Friday the 13th*'s Jason Voorhees battles it out with Freddy Krueger to a bloody, unresolved climax, in the manner of the mid-1940s Universal "monster rally" films.

Craven then felt free to develop another franchise with the *Scream* series, starting in 1996 with *Scream,* which Craven directed from a script by Kevin Williamson. The plot line of the film is simplicity itself. A masked killer stalks a series of young victims and murders them one by one in ritualistic fashion, while tormenting them with phone calls in a heavily disguised voice. Drew Barrymore, appearing in the first film in the series, is summarily killed off in the opening sequence. (This is *Psycho* in fast forward; instead of murdering a supposedly central character halfway through the film, Williamson and Craven dispose of Barrymore's character, Casey Becker, in fewer than fifteen minutes.) The film's real "final girl," Sidney Prescott (played by Neve Campbell), survives to be menaced again in Craven's *Scream 2* (1997), also from a script by Williamson, and yet again in Craven's *Scream 3* (2000). As of this writing, Craven is in production for *Scream 4,* with a Williamson script and with Courtney Cox and David Arquette in the leading roles. Once again he appears to be trying to jump-start another aging franchise, but one that he still controls and one that remains highly lucrative.

Oddly enough, the working title of the first *Scream* film was *Scary Movie,* which in itself became a franchise of comedy/horror films, starting with Keenen Ivory Wayans's *Scary Movie* (2000) and then, in rapid succession, Wayans's decidedly less successful *Scary Movie 2* (2001) and David Zucker's *Scary Movie 3* (2003). Zucker, the co-director and co-writer of *Airplane!* (1980), attempted to breathe some new life into the series.

Wes Craven is also responsible for another ultra-violent assault on cinematic sensibilities, *The Hills Have Eyes* (1977), in which an average American family on vacation is attacked by a renegade family of cannibalist mutants who were left to die at an atomic test site. Jupiter (James Whitworth), the family patriarch, has a score to settle with conventional society for the crime against his family. Craven would revisit the franchise again in 1985 with *The Hills Have Eyes II,* which, despite a more generous budget and some sense of character continuity, failed to ignite at the box office. The prolific auteur also tried his hand at a modern werewolf story with *Cursed* (2004), with indifferent results, and also functioned as a producer for other directors' genre films in his minimal spare time.

The *Friday the 13th* franchise followed much the same trajectory, racking up no fewer than twelve feature films, along with comic books,

35. Kevin Bacon is slaughtered in the first of the *Friday the 13th* films. Courtesy: Jerry Ohlinger Archive.

novels, video games, and a short-lived television series "inspired" by but not directly linked to the series itself. The first *Friday the 13th* (1980) was shot on the cheap by Sean S. Cunningham. He assembled a no-frills cast, including Kevin Bacon in his first role of any consequence, Bing Crosby's son Harry Crosby, and 1950s ingénue Betsy Palmer as the mother of Jason Voorhees. Jason, played in this first film by Ari Lehman, is a mute, imbecilic, homicidal maniac in a hockey mask who runs amok at Camp Crystal Lake, where an assembly line of teens who smoke pot, have sex, and drink are hacked to death for their "transgressions."

Cunningham, who had worked with Wes Craven on *Last House on the Left,* saw John Carpenter's *Halloween* (1979) and realized that a similar franchise would probably gain a following. Although the working title of the film, from Victor Miller's script, was the more prosaic *Long Night at Camp Blood,* Cunningham felt strongly that the title *Friday the 13th* was infinitely more commercial, and so he pushed ahead, even though there was an earlier, unrelated film, John Ballard's *Friday the 13th . . . The Orphan* (released in 1980). The producers of that film felt they had priority on the title, but this minor problem was cleared up.

Cunningham's film was rapidly shot and released, and promptly cleaned up at the box office, setting a new standard for graphic violence.

Paramount Pictures then purchased the distribution rights to the series and began cranking out one low-budget sequel after another, including Steve Miner's *Friday the 13th Part 2* (1981) and *Friday the 13th Part 3* (1982), Joseph Zito's *Friday the 13th—The Final Chapter* (if only it had been true) in 1984, Danny Steinmann's *Friday the 13th Part V: A New Beginning* (1985), Tom McLoughlin's *Friday the 13th Part VI: Jason Lives* (1986), and John Carl Buechler's *Friday the 13th Part VII—The New Blood* (1988), all with pretty much the exact same script.

Still, the films continued to make money. They required no stars, minimal budgets, and little more than a string of increasingly gruesome killings to fill out their running time. In Rob Hedden's *Friday the 13th Part VIII: Jason Takes Manhattan* (1988), the script continued to allow Jason to roam the streets of New York on his endless killing spree, but budget cuts to this extremely cheap film forced most of the action to be confined to a boat; only the last third of the film takes place on land, with Vancouver, British Columbia, standing in for New York. The resulting film was so inept that it failed to do well at the box office, and Paramount dropped the series, which eventually was sold to New Line Cinema by the series' original backers. Adam Marcus's *Jason Goes to Hell: The Final Friday* followed in 1993 after protracted negotiations; although *Freddy vs. Jason* was already in the works in both Craven's and Cunningham's minds, it would take a full ten years before the two "monsters" finally met in 2003.

Before that momentous meeting, Jim Isaac directed *Jason X* (2002), the tenth film in the series and one of the more inventive. Jason is inexplicably found frozen in a block of ice in the year 2455 by a deranged scientist, Dr. Wimmer (director David Cronenberg in a brief and effective cameo; more on this talented cineaste later). Wimmer immediately decides to thaw him out, despite repeated warnings, and is promptly speared through the chest by the mute killer, who then hides out on a spaceship and begins picking off the young and attractive crew members one by one. *Jason X,* at least, knows that it's a parody. At one point, when one of Jason's victims is about to be sucked through a massive sieve and thus reduced to a bloody pulp, the actress turns toward the camera and directly addresses the viewer, "This whole thing *sucks* on so many levels."

One would think that all this would be more than enough killing for one homicidal maniac, but no. In Marcus Nispel's *Friday the 13th* (2009), the entire saga starts all over again at Camp Crystal Lake, exactly as it did twenty-nine years earlier, with a larger budget and more convincing prosthetic special effects, but with the same savage insistence on one violent death after another. No doubt there will be more *Friday the 13th* films in the future. The formula is simple, direct, and appeals to the same desensitized audience that flocked to Herschell Gordon Lewis's films a quarter of a century earlier.

John Carpenter's *Halloween* (1978) is a different matter altogether, at least in its first iteration. Carpenter, who had created only two films prior to *Halloween,* the micro-budgeted science-fiction thriller *Dark Star* (1973), which was shot in 16mm, and the Howard Hawks–inspired revenge thriller *Assault on Precinct 13* (1976), which scored a solid hit with critics and audiences, especially in Britain, was and is a genuine auteur who puts a great deal of his own personal experience into his work. He is also something of a renaissance man. On *Dark Star,* he served as director, producer, screenwriter, and music composer; on *Precinct 13,* which cost a mere $100,000 to make, he directed, wrote the screenplay (loosely based on Hawks's *Rio Bravo* [1959]), composed the music, and even edited the film (under the pseudonym of John T. Chance, the name of John Wayne's character in *Rio Bravo*).

At the same time he was making *Precinct 13,* Carpenter was also busy writing a screenplay for what would become Irvin Kershner's *Eyes of Laura Mars* (1978), a suspense thriller about a high-fashion photographer who "sees" through the eyes of a psychopathic killer. In eight days in May 1978 Carpenter wrote the script for *Halloween* with producer Debra Hill and then shot the film in a mere twenty days for $325,000. Besides introducing Jamie Lee Curtis to viewing audiences, the film launched one of the most highly lucrative franchises in motion picture history. As with his earlier projects, Carpenter served in multiple functions, as director, co-screenwriter, and music composer. The film opened in October as an independent release but soon attracted widespread attention and became a cult phenomenon, leading to Carpenter's career as a mainstream Hollywood director.

Originally titled *The Babysitter Murders, Halloween* is a simple slasher film, but with something of a backstory and a remarkable performance

36. John Carpenter's breakthrough film, *Halloween*. Courtesy: Jerry Ohlinger Archive.

by Donald Pleasance as the implacable Dr. Samuel Loomis. Loomis is the antagonist to psychopathic killer Michael Myers, who, much like Jason Voorhees in the *Friday the 13th* films, is intent only on killing anything in his path. The film starts with a flashback. In 1963 the six-year-old Michael Myers killed his seventeen-year-old sister Judy (Sandy Johnson) on Halloween night. Flash forward to 1978. Michael (now an adult played by Nick Castle) has been confined to a sanitarium for fifteen years, where Dr. Loomis tries vainly to reach and reform him before realizing that Michael's case is hopeless.

When Michael escapes from the mental hospital, he reflexively returns to his home town, on Halloween, and goes on a murderous rampage that claims numerous victims—all teenage babysitters—before Dr. Loomis empties a revolver into Michael just as he is about to slaughter Laurie Strode (Jamie Lee Curtis), the one would-be victim with enough intelligence and skill to evade his murderous advances. But is Michael really dead? In the last few shots of the film, we see Michael's body lying on the front lawn, but when we look again, Michael's

"corpse" has vanished. Carpenter seems to suggest that Michael, or his spirit, will always be with us.

The film's low budget was never really apparent in the finished project. As he had with *Precinct 13,* Carpenter shot *Halloween* in CinemaScope and color for added production value, and the sets and costuming for the film were created simply and cheaply. Throughout the film, Michael wears a shapeless, humanoid mask, so that we never see his face (Sean Cunningham would later borrow this same concept for Jason's hockey mask disguise in the *Friday the 13th* films). With the budget so tight, production designer/art director Tommy Lee Wallace purchased a William Shatner *Star Trek* Halloween mask at a dime-store for $1.98, cut it up with a razor blade, and created one of the film's trademark images for next to nothing. Although *Halloween* was shot quickly, Carpenter knew precisely what he was doing, as did producer Hill, and the two worked together to bring the film in on time and under budget. In many ways, it is Carpenter's purest and most successful work.

The franchise that followed, however, was undistinguished. Although Carpenter received payment for the use of his characters and basic story line for each subsequent entry in the series, he had little or no personal involvement with any of the remaining films. *Halloween II* (1981), directed by Rick Rosenthal, was an uninspired catalogue of gore effects and mindlessly sadistic killings; despite a budget of $2.5 million, it had little of the impact or intensity of the original film. On *Halloween III: Season of the Witch* (1983), Tommy Lee Wallace, who designed the first film, got a chance to direct, but this entry has no real connection to the series; the character of Michael Myers is missing entirely, and the plot revolves around a grisly plan to slaughter the world's children on Halloween.

Even though *Halloween III* did indifferent business at the box office, it paved the way for Michael Myers's inevitable return in Dwight H. Little's *Halloween 4: The Return of Michael Myers* (1988), which also brought Donald Pleasance's Dr. Loomis back into the franchise. The subsequent entry in the series, Dominique Othenin-Girard's *Halloween 5* (1989), offered more of the same, as did Joe Chappelle's *Halloween: The Curse of Michael Myers* (1995). It seemed as if the series had run its course.

Surprisingly, Jamie Lee Curtis agreed to return to the series that had propelled her to stardom with *Halloween H20: 20 Years Later* (1998), but

Steve Miner's uninspired direction gave the film a tired, perfunctory air. Curtis's presence made it the highest-grossing entry in the series up to that date, with more than $73 million in worldwide rentals; only the original entry came close to this figure, with an international gross of roughly $55 million.

Curtis returned to the series again in Rick Rosenthal's *Halloween: Resurrection* (2002), but the film lacked even the spark of the 1998 reunion. The series seemed to have truly run its course. And yet, in 2007, musician and filmmaker Rob Zombie signed on to helm a reboot, with Malcolm McDowell replacing the late Donald Pleasance in the role of Dr. Loomis. The new film, entitled *Halloween,* took the series back to its roots and, ironically, was the most commercially successful project of the entire series, raking in nearly $80 million worldwide. Rob Zombie (real name Robert Bartleh Cummings) began his career as a death metal rocker with his band White Zombie, named after Victor Halperin's classic film, but soon tired of the constantly touring lifestyle associated with rock music in the post-CD era and turned to horror films. He began with *House of 1000 Corpses* (1999), centering on the murderous Firefly family, which was shot at Universal but sold to Lionsgate because Universal felt the film was too violent. An homage, of sorts, to *The Texas Chainsaw Massacre,* the film finally saw the light of day in 2003.

Zombie's *The Devil's Rejects* (2005) picks up the story a few years later, with the Firefly family leaving mayhem in their wake as they roam the highways and byways of America. In early 2009, Zombie signed on to direct yet another film in the revived *Halloween* series, *Halloween II* (2009), which he promised would be "very realistic and very violent"—given Zombie's other projects as a filmmaker, not an idle threat. And yet, at the same time, Zombie noted that he no longer felt any obligation to adhere to the original concept of the series, saying that he felt no need to help any "John Carpenterness" in the new film and that he could do "whatever" he wanted with the *Halloween* franchise.

While *Halloween* was marching forward without him, John Carpenter was busy with a series of stylish and inventive genre films that were entirely original—one can easily see why he stepped away from the creative straitjacket of a nearly endless series. In 1980 he directed the Gothic ghost story *The Fog,* one of his most atmospheric and restrained films, in which almost nothing is shown; rather, evil is suggested, to great effect,

as in the films of Val Lewton. The action thriller *Escape from New York* (1981) effectively depicted a futuristic Manhattan as a hellish jungle for hardened criminals, walled off from the outside world. When Air Force One goes down over the city, maverick criminal Snake Plissken (Kurt Russell) is sent in to bring the president (Carpenter regular Donald Pleasance) back to safety.

In many ways, Carpenter's next project, a remake of the Hawks/ Nyby *The Thing from Another World,* this time titled *John Carpenter's The Thing* (1982), is his signature and most accomplished work, a nihilistic vision of a group of explorers at an isolated polar research station. Led by the resourceful MacReady (Kurt Russell again), they battle a shape-shifting monstrosity from another world, capable of taking on any form it needs in order to survive. The film's screenplay, by Burt Lancaster's son Bill Lancaster, is relentlessly downbeat, and Rob Bottin's still-staggering prosthetic special effects (the film belongs firmly in the pre-digital era) give the film an air of authenticity that is disturbingly real and deeply disquieting.

But *The Thing's* stark pessimism, perhaps a reflection of Carpenter's distrust of humanity in general, alienated audiences and resulted in Carpenter being fired from what would have been his next film, *Firestarter,* based on a novel by Stephen King (the film was given to director Mark L. Lester, who turned in a perfunctory job of work on the project, which was released in 1984). It also didn't help matters that Steven Spielberg's *E.T.—The Extra Terrestrial* (1982) opened within weeks of Carpenter's profoundly despairing film, offering a much more accessible alien presence for general audience consumption.

By contrast, in *The Thing,* the invader manages to kill all the members of the expedition except for MacReady and his perpetual antagonist, Childs (Keith David). Realizing that the situation is hopeless and that one of them may be the Thing in disguise, MacReady and Childs torch the base station. In the film's final moments, they are seen sharing a bottle of scotch as the flames die down, knowing that they both will freeze to death. The film cuts to black, and the horror is thus left unresolved. Although *The Thing* is now routinely considered one of the classics of 1980s horror/science fiction, it nearly killed Carpenter's career as a filmmaker. A costly personal vision had flopped badly. What would he do now?

Faced with nearly universal opprobrium, Carpenter did what he had to, and he survived. His budgets were cut, his paychecks became smaller, and his projects became simultaneously more routine (*Christine* [1983], about a cursed 1958 Plymouth Fury, and *Starman* [1984], a gentle science-fiction allegory in which Jeff Bridges appears as a sympathetic alien) and more eccentric (the bizarre *Big Trouble in Little China* [1986], an embarrassingly Orientalist fantasy set in San Francisco's Chinatown, and *They Live* [1988], an interesting tale of consumer manipulation by alien forces that is fatally flawed by the casting of wrestler Roddy "Rowdy" Piper in the leading role). *Memoirs of an Invisible Man* (1992), a bland Chevy Chase sci-fi comedy, may have been Carpenter's low point, although his oddly effective supernatural thriller *In the Mouth of Madness* (1995), with obvious and intentional debts to H. P. Lovecraft and a strong performance by Sam Neill as private investigator John Trent, is one of his better late works.

Less successful have been Carpenter's remake of Wolf Rilla's 1960 *Village of the Damned* (1995; tragically, this was Christopher Reeve's last film before his crippling horse-riding accident), his *Escape from L.A.* (1996, a weak retread of *Escape from New York,* with Kurt Russell reprising his role as the rogue adventurer Snake Plissken), and, most recently, his *Ghosts of Mars* (2001, a tired remake of *Assault on Precinct 13* set on Mars in the year 2176). Carpenter has also done some work in television: an excellent 1998 biopic of Elvis Presley, with Kurt Russell in the leading role, and an unsuccessful horror anthology series in 1993 entitled *Body Bags*. But although Carpenter's best work seems to be behind him, and although his list of major works is short, his impact on the genre as a whole is undeniable. John Carpenter's vision is that of a bold, uncompromising artist, just the sort of auteur Hollywood cannot abide.

One project that stood out from the rest of the pack in 1970s horror is Jim Sharman's *The Rocky Horror Picture Show* (1975), which deftly lampooned the more predictable conventions of the genre and became a cult hit in the process at midnight screenings throughout the world. A squeaky-clean young couple, Brad Majors and Janet Weiss (Barry Bostwick and Susan Sarandon), is stranded with a flat tire on a dark and stormy night and seeks refuge in the castle of Dr. Frank N. Furter, a transvestite mad scientist (Tim Curry at his most flamboyant). Soon they are involved in all manner of genre bending, as well as gender-bending

mayhem. Charles Gray, an expert in smooth menace, narrates the proceedings as a criminologist telling the entire story in flashback. *The Rocky Horror Picture Show* was so successful as a cult item that it continues to show to this day at midnight screenings, where audiences chant along with the dialogue and interact with the film in a manner that can only be described as cheerfully obsessive.

Even though *The Rocky Horror Picture Show* is less a horror movie than a transgendered musical from the Theater of the Ridiculous school, it is nevertheless an affectionate spoof of the genre. Its wide appeal spawned a sequel, Sharman's 1981 *Shock Treatment,* which failed to repeat the out-of-the-box success of the original film. In its outright burlesque of the horror genre, the film is akin to Mel Brooks's 1974 comedy *Young Frankenstein,* starring Gene Wilder as the mad Dr. Frederick Frankenstein, who is determined to carry on in his father's footsteps and winds up concocting a monster (Peter Boyle) whose crowning achievement is his ability to perform, near the end of the film, a spirited if barely coherent version of Irving Berlin's classic song "Puttin' on the Ritz."

Another maverick is Larry Cohen, a clever and industrious genre specialist who scored a hit with his quirky horror film *It's Alive* (1974), which featured a remarkably effective score by Bernard Herrmann and a monstrous, fanged newborn designed by makeup expert Rick Baker. After killing the doctor and nurses in the delivery room, the demon child embarks on a reign of terror that was so bloodthirsty it couldn't be contained in one film; the killer baby was back in Cohen's 1978 *It Lives Again* (aka *It's Alive II*). As the film's tagline promised, "There's only one thing wrong with the Davis baby . . . It's Alive!"

Since then, Cohen has continued to direct a series of offbeat horror films, such as *Full Moon High* (1981), a teenage werewolf story, and *Q* (aka *Q, the Winged Serpent,* 1982), in which the Aztec god Quetzalcoatl flies through the skies of New York, making a nest for itself in the Chrysler Building (the film is a loose remake of Sam Newfield's *The Flying Serpent* [1946], in which Quetzalcoatl is slightly smaller, but equally lethal). *The Stuff* (1985) is a horror/science-fiction film about some lethal muck sold as a dessert. Cohen's darkest film is undoubtedly *God Told Me To* (aka *Demon,* 1976) in which grisly murders are committed by everyday citizens, who afterward say only that "God told me to" when asked for an explanation for their actions.

Splatter films ruled the 1970s, but Ruggero Deodato's *Cannibal Holocaust* (1980), an Italian splatter/horror film, is in a class all by itself. It features some opening and closing scenes shot in New York and music by none other than Riz Ortolani, who composed the famous theme "More" for the pioneering Italian exploration documentary *Mondo Cane* (1963). Purporting to present the "lost film" documenting the fate of an anthropological expedition deep in the Amazon rainforest, *Cannibal Holocaust* instead reels out the fictional narrative of a film crew consisting of director Alan Yates (Carl Gabriel Yorke), his girlfriend Fay Daniels (Francesca Ciardi), who also serves as the "film's" script clerk, and two cameramen, Mark Tomaso (Luca Barbareschi) and Jack Anders (Perry Pikanen).

As *Cannibal Holocaust* opens, the film crew is missing, and Professor Harold Monroe, a New York cultural anthropologist (Robert Kerman), agrees to lead a rescue mission to discover its whereabouts. With the help of his guide, Chaco Losojos (Salvatore Basile), and an assistant, Professor Monroe and his party find the village where the film crew disappeared and are met with violence and hostility. Eventually, Monroe is taken by tribesmen to an improvised memorial made from the bones of the film-makers, and he realizes that his only concern now is to get out alive.

Bartering for the lost reels of the crew's work, Monroe flies back to New York and screens the footage, which reveals that the team of film-makers has been unscrupulous in the extreme. Director Alan Yates, in one scene, allows Jack Anders to shoot a native in the leg in order to follow him more easily through the jungle; in another, the crew members herd a group of natives into a hut and burn it to the ground, simply to create an exciting scene for their film. Monroe is understandably disgusted, and he is even more appalled when executives of the fictional Pan American Broadcast Company plan to air the film on their television network.

Monroe then shows the executives the last two "unedited" reels of the "lost film" in the hope that they will relent. Soon we witness a gang rape by the crew members of a young native woman, then a sequence in which the woman's body is impaled on a wooden spike. Jack Anders finally falls victim to the natives' displeasure; he is ritually disemboweled, cooked, and eaten, all of which Alan Yates films impassively. Alan finally attempts to leave, but the natives gang rape Faye and then behead her,

before turning on Alan himself. The last image we see is Alan's face, covered in blood. The Pan American executives are stunned and order the footage burned; Monroe leaves the screening room, musing on man's inhumanity to man.

Like the so-called video nasties that proliferated in the 1970s and '80s in Britain with the introduction of videotape for home use, *Cannibal Holocaust* and its ilk are depressing, degrading documents, inherently inhumane and senselessly cruel. What art and craft there is in these films relies, for the most part, on the ruthlessness of the filmmakers involved, who seek only to pander to the basest instincts of viewers for what seems to be considerable profit. *Cannibal Holocaust* is a film that is *literally* a document of "man's inhumanity to man." In short, the viewer of *Cannibal Holocaust* shares in the complicity of the enterprise by viewing the film; the end effect is one of sadness and desperation.

Low-budget auteur Abel Ferrara isn't strictly a horror director, but his brutal debut film, *The Driller Killer* (1979), in which Remo Miller, a mad artist (played by Ferrara himself), goes on a murderous rampage with a portable electric drill, certainly made viewers sit up and take notice. This was followed by *Ms. 45* (1981), in which a young woman, raped by two thugs, grabs a gun and starts killing every man in sight. *Fear City* (1984), with a larger budget and a "name" cast, including Melanie Griffith, Billy Dee Williams, and Rae Dawn Chong, takes place in a sleazy Manhattan strip club, where a mysterious killer murders the employees one by one.

By this time, Ferrara was attracting a good deal of industry attention. In 1993 he was given the job of directing a big-budget remake of Don Siegel's 1956 science-fiction classic *Invasion of the Body Snatchers*, known as *Body Snatchers*. But the film failed to click with audiences or critics, and Ferrara made only one more true horror film, the interesting *The Addiction* (1995), starring indie veteran Lili Taylor as Kathleen Conklin, a New York University graduate student who turns into a vampire after being attacked on the streets by a mysterious woman, Casanova (Annabella Sciorra). At her graduation ceremony, Kathleen initiates a blood-soaked orgy as she attacks her professors with maniacal glee. Since then, Ferrara has busied himself with a variety of crime and action thrillers, usually shot on modest budgets, but has left his roots as a splatter director behind.

In Italy during this period, the director Lucio Fulci was carving out an equally renegade reputation for himself with a series of strangely dreamlike, hyper-violent films that put one's teeth on edge and one's heart on trial. Born in Rome in 1927, Fulci was raised as a devout Catholic; after a brief period of medical training, he decided that he wanted to pursue a career in film. He also became an outspoken Marxist in his political leanings, which may go a long way to explain the chaotic and disruptive narratives contained within his films. A director since 1959, working in a variety of genres and under numerous names, including Louis Fuller, Lucille Folon, Louis Fulci, H. Simon Kittay, and Jerry Madison, Fulci found his true métier with such horror films as *Non si sevizia un paperino* (*Don't Torture a Duckling,* 1972), and hit his stride with the phantasmal horror films *Gli ultimi zombi* (*Zombi II,* 1979), *Paura nella città dei morti viventi* (*City of the Living Dead, The Gates of Hell,* 1980), *Il gatto nero* (*The Black Cat,* 1981), and *E tu vivrai nel terrore—L'aldilà* (*And You Will Live in Terror: The Beyond,* aka *The Beyond,* 1981), which many consider Fulci's masterpiece, as well as *Quella villa accanto al cimitero* (*The House by the Cemetery,* 1981), and *Lo squartatore di New York* (*The New York Ripper,* 1982).

37. A typically brutal scene from Lucio Fulci's *Zombi II*. Courtesy: Jerry Ohlinger Archive.

All of these films eschew traditional narrative logic for a sense of dread and unease, and at their most effective they constitute a catalogue of surrealistic events in which motivation, character, or even the boundaries of time and/or reason are suspended. In Fulci's films, a young blind woman's faithful guide dog can turn on its mistress without warning and tear out her throat; the dead can walk the streets with impunity, murdering the living; and graveyards are hardly locations of eternal rest. *The Beyond,* which was released in a censored U.S. version entitled *Seven Doors to Death* before Quentin Tarantino restored it to its original length in a superb reconstruction in 2000 through his company Rolling Thunder Films, is perhaps the best example of Fulci's complete disavowal of logic or justification in his films; things simply happen because they can, and do.

The Beyond's plot is simple. A young woman named Liza (Catriona MacCall) inherits a rundown New Orleans hotel, which just happens to have been built over one of the seven gateways to Hell. Aided by local physician John McCabe (David Warbeck), Liza is soon caught up in a wave of terrifying and inexplicable incidents, including a sequence in the hotel's basement in which Liza and John are attacked by ravenous zombies and a bizarre scene in a deserted nearby hospital in which the dead return to life. One of the film's most unsettling sequences takes place on a long strip of deserted highway, stretching out as far as the eye can see, as Liza's car is abruptly stopped by a young blind woman whose prophecies of doom are all too accurate.

For all the carnage in Fulci's films, the ultimate sensation is one of surreal unease; as the stylistic heir to Luis Buñuel, and a man who apprenticed himself with the classical filmmakers Max Ophuls and Marcel L'Herbier, Fulci is first and foremost a visual stylist, with an eye for arresting and disturbing psychic imagery. In the final moments of *The Beyond,* Liza and John are trapped in a landscape of eternal emptiness, suggesting as surely as any Antonioni film the utter alienation of modern life, or afterlife. As the camera pulls back, we see that they are frozen within the frame, locked in place forever, figures of hopeless determination in an indifferent world.

Fulci's *The Gates of Hell,* as another example, contains a nominal plot: a priest hangs himself, thus opening the gates of Hell both in the town of Dunwich (one of H. P. Lovecraft's favorite fictive locations, as

used in the author's *The Dunwich Horror*) and in New York City. Most of the film was shot in Italy, but for the international market, Fulci shot for a few days on one blocked-off street in Midtown Manhattan. Christopher George, as reporter Peter Bell, walks through his starring role with a notable absence of conviction; clearly, for the New York sequences, time was of the utmost essence. Yet none of this detracts from the film; once the gates of Hell have been opened, the film becomes a series of grisly murders, photographed in brilliant color and clinical detail.

The Black Cat, yet another film "inspired" by Poe's short story, is notable for one of the last performances of Patrick Magee. Visibly aging in his few linking sequences in the film, Magee nevertheless brings to his role an aura of genuine menace and authority, and serves as a suitable counterbalance to the rest of the film, which, in typical Fulci style, eschews narrative structure for a series of violent deaths. The film uses Poe's story as a jumping-off point for a bizarre mixture of Samuel Beckett's *Krapp's Last Tape* and large doses of Grand Guignol butchery, as the reclusive Professor Robert Miles (Magee) recounts to a tape recorder an endless succession of torments visited upon him through the agency of a malign and seemingly supernatural black feline. Shut up alone in a country house that no one visits, Miles has entombed himself in the manner of many of Poe's protagonists; he is already one of the living dead. Miles's reminiscences are intercut with a series of disconnected and violent interludes that have nothing to do with the exterior narrative of the piece; rather, they serve as further proof of the random nature of violence in everyday life.

Near the end of Fulci's film, the black cat knocks over a conveniently placed candle, thus starting a fire that both destroys the audiotapes and burns Miles to death in an excruciatingly graphic sequence that takes many minutes to unreel. The cat's penultimate act seems utterly random, as random as the scenes of disassociational violence that punctuate Miles's tortured memoir throughout the film. Thus, it matters little what circumstances have brought the victim's destruction. The very absence of motivation is Fulci's hallmark, a walking dream state from which the sleeper never awakes. Along with the better-known Dario Argento and Mario Bava, Fulci, who died in 1996, was one of Italian horror's elder statesmen. Ironically, his work is more popular now than ever, and it has become a major influence on contemporary European horror.

Horror also became a part of the human landscape during the late 1970s, '80s, and '90s, with psychopathic killers stalking the streets in search of victims. The figure of Hannibal Lecter, M.D., a brilliant psychiatrist who also happens to be a homicidal maniac and serial killer who feasts, literally, upon his victims, became one of the totemic icons of the era. First introduced in Thomas Harris's novel *Red Dragon,* Lecter was brought to the screen in 1986 by director Michael Mann in *Manhunter,* where he was portrayed by Brian Cox. However, the character of Hannibal Lecter did not fully penetrate the public consciousness until Jonathan Demme's 1991 film *Silence of the Lambs,* in which Lecter (Anthony Hopkins) goes toe-to-toe with FBI agent Clarice Starling (Jodie Foster), as she uses the now-imprisoned Lecter's uncanny insight into the criminal mind to catch another serial killer who is still at large. *Silence of the Lambs* touched such a chord with the public that it became one of the few horror films to win almost universal critical acclaim as well as success at the box office. In addition to winning Best Picture at the Academy Awards, the film garnered Best Actor for Hopkins, Best Actress for Foster, and Best Director for Demme. Ted Tally also won for his screenplay adapted from Harris's best-selling novel.

Although he was on-screen for fewer than seventeen minutes in the role of Hannibal Lecter, Hopkins made such an impact with audiences and critics that a sequel was all but inevitable. Ridley Scott's uneven *Hannibal* (2001) gives us Lecter on the loose in Florence, Italy, where he picks up his curiously symbiotic relationship with agent Starling (now portrayed by Julianne Moore). The film did acceptable business at the box office, but failed to ignite much excitement; and yet Lecter's character continued to fascinate auteurs, in addition to providing Hopkins with a nice paycheck for his services. Thus, Brett Ratner, a strictly commercial director of no distinction, was given the green light for *Red Dragon* (2002), with Hopkins again reprising his role in what was essentially a remake of *Manhunter,* the film that kicked off the entire series. Even with a cast that included Hopkins, Edward Norton, Ralph Fiennes, Emily Watson, Harvey Keitel, and Philip Seymour Hoffman, the film seems forced and flat, designed to wring a few more dollars out of a dying franchise.

Another horror franchise of distinctly less ambition during the late 1980s and early 1990s was the *Maniac Cop* series, in which a hulking,

uniformed New York City police officer stalks the streets of Manhattan, killing as many people as he possibly can with almost supernatural impunity. As the tagline for the film accurately noted, "You have the right to remain silent . . . forever." The first film, titled *Maniac Cop* (1988), was directed by William Lustig, who had raised critical and audience outcries in 1980 with his similarly themed *Maniac,* in which loner Frank Zito (character actor Joe Spinell) also roams the streets of New York City, killing and scalping women, and then using the scalps to decorate a series of mannequins in his apartment, each of whom Frank fashions in the image of his deceased mother. At the film's end, Frank imagines that the numerous mannequins have come to life and tear him limb from limb.

Maniac was so violent that it was released without a rating—which probably would have been an "X." Despite Tom Savini's expert special effects, the film was generally reviled by both audiences and critics. Shot quickly and cheaply, often without permits, the film nevertheless rapidly gained a cult following and, amazingly, inspired the song "Maniac," a sort of homage written by Dennis Matkosky and Michael Sembello. With new lyrics, the song became a hit in Adrian Lyne's 1983 musical *Flashdance,* which was emphatically not a horror film. Thus, with *Maniac Cop,* Lustig was revisiting familiar territory, and this time he kept the violence level in check, to the degree that the film got a mainstream release and led to the production of *Maniac Cop 2* (1990). This installment, directed by Lustig from a script by Larry Cohen, offered more of the same; the maniac cop, Matt Cordell (Robert Z'Dar), returns from the grave to kill policemen who have hampered his efforts at "crime control" in the past.

In 1993 Lustig and Joel Soisson co-directed *Maniac Cop II: Badge of Silence* ("the wrong arm of the law is back") from a script by Larry Cohen, in which Cordell returns from the grave once more to avenge a female colleague who is accused of brutality in a hostage situation. The film was perhaps the most violent of the series, with Cordell brutally murdering all who would oppose him, and initially earned an "NC-17" rating for violence before cuts reduced it to an "R." This sequel also aroused protests from real police officers for its depiction of a homicidal beat cop as a mute, brutal engine of mindless destruction. For the moment, it seems, we have heard and seen the last of Matt Cordell; no

new sequels have been announced, but, given the enduring fan base of the series, his fourth resurrection is always a possibility.

A much more inventive and nuanced horror franchise of the era is Ridley Scott's *Alien* (1979), one of the most influential and original horror/science-fiction films, even if the script owed a considerable debt to Edward L. Cahn's *It! The Terror from Beyond Space* (1958) and Mario Bava's aforementioned *Planet of the Vampires*. The film's plot is both simple and well known. A space ship, the *Nostromo*, guided by a malevolent computer (ironically known as "Mother") under the control of a ruthless hyper-conglomerate, sets down on a seemingly deserted planet in response to a distress signal.

Unbeknownst to all of the crew members except Science Officer Ash (Ian Holm), who is actually a robot, the real purpose of the *Nostromo*'s unscheduled side trip is to capture a specimen of an alien life form and return it to Earth, sacrificing the crew if necessary to do so. As Ash puts it, the Alien's "hostility is matched only by its structural perfection." The intruder rapidly proves to be inescapably lethal, eventually killing all of the crew members with the exception of Warrant Officer Ripley (Sigourney Weaver, in the role that made her a star).

Alien was initially given the go-ahead with a minimal budget of $4.2 million, which was doubled to $8.4 million when director Ridley Scott, fresh from his well-received feature debut *The Duellists* (1977), was signed to direct. Tellingly, Scott wanted to "up" the horror quotient in the script, hoping that the finished project would turn out to be *The Texas Chainsaw Massacre* of the genre. In the meantime, Swiss designer and artist H. R. Giger became attached to the project, and Scott immediately recognized that Giger's visualization of the Alien itself, as well as the desolate planet, the alien spaceship, and the "face hugger" and "chest burster," were perfect for the film's look.

Scott cast the film with an unusual group of actors, including Bolaji Badejo, a 7′2″ Nigerian non-actor as the Alien, and Veronica Cartwright, Harry Dean Stanton, Yaphet Kotto, and Tom Skerritt as the other crew members and officers of the *Nostromo*. Key to the film's conception was the run-down look of the *Nostromo*, described in the film's script as "a commercial towing vehicle," which seems to have seen much better days and is given to repeated equipment breakdowns.

So influential was this dystopic vision of the future that it became the template for nearly every "downbeat" science-fiction film that followed, as was the case with Peter Hyams's *Outland* (1981), a science-fiction thriller starring Sean Connery as a twenty-first-century space marshal who uncovers vast, corporate-sanctioned corruption on a distant mining planet, where the workers are fed massive doses of an amphetamine-like drug to keep them working at top speed. During production of *Outland,* the design office was plastered with signs stating flatly that "this film has got to look like *Alien,*" and even Ridley Scott's own *Blade Runner* (1982) capitalizes on this "future as non-functional Hell" concept in both design and execution.

Predictably, no fewer than five sequels to date followed *Alien,* each less interesting than the last. James Cameron's *Aliens* (1986), with Sigourney Weaver now trapped in the role of Ripley as surely as Bela Lugosi was forever typed as Dracula, was more of an action adventure film, loud, violent, and lacking in both subtlety and depth. David Fincher's *Alien 3* (1992) finds Ripley stranded on a prison planet with a group of violent sociopaths; in the most pessimistic variation of the original story line yet, she commits suicide at the end of the film in an attempt to thwart the Alien's continued existence. Jean-Pierre Jennet's *Alien Resurrection* (1997) offers a cloned Ripley, much as before, battling the Alien in an increasingly sadistic and violent production, whose only distinction is its pictorial inventiveness, not surprising from the director who would go on to make *Amélie* (*Le fabuleux destin d'Amélie Poulain,* 2002), a dazzlingly romantic tale of love and desire set in contemporary Paris.

In 2004 genre director Paul W. S. Anderson created the PG 13–rated *Alien vs. Predator* in an attempt to jump-start both the *Alien* franchise and the *Predator* series, first introduced in John McTiernan's 1987 film *Predator,* in which Arnold Schwarzenegger and a band of mercenaries face off against an invisible, lethal foe in the jungles of South America. (The first film was followed by Stephen Hopkins's *Predator 2* [1990], which transported the creature to modern-day Los Angeles.) From the start, Anderson aimed to increase audience share by designing the film for younger viewers. The film proved commercially if not artistically successful and led to the production of *Aliens vs. Predator: Requiem* (2007), directed by the brothers Colin and Greg Strause, which seemed

to bring both series to a rather cataclysmic end. Despite all these dispir-
iting sequels, the first *Alien* film remains one of the finest horror/
science-fiction films of the era and a touchstone for many other films
that followed in its wake.

In France, the maverick director Jean Rollin was pursuing a signifi-
cantly less lavish series of films, yet ones that have continued to capture
the imagination of horror aficionados around the world. Working with
minuscule budgets, Rollin was nevertheless able to give his erotic vam-
pire films the illusion of higher production values by shooting on loca-
tion at ruined castles, actual graveyards, decaying houses, and the like,
and by using intriguing camera set-ups to enhance the visual allure.

Rollin's most notorious film is undeniably *Le viol du vampire* (*The
Rape of the Vampire*, aka *Queen of the Vampires* in the United States, 1968),
which engaged a cast of his friends, including a psychiatrist, in a violent
and bloody vampire tale with copious doses of nudity. Shot for about
$20,000, with nearly half of the script improvised on the spot, the orig-
inal film was only forty-five minutes long and thus not suitable for com-
mercial feature-length distribution on its own. The producer, one
Samuel Selsky, reasonably suggested that Rollin shoot another forty-five
minutes to solve the problem, but there was one catch: the film's entire
cast had been "killed off" by the end of the film. Rollin's solution was
both ingenious and simple; the vampires are revived by a river of blood
and carry on as before.

The initial screening of *Le viol du vampire* was highlighted by an
audience riot, in the best French cinematic tradition, as viewers reacted
strongly to the film's often inchoate mixture of sex and violence. The
near absence of plot or character motivation resulted in a film that can
most accurately be described as a series of dreamlike images that have no
external (or even internal) logic, much like the work of Lucio Fulci in
Italy a decade or so later. The reviews were uniformly negative, but the
reaction was so intense that the film was a surprise sensation and almost
immediately made back its meager investment.

Rollin, who as a youth had been steeped in surrealism and the
bizarre (Georges Bataille, the controversial author of the scandalous
novel *Histoire de l'oeil* [*The Story of an Eye*], was a close family friend),
began making films in 1958 at the age of twenty while also working as
an assistant director, script writer, and set runner. In 1962 he found

employment as the first assistant director of Jean-Marc Thibault's *Un cheval pour deux* (*A Horse for Two,* 1962), which Rollin later described as being an unpleasant experience.

Desperately wanting to make his own films, Rollin began shooting *L'itinéraire marin* (*The Sailor's Journey*) in 1963 with the legendary actor Gaston Modot—famous for his roles in Jean Renoir's *La règle du jeu* (*The Rules of the Game,* 1939) and Luis Buñuel's *L'âge d'or* (*The Age of Gold,* 1930)—from a script by Marguerite Duras and René-Jacques Chauffard, but Modot's sudden death brought an end to the project. Rollin kept busy with a variety of jobs for hire, including work as a sound editor for Actualités Françaises, a French newsreel company. Rollin eventually met Samuel Selsky through a mutual acquaintance, and the two men hit it off. *Le viol du vampire,* amazingly enough, was originally conceived as the companion feature for the French theatrical release of Sam Newfield's 1943 *Dead Men Walk,* but in its final ninety-minute form, the film went out on its own, and the resulting tumult typed Rollin forever as a director of erotic horror.

Capitalizing on this early success, Rollin rapidly began creating equally idiosyncratic, surreal, and free-form exercises in supernatural eroticism, including *La vampire nue* (*The Nude Vampire,* 1969), *Le frisson des vampires* (*Sex and the Vampires,* 1970), *Requiem pour un vampire* (released in the United States as *Caged Virgins,* aka *Crazed Virgins,* 1972), *Les démoniaques* (*Demoniacs,* 1974), and numerous other films, all shot quickly and efficiently, and almost all ignored in America.

As the horror franchises raged through the late 1970s and into the present, a number of "one-off" horror films also commanded the public's attention, perhaps none more spectacularly so than William Friedkin's *The Exorcist* (1972). The plot, as with all straightforward horror films, is simplicity itself; a young girl, Regan (Linda Blair), is possessed by Satan, and an exorcism is required to remove the malign presence. Scripted by William Peter Blatty from his best-selling novel, the film soon becomes a catalogue of outrageous gore effects: the young girl masturbates with a crucifix, her head spins around in a circle while vomiting green bile, and her bed levitates from the floor in a suddenly ice-cold room as the demon-possessed child violently curses all those who would oppose her (using the uncredited voice of actress Mercedes McCambridge as that of the Devil).

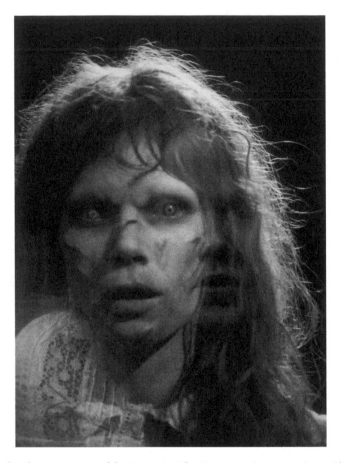

38. Linda Blair is possessed by Satan in *The Exorcist*. Courtesy: Jerry Ohlinger
Archive.

The Exorcist is that rare horror film that, for once, was taken seriously
by the industry and critics. Nominated for ten Academy Awards, includ-
ing Linda Blair as Best Supporting Actress, Ellen Burstyn as Best Actress,
and Jason Miller as Best Supporting Actor, along with Best Art Direction
and even Best Picture—a rare accolade for a horror film—*The Exorcist*
was enormously successful and controversial. It reignited public debate
not only about the genre, but also about the nature of good and evil.
Naturally, it inspired a host of inferior imitations. To date, three "offi-
cial" sequels have been made: *The Exorcist II* (1977), an incomprehensi-
ble mess directed by the otherwise talented John Boorman; *Exorcist III*

(1990), which gave author William Peter Blatty a shot at interpreting his own work in a decidedly less sensationalistic manner; and *Exorcist: The Beginning* (2004), a failed attempt to restart the series. The last was begun by writer/director Paul Schrader but eventually handed off by the studio to the effects-driven Renny Harlin, who did little with the material other than use it as a springboard for a dizzying variety of computer-generated special effects.

Tobe Hooper's disturbingly realistic horror film *The Texas Chainsaw Massacre,* made in 1974, was mentioned briefly in chapter 3. That film also saw a plethora of sequels, including Hooper's *The Texas Chainsaw Massacre 2* (1986), which was far more explicitly violent than the original, albeit with an almost comic edge. Jeff Burr's *Leatherface: The Texas Chainsaw Massacre III* (1990) was an equally uninspired sequel, and Kim Henkel's *Texas Chainsaw Massacre: The Next Generation* (1994) is an almost shot-for-shot remake of the original, notable only for the presence of Renée Zellweger and Matthew McConaughey in the film's leading roles, long before they were stars.

Tobe Hooper himself emerged as something of a *cinéaste maudit* as his career unfolded. Despite the success of his debut film, Hooper soon found himself working for Roger Corman's New World Pictures on the micro-budgeted *Eaten Alive* (1976), a distinct step down for the young director, in which a deranged hotel owner (Neville Brand) kills off his "guests" in assembly-line fashion, including Mel Ferrer, Carolyn Jones (late of television's *Addams Family* series), and Stuart Whitman. The film went through a variety of title changes, including *Starlight Slaughter, Death Trap,* and *Horror Hotel Massacre,* and did nothing for Hooper's fledgling career.

In 1981 Universal gave Hooper a chance to direct *The Funhouse,* another film plagued by production problems and a distinctly threadbare premise; a deformed killer in a Frankenstein mask stalks a carnival funhouse, routinely murdering all those who cross his path. Shot in Florida at the Ivan Tors studios (home of *Flipper*), the film was a critical and commercial failure. In 1982 Steven Spielberg hired Hooper to direct his first really big-budget film, *Poltergeist,* but the two directors clashed over the film's tone and style. Hooper, not surprisingly, wanted a darker film, while Spielberg, also not surprisingly, wanted a more audience-friendly "thrill ride" of a film. Hooper retains sole directorial credit, but the film

was essentially taken away from him and re-edited and partially reshot by Spielberg. Although the film was a commercial success, Hooper's own career failed to advance.

In 1985 Hooper finally got a major budget and complete creative control on *Lifeforce,* a space vampire film shot in England, based on Colin Wilson's intriguing novel *The Space Vampires.* But despite an excellent cast, including Steve Railsback, Peter Firth, and Patrick Stewart (before his *Star Trek* days), the film's structure was so bizarre that most viewers didn't know how to respond to it. Traveling in space, astronaut Railsback encounters a colony of extraterrestrial vampires; when one of their number (a nude, seductive female vampire) is transported back to Earth, she unleashes an outbreak of "energy vampirism," in which the "lifeforce" is literally sucked out of the victim's bodies, leaving them dried-up hunks of bone and gristle. A Fulciesque end-of-days scenario follows, in which London is attacked by a wave of zombies as the space vampires attempt to suck the Earth dry of all its mortal energy.

Lavish, crazed, and having almost nothing to do with Wilson's novel, *Lifeforce* was a critical anomaly and led to Hooper's 1986 remake of William Cameron Menzies's 1953 science-fiction horror classic *Invaders from Mars,* which was equally idiosyncratic. Despite a massive promotional campaign, it failed to impress audiences or critics.

Hooper's last film of consequence, oddly enough, is *The Mangler* (1995), based on a Stephen King short story. Set in a commercial laundry, *The Mangler* is a fascinating meditation on class, power, and the mechanics of fate, as the laundry's massive "mangler," which prepares wash for cleaning and folding, assumes a life of its own and begins attacking and consuming the laundry's hapless employees, who clearly work in a Hell on Earth. *Nightmare on Elm Street* star Robert Englund offers a memorable performance as the callous, overbearing supervisor of the laundry, but the film rapidly vanished from theaters. Once again, Hooper was cut adrift. At present, his future as a director, aside from television work, seems uncertain. In 2003 Hooper remade Dennis Donnelly's *The Toolbox Murders* with surprising panache, but his output since then has been minimal.

Brian de Palma's *Carrie* (1976), with a young Sissy Spacek, is perhaps the ultimate story of high school revenge. Carrie White (Spacek) is tormented by teen bullies Christ (Nancy Allen) and Billy Nolan (John

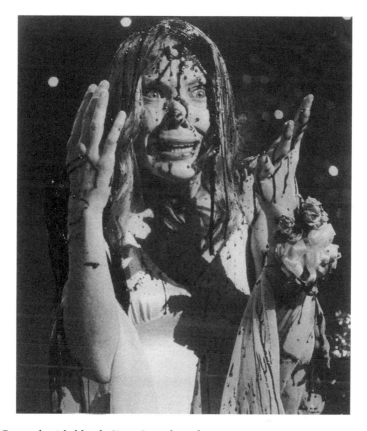

39. Covered with blood, Sissy Spacek seeks revenge in *Carrie*. Courtesy: Jerry Ohlinger Archive.

Travolta), until she exacts violent, telekinetic retribution at the high school prom, neatly photographed in split screen by the relentlessly violent director, with copious amounts of blood and gore. The film is now considered a classic of the genre and brought instant stardom to Spacek, who has arguably never had a better role for her considerable talents.

If nothing else, Richard Donner's production of *The Omen* (1976) further refined the popular concept of the demon child as fantasy figure. *The Omen* was also by far the most violently graphic of these films and merged extreme depictions of human mutilation with the image of the child as Satan. Thus Damien Thorn (Harvey Stephens) serves as the "deus ex" for a series of horrifying murders. *The Omen* has the distinction of being one of the first films from a major studio that has no plot

except unremitting violence, with a violent murder punctuating every ten minutes of the film's running time.

Damien is responsible for a decapitation, a hanging, an impalement, and a fatal fall down a flight of stairs; in between these incidents, Damien is called upon to do nothing more than exist within the terms of the film's narrative. Damien's mere physical presence serves as an instantly comprehensible symbol of destruction. Indeed, Damien is so young he cannot even speak, and he relies upon all of his victims to do the acting for him, which they do, each dedicating his or her demise ("Damien, it's all for you") to his implied satisfaction.

The adults in the film seem impotent or singularly unaware of what Damien is up to. Mrs. Baylock (Billie Whitelaw), as Damien's satanic nanny, protects the child with the aid of two large attack dogs. Only the film's fringe characters, particularly Jennings (David Warner), an eccentric photographer, and Bugenhagen (an uncredited Leo McKern), a monk locked away in a monastery in the hills of northern Italy, are allowed to fight back against the child. Damien's adoptive mother Katherine (Lee Remick) is toppled from a balcony of their home when Damien bumps into her with his tricycle, and she falls several floors to her near death. Recuperating in a hospital after the accident, she inexplicably jumps from a window into the street below, conveniently plunging through the roof of a waiting ambulance.

Along with the vicious intensity of its vivid, lip-smacking depictions of horrific violence, the film ends in a way that is at once cynically commercial (ensuring the production of the two sequels that would follow) and triumphantly despairing. In many ways, *The Omen* represents the supreme elevation of the "child as monster"; although subsequent episodes of the *Omen* series and other similar films strove to top the graphic effects of the original, none of them lived up to the impact of the first film. The meaningless death of Damien's adoptive father (Gregory Peck) at the end effectively underscores the complete inability of the adult world to control Damien; doctors, priests, psychiatrists, teachers, parents—all are useless and impotent. The certainty of their destruction (as the film assumes its true structure, that of a string of grisly murders) makes one impatient with any attempt at characterization.

As always, sequels inevitably followed, starting with Don Taylor's *Damien: Omen II* (1978), with an aging William Holden cast as the boy's

new foster father; more mayhem ensues. Graham Baker's *The Final Conflict: Omen III* (1982) finds Damien grown up (portrayed by Sam Neill) and preparing to enter his first foster father's profession as ambassador to England. A group of renegade monks tries to stop Damien's machinations, but as with the first sequel, the film rapidly devolves into a predictable series of grisly killings. A television movie followed; Jorge Montesi and Dominique Othenin-Grand's *Omen IV: The Awakening* (1991) featured a female Antichrist, but few cared. John Moore's big-budget 2006 remake with Liev Schreiber and Julia Stiles, an attempt to reboot the series from the ground up, also failed to attract much audience interest and garnered generally negative reviews.

George Romero, in the meantime, had turned his obsession with zombies into a lucrative franchise of his own. In *Dawn of the Dead* (1978) brain-dead zombies stalk their victims in a shopping mall, a comment on American consumer culture. *Day of the Dead* (1985) finds the zombies given military training (!) in an attempt to make them productive members of society. The most recent entry is *Land of the Dead* (2005). In 2004 Zack Snyder, director of *300* (2008) and *Watchmen* (2009), remade Romero's *Dawn of the Dead* in an effective if routine fashion. Romero has also made other genre films that depart from his recurrent zombie motif; most notable are the multipart *Creepshow* (1982), based on 1950s horror comics and scripted by Stephen King, who also acts in the film, and *Martin* (1977), a decidedly offbeat vampire film in which a disturbed young man stuck in a dying rustbelt town turns to vampirism as a respite from his mundane existence and his zealously religious family.

David Cronenberg, another 1970s horror auteur, kicked off his career by taking advantage of Canadian tax laws, which offered significant subsidies to Canadian nationals (Cronenberg was born in Toronto in 1943) who shot their films in Canada, in an attempt to jump-start the nation's film industry, which then, as now, largely relies on "runaway" Hollywood productions for its livelihood. After making several experimental features entirely by himself, including *Stereo* (1969) and *Crimes of the Future* (1970), Cronenberg made his commercial debut with *Shivers* (aka *The Parasite Murders* and *They Came from Within,* 1975), a violent and disturbing film about a venereal parasite that takes over its victims; it eerily prefigures the then-nascent AIDS epidemic. Cronenberg directed and wrote the film, as he did with nearly all of his subsequent work.

Rabid (1977) starred the late porn actress Marilyn Chambers as a young woman who survives a near-fatal motorcycle accident and is the subject of an experimental skin graft. As in *Shivers,* the experiment leads to the creation of a feeding tube that sucks the blood from her numerous lovers. *The Brood* (1979) featured Hammer horror icon Oliver Reed as Dr. Hal Raglan, a crazed psychologist whose "therapy" consists of convincing his patients to create physical manifestations of their inner rage; most notably, a female patient, played by Samantha Eggar, channels her hate into the spontaneous creation of a group of killer "children" who prey on her relatives.

Scanners (1981) was the idiosyncratic director's breakthrough hit, starring the maverick actor Patrick McGoohan as a medical researcher whose research activities center on a group of physical anomalies known as scanners, which have telekinetic powers that enable them to control the actions of others, erase their memories, or, most spectacularly, cause their heads to explode in a burst of blood and brain tissue. Some scanners use their powers for the benefit of mankind, but a renegade group, led by Darryl Revok (the reliably villainous Michael Ironside) seeks to control the scanner community to the detriment of society. McGoohan glides through his role with his customary authority, as does Ironside; but what makes the film remarkable are Dick Smith's astonishing prosthetic effects, which were so graphically violent that some scenes were excised in numerous countries, as well as in early television re-cuts of the film.

Videodrome (1983) was even more ambitious and benefited from another interesting choice of leading man, the actor James Woods. The film deals with the addictive power of television pornography in a series of disturbingly graphic effects revolving around a pirate "snuff" satellite station; when viewed, the programs cause brain tumors and other unpleasant side effects in audiences. Cronenberg's other effort that year, *The Dead Zone* (1983), based on Stephen King's novel, was a competent but routine project for the director, though with a memorably creepy Christopher Walken perfectly cast as a societal outsider who can unwillingly foretell the future.

In 1986 Cronenberg followed *The Dead Zone* with a very loose remake of Kurt Neumann's *The Fly* (1958), starring Jeff Goldblum as a scientist obsessed with teleportation, with tragic and unintended consequences. The film proved to be Cronenberg's major commercial hit to

date and gave him the freedom to pursue *Dead Ringers* (1988), a tale of twin gynecologists who become obsessed with their work and addicted to a rainbow of mild-altering drugs in the process; eventually, the brothers (both played by Jeremy Irons, in an astonishing performance) commit suicide as the result of a drug overdose. The film was based on an actual case in New York City in the late 1970s, which led to the startling *New York Daily News* headline, "Find Twin Docs Dead in Posh Pad." Perhaps this lurid tabloid coverage brought the subject to Cronenberg's attention.

In 1991 Cronenberg tackled an adaptation of William F. Burroughs's *Naked Lunch*, which didn't really come off, but he redeemed himself with the quirky, death-obsessed *Crash* (1996), based on a novel by J. G. Ballard, which centers on a group of sensation-seeking outsiders who restage infamous automotive accidents (the death of actor James Dean, for example) for frolic entertainment. *EXistenZ* (1999) is a consideration of the uneasy interplay between video game play and reality, and *A History of Violence* (2005) is a tightly knit crime thriller with copious amounts of violence and a good deal of knowing self-referentiality.

Cronenberg's more recent work is outside the horror genre, but he remains inextricably identified with the "splatter" film and recognized for his predilection for, in his words, "show[ing] the unshowable, and speak[ing] the unspeakable." Of all the auteurs discussed in this volume, Cronenberg is at once the most accessible and yet the most mysterious; his films fulfill genre requirements and yet inhabit a psychic terrain that is uniquely their own. Cronenberg also played the leading role of a psychotic serial killer in director/writer Clive Barker's *Nightbreed* (1990) and has had cameos in other horror films, including *Jason X* in the *Friday the 13th* series.

Dario Argento, who was both a colleague and a competitor of Lucio Fulci until Fulci's death in 1996, began his career as a film critic and publicist. A friendship with director Bernardo Bertolucci led to his work on the script of Sergio Leone's epic *C'era una volta il West* (*Once Upon a Time in the West*) in 1968 and, from there, to his first feature as a director, the stylish and carefully structured slasher thriller *L'uccello dalle piume di cristallo* (*The Bird with the Crystal Plumage,* 1970). Although it owes an enormous pictorial and thematic debt to the work of Mario Bava, the

film displayed an originality of vision and execution that almost instantly won Argento a cult following.

More violent thrillers followed, such as *4 mosche di velluto grigio* (*Four Flies on Grey Velvet,* 1971) and *Profondo rosso* (*Deep Red,* 1975). His landmark film is *Suspiria* (1977), in which ballerina Suzy Banyon (Jessica Harper) arrives at the Tanz Akademie in Black Forest country seeking instruction, but soon finds herself involved in a maelstrom of murder and violence orchestrated by headmistress Madame Blanc (1940s noir icon Joan Bennett, in one of her last roles). One by one, the school's students are murdered in a procession of unspeakably violent set pieces, as Argento upped the horror quotient from the first reel onward, teasing his audiences with a mixture of dread and expectation.

The film set a standard for graphic violence and stylish use of color design and set décor for a new generation of filmmakers and profoundly influenced such then-budding cineastes as John Carpenter, Wes Craven, and George Romero. Abandoning his thriller reputation as "the Italian Hitchcock," Argento plunged headlong into a world of death and brutality in his subsequent films, *Inferno* (1980), *Tenebrae* (1982), *Phenomena* (1985), and *Opera* (1987), many of them paced to the hard rock beat of the Goblins, a band that Argento discovered and then used to score much of his work. In the late 1970s, Argento turned his attention to producing, working with George Romero on *Dawn of the Dead* and with Lamberto Bava, Mario Bava's son, on *Demons 2: The Nightmare Returns* (1986).

One person, oddly enough, with whom Argento refused to work was Lucio Fulci, who, perhaps out of jealousy or sheer spite, openly criticized Argento's work. Certainly, Fulci was well known for his irascible temperament both on and off the set, and perhaps Fulci was upset, too, that Argento's work routinely received widespread critical acclaim, while his own work was relegated to the margins of cinematic discourse. The two men finally agreed to collaborate on *Maschera di cera* (*The Wax Mask*) toward the end of Fulci's life, but the joint project collapsed with Fulci's death; the film was eventually released in 1997, directed by Sergio Stivaletti. Argento keeps busy working in television to the present day, even producing a game show in 1987. As a stylist and a pioneer, Argento is one of the major figures of Italian horror in the 1970s and '80s.

Other directors, writers, and actors made significant contributions to 1970s and '80s horror films. Clive Barker, better known as an author of horror fiction, directed *Hellraiser* (1987) from his own novella *The Hellbound Heart*. Larry (Andrew Robinson) and Julia (Clare Higgins), a young couple, move into the family home, unaware that in the attic lurks Larry's brother Frank, with whom Julia has been having an affair; Frank now exists in a semi-living state of non-existence, having returned from the dead to feed on the blood of the living. Complicating matters further is the existence of a puzzle box that literally opens the gates of Hell, so that a race of Cenobites, sadistic demons who exist solely to inflict pain, can invade the world of the living. Brutal and uncompromisingly downbeat, *Hellraiser* introduced the world to the memorable figure of Pin-Head (Doug Bradley), a Cenobite whose head is festooned with hammered-in nails and who functions as a sort of satanic ringmaster for the grim proceedings.

In the climactic sequence of *Hellraiser,* the body of the male protagonist is literally shredded to pieces before the viewer's eyes by a multitude of minute grappling hooks deeply anchored in the flesh of the victim. The victim's last words, "Jesus wept," signify Barker's thematic link to the fragmented and crucified body of Christ. And there will inevitably be resurrection, after a fashion. Barker, as director/scenarist of *Hellraiser,* is on to something here. Central to the conceit of the film is the puzzle box—the "torture box"—that contains all the pain and suffering imaginable in this, or any, world.

Freed from the confines of the box, the denizens of Barker's netherworld inflict torture for the sake of torture, as they themselves (particularly in their heads) are the victims of constant pain. Barker's torture box represents the closed confines of the torture chamber, the body sealed inside itself during the act of torture, the bond forged between torturer and victim, the black box of the movie camera, the passive box of a flatscreen television. In numerous sequences in *Hellraiser* we are presented with scenes in which the body, unable to support further pain, collapses against itself, imploding in a maelstrom of violence. For Barker, life itself is torture, from which even death is not a release.

The inevitable sequels followed: Tony Randel's *Hellbound: Hellraiser II* (1988), Anthony Hickox's *Hellraiser III: Hell on Earth* (1992), and the unsigned *Hellraiser: Bloodline* (1996; although partially directed by Kevin

Yagher, it's credited to the infamously pseudonymous *nom de désastre* Alan Smithee). The last one pretty much killed off the theatrical series. But no fewer than *four* direct-to-DVD sequels followed, making *Hellraiser* one of the more prolific horror franchises of the 1980s, even if only the first film has any real distinction or originality.

Kathryn Bigelow's *Near Dark* (1987), on the other hand, compellingly chronicles the vagrant existence of Caleb Colton (Adrian Pasdar), who is taken in by a group of country-western vampires who roam the Southwest in a customized trailer in search of liquid sustenance. Though the vampire group is nominally headed by the rapacious Jess Hooker (Lance Henrikson), the gleefully sadistic Severen (Bill Paxton), and the coldly calculating Diamondback (Jenette Goldstein), there are schisms within the group, most notably configured within the character of Mae (Jenny Wright), who "adopts" Caleb and sponsors him to the reluctant members of the "family."

Of all the characters in the film, it is Mae who is arguably the most fully realized; she feeds Caleb her own blood when he is afraid to make his first "kill" and thus initiate himself into the group of vampire outlaws, and she fights for his possession as a totemic love object over the strenuous dissent of Jesse and Diamondback. Caleb soon finds himself falling under Mae's spell and reluctantly joins the marauding group in their continued search for blood. Perhaps the film's most remarkable set piece is a ritual slaughter in a bar, as the vampires overpower the astonished locals and kill them one by one, drinking their blood in order to survive.

Near Dark, as its director notes, is a generic hybrid, a "vampire western"; it enabled Bigelow, in her words, "to invest the genre [of the horror film] with new material, seeing where the edges of the envelope are." What has particularly disturbed a number of critics in all of Bigelow's work is, paradoxically, her brilliance as an action director, especially her choreographed scenes of unremitting and inexorable violence. When the vampire group attacks the drunken rednecks in an isolated tavern late at night, effortlessly slaughtering patrons and employees alike, Bigelow treats the entire episode as some sort of monstrous game, which is, of course, exactly what it is: the dance of death between the predator and victim.

Stanley Kubrick's *The Shining* (1980) is perhaps the most effective adaptation of Stephen King's work to the screen, though King initially

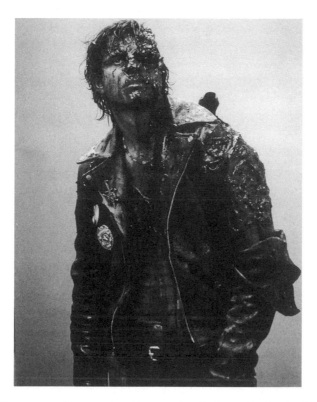

40. Bill Paxton as the vampire Severen in Kathryn Bigelow's *Near Dark*.
Courtesy: Jerry Ohlinger Archive.

professed to dislike it intensely. Blocked writer Jack Terrance (Jack Nicholson) moves his wife, Wendy (Shelley Duvall), and son, Danny (Danny Lloyd), to a deserted hotel in the Colorado Rockies to take up the job of winter caretaker. Like many of King's protagonists, young Danny has a gift, a "shining," which allows him to tap into the hotel's violent past, as well as his father's incipient descent into madness. As the deserted hotel takes hold of the family, Jack descends into complete madness, typing out the simple phrase "All work and no play makes Jack a dull boy" over and over again instead of working on his proposed novel. He finally turns on his wife and son with an ax, while Danny has visions of two young girls—murder victims from the hotel's violent past—in pools of blood, redolent of the best of Grand Guignol.

King's script, which Kubrick rejected and then rewrote with Diane Johnson over King's objections, stressed that the hotel itself was a cursed

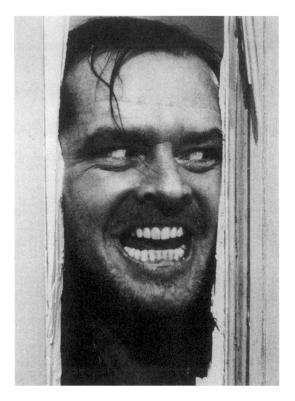

41. Jack Nicholson runs amok in Stanley Kubrick's *The Shining*. Courtesy: Jerry Ohlinger Archive.

location, a much more conventional trope than Kubrick's isolation-leads-to-insanity conceit, which served as the film's ultimate narrative structure. King was annoyed, complaining in an interview at the time that "Kubrick knew exactly where all the scares should go and where all the pay-offs should come. It seems as though he simply said, 'This is too easy. I'm not going to do it this way.' So he didn't, and what he got was very little."

But that's precisely the point. Kubrick, who worked in a variety of genres, had one overarching theme in all his films: "the mind breaks down." Consider General Jack D. Ripper in *Dr. Strangelove* (1964), Hal, the computer in *2001: A Space Odyssey* (1968), and Alex, the head Droog in Kubrick's adaptation of Anthony Burgess's *A Clockwork Orange* (1971). The director was after more than stock "pay-offs" and "scares" in his version of *The Shining*, which is, of course, what makes the film so

effective and what separates it, in its thoughtfulness and relative restraint, from many of the more explicit 1980s horror films.

Another individualistic talent is Sam Raimi, who has carved a career for himself in Hollywood that is the envy of many of his peers. He has also forged an original vision in horror films as a producer, director, and entrepreneur. Raimi was movie-mad from childhood, idolized the Three Stooges, and spent much of his youth making Super 8mm films. After college at Michigan State University, he returned to the film industry as his life's work. In 1978, at the age of nineteen, he made a short horror film entitled *Within the Woods*; in 1982 Raimi expanded it into the feature-length film *The Evil Dead,* which ultimately took the 1983 Cannes Film Festival by storm.

The plot of *The Evil Dead* is simple. Five teens gather at an old cabin in the woods of Tennessee for a three-day binge of sex and drugs; while there, they discover a copy of the Necronomicon (H. P. Lovecraft's fictional bible of black magic and witchcraft) and, by the simple act of reading the cursed text, bring down a reign of demons intent on destroying them all. What distinguishes *The Evil Dead* from its competition is Raimi's twisted sense of humor and his aggressive use of visuals in telling his story. Above all, Raimi is a master of comic-book composition, and his work pops off the screen with energy and vitality, highlighted by unusual camera set-ups and a restlessly moving pictorial style, jolted by lightning-fast tracking shots.

Shot for $500,000, *The Evil Dead* became an instant classic of the genre, and Raimi smoothly moved into a niche as a triple threat within the industry, directing *Evil Dead 2: Dead by Dawn* (1987), essentially a big-budget remake of the original film; *Darkman* (1990), a comic book–inspired revenge thriller; *Army of Darkness* (1992), yet another riff on the *Evil Dead* theme; and the quirky western *The Quick and the Dead,* starring the unlikely team of Sharon Stone and Leonardo DiCaprio, with the ever-reliable Gene Hackman as the film's over-the-top villain.

Raimi has since moved into the big leagues with his direction of *Spider-Man* (2002) and *Spider-Man 2* (2004), guiding both films to impressive box-office success with his customary aplomb and stylistic assurance. Raimi has also appeared as an actor in small roles in a number of films, in order to get a better feel of what it's like to be in front of the camera. More recently, with his producing partner Robert Tapert, he

produced the American remake of Takashi Shimizu's *The Grudge* (2004) as part of a slate of productions from his company Ghost House Pictures.

What is most striking about Raimi is his versatility. Though not a horror buff by nature, but drawn to it because of economics and a definite career goal, he has also turned his skills to television (producing the teleseries *Hercules: The Legendary Journeys* from 1995 to 1999 and *Xena: Warrior Princess* from 1995 to 2001) and to writing scenarios for others, most notably *The Hudsucker Proxy* (1994) for Joel and Ethan Coen, which Raimi co-scripted and also acted in. What will happen next for Raimi seems a matter of conjecture; he could follow one of many paths, seemingly with equal success. For the moment, he seems focused on his Ghost House Pictures production slate, specializing in remakes of recent genre classics and contemporary Japanese horror films (known as "J-Horror films" to their fans) for American audiences, as he did with *The Grudge.*

John Landis, better known as a comedy director, created *An American Werewolf in London* in 1981, with spectacular special effects by Rick Baker. The film, along with Joe Dante's *The Howling* (1981), with special effects by Rob Bottin, redefined the werewolf genre, taking it from the relatively humanoid vision of Universal in the 1940s and moving it decisively into the prosthetic 1980s. In Landis's film, a young American abroad is bitten by a werewolf and thus becomes one himself (to the tune of the Marcels' "Blue Moon"); in Dante's effort, a plucky news anchor infiltrates a pack of werewolves only to become infected herself. Both films had superior production values, and both had a slightly parodic edge. Dante's *Howling,* in particular, used the names of such classic horror directors as Charles Barton and George Waggner for many of its characters and prominently displayed "smiley face" stickers on walls, filing cabinets, and other props during the attack sequences.

Both films, of course, had sequels. In the case of Landis's film, there was an execrable "Euro-pudding" directed by Anthony Waller entitled *An American Werewolf in Paris* (1997). *The Howling* inspired a veritable wave of dubious knockoffs, including Philippe Mora's comedy *Howling II: Your Sister Is a Werewolf* (1985) and Mora's *Howling III* (1987). The latter, a more straightforward approach to the material at hand, added an interesting twist; the film, which was shot in Australia, features a female werewolf who nurses her young in a kangaroo-like pouch. Veteran

director John Hough's *Howling IV: The Original Nightmare* (1988) is a distinct comedown, however; shot on the cheap in South Africa, the film is set in an isolated cabin, where a young woman must fight off an invasion of werewolves. *Howling V: The Rebirth* (1989), directed by Neal Sundstrom, is an even more peculiar project, in which visitors to an old castle are murdered one by one by a werewolf who is, in reality, one of them.

Howling VI—The Freaks (1991), directed by Hope Perello, is perhaps the oddest and most arresting film of the entire group. Ian (Brendan Hughes), a werewolf drifter, floats into a small desert town at the same time that a circus arrives under the direction of the delicious R. B. Harker (Bruce Payne) and sets up for business—only in this case, the circus features human "monstrosities" rather than the more conventional lions, tigers, and/or bears. Soon the drifter and the monsters are locked in a battle for the town's soul. Harker sees a quick profit in exhibiting Ian as a "genuine werewolf" along with the rest of his circus freaks, but Ian has secrets of his own that eventually bring matters to a head.

Complicating the plot further is the fact that Harker, who sleeps in a coffin on a bed of his native soil, is a genuine vampire, although he is never specifically designated as one. In his vampiric state, Harker (the name itself is a reference to Jonathan Harker, one of the central characters in Bram Stoker's novel *Dracula*) becomes a monstrous thing, looking somewhat like Max Schreck in Murnau's 1922 *Nosferatu,* but in his humanoid state he exudes nothing but charm to the townspeople. All in all, *Howling VI* presents an interesting series of premises and a neatly original entry in the long-running series.

Stephanie Rothman, director of the horror films *Blood Bath* (1966) and *The Velvet Vampire* (1971), as well as *It's a Bikini World* (1967) and *Terminal Island* (1979), initiated the first wave of feminist horror films in the 1960s. The first woman to win the Director's Guild of America Fellowship while studying at the University of Southern California in the 1960s, Rothman started out doing second-unit work for AIP and rapidly drifted into Roger Corman's orbit, where she was recognized as a skillful and talented filmmaker. Rothman's first horror film, *Blood Bath,* a vampire slasher film, had a decidedly compromised genesis; she was brought into the project halfway through shooting. The finished film has a phantasmal, uncertain air about it (not surprisingly, given the

production circumstances), but Rothman demonstrated that she could take over a project in difficulty and bring in *something* usable, and so, for a time, her career prospered. But as the 1960s turned into the '70s, Rothman failed to obtain the opportunities she deserved. After directing the exploitational *The Student Nurses* (1970) for Corman's New World Pictures, Rothman split with Corman to found Dimension Pictures with her husband, Charles Swartz, where she directed *The Velvet Vampire*. Still, by the end of the 1970s she was both bored and frustrated by the severe limitations forced on her by typical Hollywood practice.

The Velvet Vampire, in particular, is intriguing because Diane Le Fanu (Celeste Yarnall), the film's vampiric protagonist, seems utterly unconcerned about her unusual feeding habits and is never haunted by conscience or any moral reservations—she's a vampire, and this is her life. In one scene, a mugger tries to attack Diane, assuming that she will be an easy target; Diane quickly turns the tables on him, subdues him, and kills him for food. Thus Rothman's Diane is in control of her vampiric destiny, in direct contrast to such earlier films with female vampires, particularly *Dracula's Daughter,* in which Gloria Holden's Countess Zaleska reluctantly drains the blood of *other* young women as her victims in order to survive in a life of perpetual torment.

In contrast, Diane Le Fanu's energetic and highly eroticized destruction of her victims in *The Velvet Vampire* transfigures previous incarnations of the movie vampire. Indeed, the film's promotional materials promised a linkage of sexual passion and vampiric destruction with the tag line, "See climax after climax of terror and desire!" which the film neatly fulfills. Diane Le Fanu is thus one of the few representations of a contemporary vampire to be created by a woman, and this aggressive reconstitutive figuration of vampiric desire remains one of the most intriguing role reversals in the horror genre.

Perhaps the most problematic genre of the postmodern horror film practice is the "slasher" film. Amy Jones's *Slumber Party Massacre* (1982), scripted by Rita Mae Brown, author of the novel *The Rubyfruit Jungle,* is an interesting variation on this prolific subgenre. For years, it had been argued that slasher films inherently went against the grain of anything that could conceivably be labeled feminist film practice. Brown and Jones set out to change all that. The killer in *Slumber Party Massacre* is

introduced precisely because he is to be resisted and destroyed, and that's exactly what the film's protagonists do.

Certainly the killer's violent end is richly deserved within the context of the film. *Slumber Party Massacre* takes the tropes of the slasher film and transforms them into a vision of feminist retribution and reconstitution. Although it would be naïve to suggest that the film was produced for these reasons, Brown and Jones nevertheless pulled off one of the most subversive acts in postmodern cinema history: they took a mainstream cinema genre and persuasively redefined it, transforming the conventional victims of the genre into self-reliant individuals who decisively take matters into their own hands, without application to any external authority for help. At seventy-seven minutes, the film is simple, brutal, and effective, demonstrating that women can control the conventions of the slasher genre as effectively as men—and perhaps with even more assurance.

Another horror auteur whose work has redefined the genre is Stuart Gordon, most famous for *Reanimator* (1985), his grisly retelling of H. P. Lovecraft's serial *Herbert West: Reanimator*. A surprise critical hit, even garnering a long and favorable reception from film critic Pauline Kael in *The New Yorker, Reanimator* was followed by the even more violent *From Beyond* (1986), which was also ostensibly based on Lovecraft's writings. Because of their intense violence and graphic special effects, both films have been either hailed or reviled. Set at the Medical College of Miskatonic University, *Reanimator* is dominated by the performance of Jeffrey Combs as Herbert West, a brash young medical student who is obsessed with the notion of returning the dead to life. This isn't exactly new territory, but Gordon's fascination with the flesh-and-bone mechanics of the process raises the film above the level of a *Frankenstein* retread into an area distinctly its own.

Reanimator, no matter what else one might say about it, is a film that stands entirely alone: there is nothing quite like it, which perhaps accounts for a good deal of the film's success. In essence, it represents a genre hot-wiring feat of considerable proportions: it is part horror film, part gore film, part black comedy, and part love story. All these elements are pushed past the boundaries of parody into a zone of hyper-realism (aided by the unsparing graphic visuals) that sweeps the viewer along with the narrative into a unique and disturbing world that is Gordon's and Lovecraft's alone.

One of the more memorable scenes in the film involves West's attempts to subdue one of a number of unruly revived corpses. When one colleague's efforts fail, West dryly pushes the man aside with a mild "excuse me" and plunges a whirring surgical saw into the entrails of the corpse, cutting a neat hole directly through the body's midsection. Combs's detached performance as West is directly complemented by the more theatrical work of Barbara Crampton as Megan Halsey and Robert Sampson as Dean Halsey, whom West reanimates from the dead with disastrous results.

More recently, H. P. Lovecraft's work has served as the basis of *The Resurrected* (1992, from Lovecraft's novella *The Case of Charles Dexter Ward*). Directed by Dan O'Bannon, the film stars John Terry, Jane Sibbett, Chris Sarandon, and Robert Romanus. Another odd but effective film is *The Call of Cthulhu* (2007), based on Lovecraft's story of the same name. Made on a shoestring budget by Andrew H. Leman, *The Call of Cthulhu* is almost an experimental work, a silent black-and-white film that is styled after the films of the 1920s. Nevertheless, Leman and his mostly nonprofessional cast remained faithful to the original story, and *The Call of Cthulhu* may very well be the most accurate representation of Lovecraft on film.

Another film that forces us to consider the "break" between real and cinematic horror is Tom Holland's clever *Fright Night* (1985), in which a young boy, Charley Brewster (William Ragsdale), a horror film buff, believes that his next door neighbor, Jerry Dandrige (Chris Sarandon), is a real vampire and not just a filmic one. Furthermore, he's right. Dandrige *is* indeed one of the undead. Naturally, no one will believe him, except for television horror host Peter Vincent (Roddy McDowall), who reluctantly is pressed into service to kill the undead marauder. Holland's direction skillfully navigates the boundaries between the real and the phantasmal, and Sarandon's performance is a model of malevolent charm underscored by the threat of general violence, which occurs in the film's final scenes.

The film takes its title from the fictional Peter Vincent's show, *Fright Night*. Vincent, like the classic television horror hosts of the 1950s through the 1980s, offers a running and often tongue-in-cheek appraisal of the films he screens for his viewers each week. "Welcome to Fright Night!" he portentously intones at the start of each episode. But in his

final showdown with Dandrige, what had been mythology takes on a terrifyingly real aspect. Cornered in Dandrige's suitably Gothic house, Vincent looks on in shock as the vampire appropriates his greeting with a slight revision, "Welcome to Fright Night . . . for real," before launching an all-out attack on his would-be adversaries. Vincent, who is also a frustrated actor, is well acquainted with vampire lore, or so he thinks, and feels apprehensive yet confident during his final confrontation with Jerry Dandrige. Unfortunately, much of what he "knows" turns out to be worthless myth, and it is only at a terrific cost that Vincent ultimately triumphs in a film that balances on the knife's edge between comedy and serious horror.

Holland wrote and directed the original film. Predictably, there was a sequel, for which only McDowall and Ragsdale returned. The unimaginatively entitled *Fright Night Part 2* was directed by *Halloween*'s former production designer, Tommy Lee Wallace, in 1989. Sadly, but perhaps inevitably, the film was only a shadow of its predecessor, and the series ended (for the moment, at least) with only two films.

George Sluizer created one of the most memorable horror films of the 1980s in *Spoorloos* (*The Vanishing,* 1988), a Dutch film in which a young woman, Saskia (Johanna ter Steege), is kidnapped at a roadside rest stop by a mysterious stranger, Bernard-Pierre Donnadieu (Raymond Lemorre), who promises several years later to reveal to her distraught boyfriend, Rex (Gene Berroets), his beloved's whereabouts, but only if Rex will drink a drugged cup of coffee. The young man drinks the coffee, falls into a drugged stupor, and wakes up to find himself buried alive in a tightly sealed coffin. On this distressing note, the film ends.

Shot for a mere $165,000 on actual locations throughout the Netherlands, the film was a critical and commercial success, so much so that Sluizer had the opportunity to direct an American remake of the film under the same title in 1993, with a cast that included Kiefer Sutherland as Jeff, the young man, Sandra Bullock as his girlfriend, Diane, and Jeff Bridges as Barney Crusins, the warped kidnapper. Though a nearly shot-for-shot remake, the new film came with a completely inappropriate "happy" ending. After Jeff wakes up buried alive, the point at which the original film ended, Jeff's new girlfriend, Rita (Nancy Trans), intervenes at the last possible moment to free Jeff from his would-be grave, whereupon Jeff beats Barney to death with the same

shovel that Barney used to bury Diane. Jeff and Rita then reaffirm their love, and, after viewing Diane's grave, Jeff decides to continue with his life and his relationship with Rita. The new ending outraged both critics and aficionados of the first film. The 1993 version grossed a mere $14.5 million at the box office, a sure sign of both critical and commercial failure. Perhaps as a consequence, Sluizer's career in Hollywood never recovered.

Brian de Palma's stylish horror film *Dressed to Kill* (1980) conflated sex, violence, and transvestitism in a brutally vicious thriller starring the underused Angie Dickinson as Kate Miller, a bored housewife who seeks momentary satisfaction in an afternoon tryst with an anonymous stranger she meets at the Metropolitan Museum of Art. After they have sex, the man falls asleep, and Kate, curious to know more about him, goes through his papers and discovers that he has been diagnosed with a venereal disease. Kate flees, but forgets her wedding ring; returning to retrieve it, she is slashed to death in the building's elevator by a mysterious blond woman. Thus, as in *Psycho,* someone who we assume will be a major character in the film is, in fact, summarily slaughtered in the opening scenes.

The balance of *Dressed to Kill* is a complex tale of betrayal, insanity, and intrigue, with Michael Caine in the flashy role of Dr. Robert Elliott, aka Bobbi, his mysterious transvestite alter ego, who emerges whenever Elliott is sexually aroused. The film provoked a good deal of controversy and indignation on the part of many gay and lesbian groups, with some justification, as de Palma's film is clearly an updated version of both *Psycho* and *Homicidal,* but with a much deeper degree of misogyny. Nevertheless, with bravura performances by Dickinson, Caine, Nancy Allen, and Keith Gordon, accompanied by Pino Donaggio's propulsive score, the film was a major hit at the box office, indeed, a *succès du scandale.*

One of the last major franchises of the decade was the *Child's Play* series, directed by Tom Holland, the man responsible for the far superior *Fright Night. Child's Play* (1988) introduced the malevolent character Chucky, a child's doll possessed of the soul of the deceased murderous Charles Ray Lee (Brad Dourif) and capable of all kinds of homicidal mischief. The first film was so successful that it almost immediately gave birth to a series of sequels, beginning with John Lafia's *Child's Play 2*

42. Chucky, the murderous doll, in *Bride of Chucky*. Courtesy: Jerry Ohlinger Archive.

(1990), in which Chucky continues his murderous rampage, Jack Bender's *Child's Play 3* (1991), offering more of the same, and Ronny Yu's *Bride of Chucky* (1988), marketed under the tagline "Chucky gets lucky!" In the latter, the homicidal doll gets a mate, voiced by Jennifer Tilly, and continues on his rampage of violence and mayhem.

In the majority of commercial horror films of the 1970s, '80s, and '90s, most of the women and men exist only to be destroyed; they are situations rather than characters. One might well argue that they never "existed" at all, so little do we care for them. As the level of graphic specificity continues to rise in the horror film, it is not so much the text of the film that matters, but rather the certainty of fleshly mutilation, torture, dismemberment, violent death, and cruelty. Suspense and mood have, for the most part, been dispensed with. The transgressions

upon the flesh, upon the victims under torture are what mesmerize audiences.

It is not enough to suggest these actions; they must be shown in clinical detail. This new requirement of specificity is an integral part of the horror film. It seems we've grown jaded, and simply put, the contemporary horror film must "horrify" the spectator. The old legends of Dracula, Frankenstein, the Wolf Man, and the Mummy no longer suffice, no longer hold audiences enthralled. Horror films have always operated on the margins of cinematic discourse, trafficking in precisely those images and situations we seek to avoid in our actual existence. Contemporary horror films are a safe ticket to a dangerous zone, a zone of uncertainty and imminent danger.

No longer are these dark visions primarily a public commodity, unspooled in a dark room filled with strangers (the conventional movie theater). Now these visions are played out in the sphere of domestic commerce, on home televisions and computers, using DVD, on-demand downloads, video games, and Web links. In the 1980s, with prosthetic special effects, it was thought that the limits of graphic representation had been reached, as displayed in such films as *The Howling* and John Carpenter's remake of *The Thing*. Current developments in digital effects demonstrate what should have been obvious all along: this was just another plateau to be transcended. With digital imaging, films are now made out of nothing at all, just keystrokes entered into computers to create a world of endless unreality.

With the current wave of ultra-violent video games, we enter an entirely new area of one-on-one participation, in which we can become either victim or tormentor, role-playing our way to a complete disavowal of our physical existence. When "playing" these "games," we become solely the sum of our basest impulses. Violently graphic horror films teach us to embrace the destruction of the flesh in this age of AIDS as an inevitable ritual to be sought out and incorporated into our consciousness.

Contemporary horror films, then, proceed on the assumption that violence, degradation, and ritual torture are inescapable facets of contemporary existence; whether we seek them or not, the agencies of destruction will find us and inflict lingering damage upon our persons with perverse delight. The destruction of the body in the horror films of

the twenty-first century is the act that cleanses the body of disease, removes it from the realm of death through erasure, and inscribes the sign of mutilation upon the flesh, in the manner of Christ, as an agency of figurative redemption, or at least surcease from suffering, the death to be longed for.

The fantasy of torture, the torture of the flesh and of the mind through the flesh, inscribes the body and psyche of the torturer upon the victim and creates a fantasy of corporeal reintegration in which that which is born separate becomes momentarily transmogrified into an artificial whole. When we talk about torture, when we speak of the victims of the rack, the pendulum that slices into bound flesh, those who are walled up within tombs while yet alive, we invoke the flesh that bears witness to this mortification, the cry of the body in pain.

CHAPTER 5

The Future

1990–PRESENT

WHILE THE FRANCHISES of the 1970s through the turn of the twenty-first century continued unabated, a number of factors combined to make horror films in the new millennium more imaginative, more original, and more accessible to a wide range of audiences. First, the rise of the DVD market made theatrical distribution merely the first step in a long chain of ancillary "play-off" possibilities, opening up other markets to distribution, as well as pay-per-view, cable, satellite, and computer downloads of both contemporary and classic titles.

Second, digital production techniques placed the tools of creating a horror film within the range of practically anyone who could afford to rent a minimal crew for a week's shoot, much as in the days of the French New Wave in the late 1950s and early 1960s. A good camera operator using a digital high-definition video camera, a sound person, and a lighting supervisor were all that a would-be director needed; and with non-linear editing equipment, assembling the finished film was a snap. Many newer films, such as John Erick Dowdle's *Quarantine* (2008) and Matt Reeves's *Cloverfield* (2008), incorporated this rough, handheld, homemade look into the thematic structures of their narratives, making faux documentaries of violent, compelling power.

Additionally, international boundaries began to crumble as European and Asian horror films flooded the market, bringing with them a new wave of auteurs enthusiastically dedicated to the genre. Japanese horror films ("J-Horror" for short) and Korean horror films ("K-Horror") became prolific subgenres as well as fertile ground for American remakes. And although many of the horror films in the first decade of the century dealt with violent and brutal imagery, a sharply rising number of features

were more subdued in their approach, offering thoughtful, psychological horror stories.

Indeed, the explosion of horror in the new century—partially linked, I would argue, to the international spiritual angst brought about by the worldwide threat of nuclear terrorism, the tragic events of 9/11, and increasing political tensions among nations—mirrored the general sense of insecurity felt by much of the world's populace, feelings that were only exacerbated by the economic crash of 2008. Thus, we have a wide range of films to consider here, reflecting differing approaches, thematic concerns, and social values.

In France, François Ozon began a career of unsettling narratives with his hourlong *See the Sea* (1997), in which a young mother, Sasha (Sasha Hails), left alone by her husband, takes in a malevolent vagabond, Tatiana (Marina de Van), who soon takes control of Sasha's household. In the film's terrifying dénouement, she kills Sasha, leaves her trussed up like a Christmas goose, and abducts her infant child for herself. When Sasha's husband returns from his business trip, all he finds is Sasha's corpse and a series of questions that, for him, will never be answered.

Ozon specializes in this sort of domestic menace; everything seems calm on the surface, but killing tensions lurk just underneath. Ozon, who is openly gay, often features gay, lesbian, bisexual, and/or transgendered characters, as in his film *Les amants criminels* (*Criminal Lovers,* 1999), in which the gay male protagonist, unwilling to declare his sexual orientation publicly, finally snaps and kills the man who is the object of his obsession. In *Swimming Pool* (2003), Charlotte Rampling and Ludivine Sagnier engage in a contest of wills with more than an overtone of sexual desire between them. Rampling portrays Sarah Morton, a mystery author with a string of bestsellers to her credit; now, however, she is having trouble getting started on the latest installment. Her publisher, John Bosload (Charles Dance), offers Sarah the use of his home in the French countryside to get her creative juices flowing, but soon her idyll is interrupted by the appearance of Julie (Sagnier), who claims to be Bosload's daughter. Julie sleeps with anyone who strikes her fancy, engaging in a series of one-night stands that at first annoy, but ultimately intrigue Sarah.

As with all of Ozon's films, matters take a dark turn when a local lothario, Franck (Jean-Marie Lamour), shows up and seems to be more

interested in Sarah than Julie. As the sexual tensions between the two women increase, Franck disappears. At length, Julie admits that she has killed him and hidden the body in a garden shed. Sarah inexplicably decides to help Julie cover up the crime, and the two women bury Franck's body. In the film's dénouement, Sarah visits her publisher with her finished manuscript, entitled *Swimming Pool,* and meets Bosload's real daughter, who is named Julia. Julia takes no notice of Sarah, and the audience is left to wonder, "Did Julie ever exist? Or is Julia real?" Or is *Swimming Pool,* the movie, as some have surmised, entirely fiction? As the film's poster notes, "On the surface, all is calm," but just beneath that placid exterior, Ozon creates a world where fantasy and reality intertwine without demarcation, and the viewer is left to fend for her/himself.

Dominik Moll is another French director of recent vintage. His *Harry, un ami qui vous veut du bien (With a Friend Like Harry,* aka *Harry, He's Here to Help,* 2000) is even more menacing, as a typical bourgeois couple, Michel (Laurent Lucas) and Claire (Mathilde Seigner), accidentally runs into Harry (Sergi López), a high school friend of Michel's, and Harry's saturnine girlfriend Plum (Sophie Guillemin). Harry rapidly insinuates himself into the couple's life with violent and comic results; indeed, it seems as if Harry will stop at nothing to make sure that Michel's interests are protected. Alternately funny and deadly serious, *With a Friend Like Harry* demonstrates, if nothing else, that you can bring horror home with you in the most unexpected fashion, through a long lost "friend" met by chance. As the film's original French-language poster asks, "Vous avez un problème? Harry a la solution" ("Do you have a problem? Harry has the solution")—although in Harry's case, the "solutions" are often unexpectedly drastic.

With a Friend Like Harry was just a dog run for Moll's 2005 *Lemming,* an exceedingly sinister domestic drama in which another young bourgeois couple, Alain (Laurent Lucas) and Benedicte (Charlotte Gainsbourg), invites Alan's employer Richard (André Dussollier) and his skittish, unpredictable wife, Alice (Charlotte Rampling), over for a formal dinner. Things soon go awry, and the night becomes an unendurable exercise in tension and paranoia, with a violent suicide just the opening act in a psychological twist thriller that takes a very dark view of the institutions of marriage and family life.

Cédric Kahn's road trip thriller *Feux rouges* (*Red Lights,* 2004) is a more directly violent horror film, yet again with a domestic touch. Antoine (Jean-Pierre Darroussin) and Hélène (Carole Bouquet) Duran are a married couple embarking on a road trip to pick up their children and start a vacation. But Antoine is a closet drinker and is already hammered when he takes the wheel, and the two soon fall into a violent argument. At length, when Antoine disappears into a particularly dangerous roadside dive for yet more alcohol, Hélène abandons him and starts to walk to the local train station, determined to catch the train to meet her children with or without Antoine's help.

But Antoine has picked the wrong bar, and Hélène has been unwise to go off on her own late at night. An escaped convict (Vincent Deniard, never named in the film) is drinking in the bar, and in a drunken stupor Antoine offers him a ride, childishly identifying with the escapee's outlaw status until matters turn unpredictably violent for both Antoine and Hélène. Adapted from a novel by French thriller master Georges Simenon, which was originally set in America, Kahn's update places the film squarely in the present, making the horror of the couple's interrupted journey all the more immediate and threatening. Scored to the haunting strains of Claude Debussy's "Nuages," *Red Lights* is harrowing and unforgettable.

Virginie Despentes and Coralie Trinh Thi's *Baise moi* (*Fuck Me,* aka *Rape Me,* 2000) became a sensation because of its unprecedented level of violence and sexuality. Two young bisexual women, Nadine (Karen Lancaume) and Manu (Raffaëla Anderson), go on a seemingly endless killing spree against society (men and women included) after being brutally gang-raped in a deserted garage. Shot on digital video for a cinema verité feel, *Baise moi* succeeds, despite all odds, as both a social document and a work of art. Our sympathies are entirely with the two young women, and their murderous rampage seems almost justified by society's alternately disinterested and dismissive attitude toward women as subjects of violence.

Equally disturbing is Claire Denis's *Trouble Every Day* (2001), in which two "vampires" (although the word is never used) go on a homicidal rampage in a bizarre, almost plotless scenario that proceeds with a certain awful, deliberate grace. Léo (Alex Descas) is a doctor whose wife, Coré (Béatrice Dalle), picks up a truck driver near the start of the film;

when Léo comes to search for her, the driver is a mutilated, blood-drained corpse, and Coré is drenched in his blood. The film cuts to June (Tricia Vessey) and Shane (Vincent Gallo) on board an airplane en route to Paris for their honeymoon. Visiting the plane's bathroom, Shane imagines that he sees June similarly covered in blood, with a strange look of satisfaction on her face. As the film unfolds, we discover that Léo and Shane were once researchers working together on an unspecified project and that Coré is somehow infected with a vampiric impulse.

As the film progresses, Coré murders two young teenagers whom she entices into her boarded-up room at the house she shares with Léo; after the slaughter, she sets the house on fire. Léo returns to find the house a smoldering ruin and Coré dead in the charred remains. Shane, in the meantime, seduces a young chambermaid, Christelle (Florence Loiret-Caille), who works in the hotel where Shane and June are staying, but the sex act rapidly turns into homicidal mania, as Shane, performing cunnilingus on her, literally eats her alive, leaving behind her bloody corpse in the staff locker room. Soon after, Shane tells June that he's tired of Paris and wants to return to the United States; on this unresolved note, the film ends.

Denis, an uncompromising feminist filmmaker who had previously scored unanimous critical successes with her anticolonialist film *Chocolat* (1988) and the homosexually charged military drama *Beau travail* (*Good Work,* 1999), is here moving into new and deeply contentious territory. As in much of contemporary French horror, sexuality, contagion, and the threat of transmitted sexual diseases, to name just a few of the many possible concerns raised by *Trouble Every Day,* are Denis's main preoccupations. As in her earlier, but equally disturbing *J'ai pas sommeil* (*I Can't Sleep,* 1994), Denis is intent on exploring our shared sexual identity and the manner in which it can define us at its most extreme.

I Can't Sleep is based on the real-life story of one Thierry Paulin, a young, gay, HIV-positive black man who murdered nineteen elderly women in Paris in the 1980s for their money; apprehended, Paulin died in prison before he could be tried for his crimes. Again, this is deeply problematic source material, but Denis, as always, is dedicated to going against the grain of popular sensibilities. In the film Paulin becomes Camille (Richard Courcet), a gay, black, HIV-positive drag cabaret performer who is also a murderer and whose lover, Raphael (Vincent

Dupont), tags along for the killings. But Denis does not concentrate on the murders; rather, she focuses on Camille's outsider status within Parisian society as a whole. What comes across most forcefully is a sense of weariness, isolation, despair, and loneliness. Denis's films court controversy with a clear and direct gaze; these are our fears, she states. What are you going to do about them? Perhaps, as in *Trouble Every Day,* by far the more violent and disturbing film, no answer is possible. We are all locked in our bodies in an age of fear and desire, and for Denis, sexuality and/or death are our only forms of release.

Xavier Gens is another member of what has been recently categorized as the "New French Extremist" filmmakers. His film *Frontière(s)* (*Frontier[s],* 2007) is a nail-biting exercise in brutality that follows a criminal gang on the run after a botched robbery. They hide out in a rundown hotel owned by a neo-Nazi family, but, of course, that's only the beginning. The hotel owners are in fact cannibals who torture and mutilate the gang members with excruciating deliberation.

Other recent French horror films include David Moreau and Xavier Palud's *Ils* (*Them,* 2006), in which a young couple living in a remote location is terrorized by a group of pre-teens, who eventually murder them after a prolonged cat-and-mouse chase through the nearby forest. When the children are asked at the end of the film precisely what motivated the slaughter, the youngest replies evenly, "They wouldn't play with us." At a mere seventy-seven minutes in running time, with much of its violence suggested, *Them* is a far more restrained film than *Frontier(s),* but undercuts its tension by falsely claiming to be based on a real-life incident, which, apparently, is a complete fabrication.

Equally unsettling is the work of "French Extremist" Gaspar Noë, whose film *Irréversible* (*Irreversible,* 2002) is perhaps his most notorious work. Told in reverse, *Irreversible* shows in graphic detail the rape of Alex (Monica Bellucci) by a criminal known only as "Le Teura" ("The Tapeworm"; Jo Prestia) and follows the attempts of her lover, Marcus (Vincent Cassel), to avenge the crime. Tracking down the man he thinks is Le Teura at an S&M nightclub called The Rectum, Marcus bludgeons him to death. But he got the *wrong man,* though Marcus and his friend Pierre (Albert Dupontel) will never find this out.

All of these events are presented in reverse chronological order. The film starts with two men talking in a small apartment, until their

attention is directed to a fight in The Rectum; Marcus and Pierre are being arrested by the police. This leads back to Alex's rape, and then to an earlier drunken party, and then to Alex and Marcus in bed after sex, and finally to a scene of Alex reading in a park. The camera backs off, rapidly spinning, until we glimpse the faint outlines of a galaxy. There is more, but this is enough. One of the most repellent films discussed in this volume, *Irreversible* has been alternately championed and reviled, but to this observer, it seems empty, nihilistic, and cheaply sensational.

In Sweden, director Tomas Alfredson created a quiet and gently disturbing horror story with *Lät den ratte komma in* (*Let the Right One In,* 2008), in which a young vampire girl, Eli (Lina Leandersson), strikes up a relationship with Oskar (Kåre Hedebraut), a lonely, bullied boy in a small town outside of Stockholm in the early 1950s. Eli lives with an older man, Håkam (Per Ragnar), who is also a vampire. Though Eli and Oskar at first avoid each other, they are gradually drawn together by the unbearable loneliness of their shared condition.

When Håkam, who has been regularly killing the neighbors for their blood, is caught in the act, Eli is left alone, with Oskar as her only friend. After a series of attacks, Eli, too, is discovered, but Oskar, now aware of Eli's vampiric nature but still fiercely protective of her, prevents a neighbor, Lacke (Peter Carlberg), from killing Eli as she sleeps. Alerted by Oskar's intervention, Eli pounces on Lacke, draining him of all his blood.

With the authorities closing in, Eli and Oskar make plans to escape their dreary, wintry life, but not before Oskar has one last run-in with the local bullies, who try to drown him in a swimming pool. Eli comes to his rescue, slaughtering the lot of them, and the film ends with Oskar traveling to a warmer climate on a railway train, alone in a compartment. At his feet, however, is a coffin in which Eli sleeps, soundly and safely. Soon, we surmise, they will take up residence in another town, perhaps with a greater degree of personal anonymity. Director Alfredson's tone throughout the film is a perfect mixture of quotidian boredom (winter in Sweden), slapstick comedy (some of Håkan's clumsiest murders are played for laughs; it's hard work being a vampire), and genuine menace (Eli is a force to be reckoned with, despite her diminutive stature).

Contemporary Russian horror films have been few and far between, but the recent *Nochnoy dozor* (*Night Watch,* 2004) and *Dnevnoy dozor*

(*Day Watch,* 2006), both directed by the gifted Russian-Kazakh film-maker Timur Bekmambetov, chronicle the uneasy tension between the forces of good and evil in an epic battle for the soul of Earth. Based on novels by Russian author Sergei Lukyanenko, the story is reminiscent of J.R.R. Tolkien's *Lord of the Rings* trilogy, but with a decidedly darker edge. In the world of these films, the Light and Dark Others are engaged in constant warfare, with Earth as their battleground.

With a kinetic editorial sense that recalls the work of master film-maker Sergei Eisenstein and a somber, brooding sensibility redolent of the work of the gifted Andrei Tarkovsky, especially in his historical drama *Andrey Rublyov* (*Andrei Rublev,* 1969) or his metaphysical science-fiction thriller *Solyaris* (*Solaris,* 1972), Bekmambetov plays with space and time like a master filmmaker, providing us with epic scenes of battle, as well as intimate sequences of deep emotional power. The first two completed sections of this trilogy, now being given wide distribution in the West, mark the arrival of a major new talent in Russian cinema, an assured and confident stylist who is also a keen observer of the human condition and the eternal struggle between the forces of destruction and regeneration.

In Spain, *The Others* (Alejandro Amenábar, 2001) took a similarly restrained approach to a classic ghost story. Based in part on Henry James's novella *The Turn of the Screw* (which had served as the basis for Jack Clayton's 1961 film, *The Innocents*), the film has Nicole Kidman and Christopher Eccleston toplining an excellent cast. It was shot in Spain with dialogue in English, and yet the completed film received eight Goya Awards (the Spanish equivalent of the Academy Awards), including Best Picture of the year and Best Director.

Kidman plays Grace Stewart, a lonely widow left with her two children and some servants in a large, rambling house in the British Isles at the end of World War II. Her children are hyper-sensitive to sunlight, and so Grace keeps the windows of the mansion covered at all times to protect them. Waiting for the return of her husband, Charles (Eccleston), Grace alternates between optimism and despair until, while walking in the woods one day, she sees Charles in the midst of a dense fog, somehow having returned from the front.

Grace is ecstatic and ushers Charles back to the house, but her husband seems abstracted and remote, for reasons Grace can't fathom.

43. Nicole Kidman in Alejandro Amenábar's *The Others*. Courtesy: Dimension Films/Jerry Ohlinger Archive.

His homecoming is short-lived; soon he vanishes again, telling Grace he has to return to the war, and Grace seems more desolate than ever. During all of this time, she is aware of "others" in the house, who manifest their presence by playing the piano, slamming doors, and engaging in bits of conversation. Convinced that the house is haunted, Grace makes every attempt to exorcise the spirits, until, in the film's twist ending, she realizes that *she* is the spirit haunting the house, along with her two dead children. The "others" are the new tenants, who are understandably perturbed to find that it is possessed by spirits.

Amenábar's sensitive, low-key direction, coupled with Kidman's ethereal performance and Javier Aguirresarobe's atmospheric cinematography, combine to make *The Others* one of the most intelligent and restrained ghost stories in recent memory. Shot on a minimal budget of $17 million, with Kidman's participation limited to several weeks of filming, *The Others* was an instant hit, grossing more than $200 million in worldwide rentals in theaters alone. Surprisingly, Dimension Pictures, usually the purveyor of low-budget graphic horror, was the distributor of this film. *The Others* demonstrated convincingly (as if any further proof was needed) that a carefully wrought and intelligently staged tale

of the supernatural can succeed without the level of gore most contemporary audiences have come to expect.

Juan Antonio Bayona's Spanish film *El orfanto* (*The Orphanage*, 2007) is equally measured in its approach to horror, as it weaves the tale of Laura (Belén Rueda), who returns to the orphanage where she spent her youth, now with her husband, Carlos (Fernando Cayo), and their adopted son, Simón (Roger Princep). Carlos hopes to fix up the dilapidated, rambling grounds as an orphanage for a new generation of children, but their son soon acquires a disturbing companion in the mysterious figure of Tomás, a young boy who wears a mask as he walks through the hallways and rooms of the building and its surrounding acreage. Then, without warning, Simón disappears.

Desperate, Carlos and Laura bring in Aurora (Geraldine Chaplin), a medium, to help them discover Simón's whereabouts. The mystery of his abrupt vanishing act is ultimately solved, but only by confronting the ghosts of the orphanage's past, at a terrible cost to Laura and Carlos. Like *The Others*, *The Orphanage* is more of a mood piece than anything else, and it takes the time to develop a properly sinister atmosphere without pandering to the audience. With dialogue in Spanish and without an international star, *The Orphanage* nevertheless won seven Goya Awards and was given an art house release in North America to considerable critical acclaim.

Predictably, an American remake is in the works, something that director Bayona views with a decidedly jaundiced edge, noting that "the Americans have all the money in the world but can't do anything, while we can do whatever we want but don't have the money . . . [Hollywood] doesn't take chances, [so] that's why they make remakes of movies that were already big hits." Guillermo del Toro, who helped first-time director Bayona get *The Orphanage* off the ground, has been given the role of producer for the American remake, but as of yet, nothing has appeared, which is perhaps just as well.

Edgar Wright's *Shaun of the Dead* (2004) is another matter altogether. Shaun (Simon Pegg), a salesman stuck in a boring job, is unhappy with his life, his stepfather Philip (Bill Nighy), his miserable roommate Pete (Peter Serafinowicz), and his prospects for the future. As a result of his utter self-absorption, Shaun misses an "anniversary" date with his long-suffering girlfriend Liz (Kate Ashfield), who promptly tells Shaun that she's through with him and walks out of his life.

44. Simon Pegg has to fight off a ravenous mob of zombies in *Shaun of the Dead*.
Courtesy: Jerry Ohlinger Archive.

That night, at the local pub with his other roommate Ed (Nick
Frost), Shaun resolves to put his life in order and achieve something of
substance—but too late. For no apparent reason, as in all of the films dis-
cussed here, zombies descend upon London, feeding on the living to
sustain their undead existence. In one of the film's most famous set
pieces, Shaun walks out of his flat in the morning to the local deli for a
morning snack, yet fails to notice that everyone around him is a raven-
ous, drooling zombie; as in George Romero's zombie films (the title

Shaun of the Dead is an obvious play on Romero's *Dawn of the Dead*), "normal" citizens are such mindless drones that it's hard to tell the dead from the living.

The film climaxes, predictably, with an all-out assault on the living by wave after wave of zombies. As they attack the Winchester pub, Shaun's favorite watering hole, Shaun and his friends try to fend them off, with mixed success. Only the intervention of the army saves Shaun and his remaining friends from certain destruction. Flash forward six months. The zombie plague has abated, but many zombies remain "alive"; they have been domesticated and are being used as unskilled laborers and in other menial positions. Shaun and Liz reconcile, and life goes on seemingly as before.

The film's script, written by Simon Pegg and director Edgar Wright, grew out of the satirical British television series *Spaced,* which Wright directed and Pegg co-produced, wrote, and starred in. After making one episode together entitled "Art," which dealt with a video game addict, Tim (Pegg), fighting off imaginary zombies while playing the video game *Resident Evil* during an amphetamine binge, the two men decided that the concept was promising enough to serve as the premise for a full-length feature, and *Shaun of the Dead* was born. Shot for the astoundingly low figure of $4 million on only a few locations (in the best low-budget tradition) and further enlivened by a nest of cameos from contemporary rustic comedians, *Shaun of the Dead* was a significant commercial and critical success, even though the one-joke premise eventually wears a bit thin.

The Mexican filmmaker Guillermo del Toro came late to the cinema, making his first short film, *Boner* (1986), at the relatively advanced age of twenty-one. Since then, he has more than made up for lost time with an impressive range of projects as producer and/or director, including *Mimic* (1997), *The Devil's Backbone* (2001), *Blade 2* (2002), *Hellboy* (2004), and his most successful film to date, *Pan's Labyrinth* (2006), all of which are disturbing, obsessive films that dwell on the dark side of human existence. His most recent film as director is *Hellboy 2: The Golden Army* (2008). In addition, he has served as executive producer on *The Orphanage* and a number of other films. He now lives in Los Angeles, after fleeing Mexico City following the kidnapping of his grandfather in 1998, an incident that proved, in real life, that the society around him was growing increasingly unstable and precarious.

45. A phantasmal scene from *Pan's Labyrinth*. Courtesy: Jerry Ohlinger Archive.

Del Toro's films often use young children as their central characters and blur the line between fantasy and reality in much the same fashion as Victor Erice's *El espíritu de la colmen* (*The Spirit of the Beehive,* 1973), a classic Spanish horror film in which a young girl, Ana (Avia Torrent), impressed by a local screening of James Whale's 1931 film *Frankenstein,* imagines that an escaped convict she discovers hiding in a nearby hut is, in fact, the Frankenstein monster. Del Toro himself admits that he is attracted to the sinister and bizarre, noting in an interview that "I have a sort of fetish for insects, clockwork, monsters, dark places and unborn things." Along with Alfonso Cuarón and Alejandro González Iñárritu, del Toro is one of the key auteurs of the new Mexican cinema (the men are know popularly as the "Three Amigos"), even if many these directors now are virtual exiles from their homeland, due to the violence of powerful drug cartels and street gangs. Del Toro's vision is absolutely his own, and he regularly turns down projects that seem too conventional for his tastes, preferring to mine his own personal inventory of dread and unease for his cinematic ventures.

But it is in Japan, Hong Kong, and Korea that one arguably finds the most fertile ground for the contemporary horror film, and this is

where such directors as Hideo Nakata, Masaki Kobayashi, Takashi Miike, and Takashi Shimizu are flourishing. Unlike American horror films, "J-Horror" and "K-Horror" films depend on a deeply felt sense of dread, unease, and foreboding, conveyed through suggestions of horror rather than graphic violence, although there are certainly exceptions. Ghost stories and tales of possession by evil spirits are particularly popular, with the figure of the *yurei* being especially common.

Yurei are Japanese ghosts who are forced to remain on Earth because of violence or trauma during their mortal lives, and they torment the living with their malevolent presence. Most dangerous are *onryo* spirits, ghosts who are given to violent retribution for the wrongs they have suffered in the past. Most yurei are female, dressed in white—the color of death in Japanese funeral costumes—and usually have long, straggling black hair that obscures most of their faces from view. Much of this iconography derives from kabuki theater, in tales of the supernatural, as the restless dead haunt the living.

Most observers cite Hideo Nakata's *Ringu* (*The Ring,* 1998) and Joji Iida's *Rasen* (*Spiral,* 1998) as the films that marked the international arrival of the J-Horror movement, along with Shinya Tsukamoto's underground 16mm black-and-white hit *Tetsuo* (*Tetsuo: Iron Man,* 1989), which took a long time to surface in the West but almost instantly became a touchstone for the nascent movement. *Ringu,* centering on a cursed videotape that brings death to all who watch it, was particularly influential. Almost immediately, Hollywood studios, sensing a new trend, ramped up low-cost remakes of the original films, starting with Gore Verbinski's *The Ring* (2002), which opened to enormous business and generally positive reviews, helped by a memorable advertising campaign that warned viewers, "Before you die, you see the ring."

Hard on the heels of the J-Horror movement, Bong Joon-ho's *Gwoemul* (*The Host,* 2006), an influential example of K-Horror, burst through into the West, playing with subtitles in mainstream theaters (an increasingly rare phenomenon). The film tells a simple but effective tale of an enormous monster who menaces a small but plucky young girl while her family desperately tries to save her from what seems to be certain death.

Interestingly, the director of *The Host,* like many of his Asian compatriots, isn't all that concerned about what Hollywood might do with a remake of his film. Similarly, Hideo Nakata, director of the first *Ring*

film, happily skipped over to Los Angeles to direct *The Ring 2* (2005), and Takashi Shimizu, who directed the first *Ju-on* (*The Grudge*, 2003) film, was pleased to direct the American remake (*The Grudge*, 2004) and yet another American sequel in the series, *The Grudge 2* (2006). At this point, no Hollywood remake of *The Host* is scheduled, but if "a truly amazing remake comes out," as Bong Joon-ho remarked in an interview, "then, as the original director, I will be happy. If the remake film turns out to be a disastrously stupid film, then the original will be evaluated greater than the new one, so I don't mind that, either."

Indeed, Japanese horror films have developed at such a rapid pace that some bizarre genre-bending films have resulted, such as Naoki Kudo and Terry Ito's *A! Ikkenya puroresu* (*Oh! My Zombie Mermaid*, aka *Ah! House Collapses*, 2004), which conflates exhibition wrestling with a mysterious bacterial infection known as the "mermaid virus." Professional wrestler Kouta Shishioh (played by Shinya Hashimoto, an actual wrestling star in Japan) builds a dream house for his wife, Asami (Urata Awata), but then destroys the house almost entirely in a battle to the death with his chief rival, Ichijoh (Nicholas Pettas), during a house-warming party. Asami is severely injured, and she is trundled off to the hospital, where her skin starts peeling off, to be replaced by fish scales and fins. To rebuild his house and pay for medical expenses, Shishioh agrees to engage in a series of televised exhibition matches in which he is forced to confront a variety of opponents, including, most remarkably, a zombie who uses his entrails in an attempt to strangle Shishioh to death. Near the end of the film, Shishioh's sister-in-law Nami (Sonim) joins him in the fight, and the entire film becomes a free-for-all of surrealistic and often comedic violence.

Equally bizarre is *SARS Wars,* a 2004 zombie/comedy film from Thailand, directed by Taweewat Wantha. When an outbreak of the SARS virus infects an entire apartment block in Bangkok, the authorities move quickly to keep the building completely quarantined. Complicating matters is the presence of a criminal gang in the building, which has kidnapped Liu (Phintusuda Tunphairao), a teenage high school student. To rescue her, a master swordsman, Khun Krabbi (Supakorn Kitsumon), must battle gang members and zombies, and also play "beat the clock," as the government moves to blow up the building entirely to eradicate the threat of infection (not the best possible plan, it seems to me).

46. An ominous scene from *Audition* by Takashi Miike. Courtesy: Vitagraph/ Photofest.

More traditional exemplars of the genre include Hideo Nakata's *Honogurai mizu no soko* (*Dark Water,* 2002), about a water-soaked apartment house haunted by evil spirits. The film was remade in the United States in 2005 by director Walter Salles to indifferent audience and critical response. Takashi Miike's *Odishon* (*Audition,* 1999) is perhaps the most notorious film of the J-Horror movement. It follows Shigeharu Aoyama (Ryo Ishibashi), a widower in his late forties who hits upon the idea of "auditioning" young women to be his new wife. He is smitten with the lovely and seemingly docile Asami Yamazaki (Eihi Shiina), who seems to fulfill the older man's fantasies, but she is not at all what she seems. A sadistic, ruthless manipulator and sociopathic killer, she ritually dismembers men who are attracted to her and intends to do the same to Shigeharu. Only the last-minute intervention of Shigeharu's son, Shigehiko (Tetsu Sawaki), saves him from further torture and certain death. Fighting with Shigehiko, Asami falls down a flight of stairs and breaks her neck. The police are left to pick up the pieces (literally).

Audition is easily one of the most disturbing films discussed here, and yet Miike's vision suggests that women will consistently refuse to be typed as sexual objects and defer to the desires of men. Miike, of course,

disavows all aspects of social commentary in *Audition,* but for a director who trained under the guidance of master filmmaker Shohei Imamura, this claim has to be taken with a good deal of skepticism. What is even more peculiar is that Miike, despite his reputation as a filmmaker who relishes extreme violence, has also directed a number of films for children. In his zombie/splatter/musical comedy *Katakuri-ke no (The Happiness of the Katakuris,* 2001), the family proprietors of a hotel have to deal with the fact that the majority of their guests die in any number of bizarre circumstances, at which point the whole film turns into a Disneyesque musical.

Also in 2001, Miike directed perhaps his most brutal film, *Koroshiya 1 (Ichi the Killer),* featuring Tadanobu Asano as Kakihara, an unspeakably violent yakuza enforcer who delights in torturing his victims as part of his "job." Wildly prolific, directing up to seven feature films a year, Miike, who was born in 1960, has a long career ahead of him and will undoubtedly continue to create a variety of disturbing yet deeply original works in any number of genres. With some seventy films to his credit already, Miike, who cites David Lynch, David Cronenberg, and Paul Verhoeven as his favorite directors, will be surprising audiences for some time to come.

One of the most unusual films of the Japanese horror renaissance is the last work of career director Kinji Fukasaku, *Batoru Rowaiaru (Battle Royale,* 2000). Fukasaku, who was born in 1930, directed numerous yakuza films from the 1960s onward, and in 1970 he was tapped to direct the Japanese sections of the international co-production *Tora! Tora! Tora!* when Akira Kurosawa bowed out. Such films as *Gyangu domei (League of Gangsters,* 1963), *Kyokatsu koso waga jiinsei (Blackmail Is My Life,* 1968), the science-fiction horror film *Gamma daisan go: Uchi dai sakusen (The Green Slime,* 1968) and *Shikingen godatsu (Gambling Den Heist,* 1975) typify Fukasaku's early output.

However, toward the end of his life, Fukasaku surprisingly became more interested in video games than in films themselves as stand-alone projects, and he directed the video portions of *Clock Tower 3,* a typically violent example of the genre. This led Fukasaku to become more interested in youth culture, albeit from a somewhat jaundiced perspective (Fukasaku's temper tantrums on the set were legendary), and with *Battle Royale,* he created what many consider his finest work, even as he was

47. A high school student goes on the attack in Kinji Fukasaku's *Battle Royale*.
Courtesy: Toei/Photofest.

dying of prostate cancer and knew that he was racing against time to fin-
ish the film.

Battle Royale's plot is straightforward. In the not too distant future,
high school students in Japan are completely out of control. To counter-
act the epidemic of bad behavior, the government annually selects a
random graduating class, drugs the students, and then transports them
to an isolated island, where they are fitted with explosive collars
that can detonate at a moment's notice. The students' teacher, Kitano
(played by action actor/director Takeshi "Beat" Kitano), tells them
that whether they like it or not, they are going to play a "game"; they
must kill each other until only one survives (the "winner"), while simul-
taneously avoiding "hot zones" on the island that will cause their collars
to detonate.

In creating the film, Fukasaku drew upon his own wartime experi-
ences as a teenager in Japan. After being drafted into the army in 1945 at
the age of fifteen, he was caught in artillery fire while working in a
munitions plant along with his fellow soldiers. To survive, Fukasaku and
some others hid under the bodies of those who had fallen in the line of
fire. Afterward, the survivors were ordered to bury the corpses of those

who had died; the experience left an indelible mark on the young man, giving him a lifelong distrust of authority.

Fukasaku's son Kenta mounted a sequel, *Batoru Rowaiaru: Rekuiemu* (*Battle Royale II: Requiem*, 2003), but Kinji Fukasaku was able to direct only one scene before failing health forced him to abandon the director's chair, and his son completed the film. Kinji Fukasaku called *Battle Royale* "a fable . . . youth crime is a very serious issue in Japan . . . whether you take that as a message or as a warning or advice is up to you, as the viewer." *Battle Royale* emerges as Fukasaku's finest and most influential film, and one that gestures with infinite despair toward the future of society.

Even more disturbing is Sion Sono's *Jiratsu Sakuru* (*Suicide Club,* aka *Suicide Circle,* 2002), an independent film that depicts a series of mass suicides that hit Japan for no apparent reason, beginning with the ritual suicide of fifty-four teenage schoolgirls at Shinjuku Station in downtown Tokyo. They line up at the very edge of the platform, hold hands, and then jump in front of a train just as it pulls into the station. The carnage is appalling, but this is only the beginning of Sono's bizarre film. A group of detectives is assigned to investigate the affair as the wave of group suicides continues, and they are eventually traced to a weird cult centering on a pop group called Dessert, an all-girl "American Idol"–style band specializing in up-tempo pop music.

At the same time, a computer hacker named Kiyoko, who prefers to be known as Komori, or "the Bat" (Yoko Kamon), tries to assist the police in their investigations, claiming that she has found a link between the suicides and a Web site with a mysterious pattern of red and white dots. But despite all efforts, the suicides continue throughout Japan, with entire families jumping off the roofs of their houses and another mass suicide at a Tokyo high school. Eventually, a young girl named Mitsuko (Saya Hagiwara) unlocks the secret of the "suicide club" and, in a backstage meeting with the members of Dessert during one of their concerts, solves the mystery. Dessert announces its decision to stop performing, and the mass suicides come to an end.

As dark and compelling as anything David Lynch ever directed, *Suicide Club* almost immediately spawned a sequel, Sono's *Noriko no shokutaku* (*Noriko's Dinner Table,* 2006), which is both a prequel *and* a sequel to the 2002 film. The film looks at the period leading up to the

suicides and then the aftereffects of the mass psychosis once Dessert's spell is broken. Sono plans one more film in the series, as yet unnamed, to further extend his surreal narrative. Sono, who began his career directing straight-to-video gay pornography, has moved on to deeply contested psychic territory in *Suicide Club*; one can only wonder what his future films will be like, once this trilogy is complete.

Other key horror auteurs in J-Horror from the 1990s through the present include Kiyoshira Kurosawa (no relation to famed director Akira Kurosawa), who began his career with straight-to-video yakuza films and later won a Sundance fellowship to study filmmaking in the United States. Then came *Kyna* (*Cure,* 1997), a hyper-violent serial-killer film, followed by two films shot back-to-back, *Hebi no michi* (*Serpent's Path*) and *Kumo no no hitomi* (*Eyes of the Spider;* both 1999), which used the same central plot as Bergman's *Virgin Spring,* that is, a father avenging the murder of his child. Kurosawa then really hit his stride with *Kairo* (*Pulse,* 2001), a supernatural thriller in which ghosts re-enter the everyday world by using the Internet as a means of transportation.

Kurosawa's *Pulse* was so successful that it served as the basis for an American remake, also titled *Pulse,* with a script rewritten by the omnipresent Wes Craven and Ray Wright. The sense of isolation and alienation that pervaded Kurosawa's original, however, was almost entirely missing from the American remake directed by Jim Sonzero, and the film failed to perform at the box office. Indeed, the 2006 American *Pulse* had little to do with the 2001 film's original intent, being more interested in conventional tropes of the dead returning to life via the Internet, as opposed to the more metaphysical and spiritual focus of Kurosawa's film. Amazingly, despite the poor reception of the 2006 version, it has produced two straight-to-DVD sequels, *Pulse 2: Afterlife* and *Pulse 3: Invasion,* both directed by Joel Soisson in 2008.

Takashi Shimizu, whose film *Ju-on* (*The Grudge*) first surfaced as a video feature in 2000, has built a prolific career on variations on his breakthrough film, which was shot cheaply and quickly on substandard equipment. With four sequels in both Japan and America to his credit, Shimizu has emerged as one of the foremost visual stylists of the J-Horror movement, seemingly obsessed with the resurgent themes of madness, possession, and supernatural vengeance that haunt his many works.

The twin Pang brothers, Danny and Oxide, broke through to the West with the success of their film *Bangkok Dangerous* (1999), an action thriller that was followed by *Gin gwai* (*The Eye*, 2002), a variation on the "hands of Orlac" theme. In the latter, a young violinist, blind since infancy, undergoes a successful eye transplant, only to discover that she is now cursed with the gift of second sight and can "see" into the future, where violent death awaits those around her. *The Eye* was truly an international co-production, backed by financiers in Singapore and Hong Kong, shot in Hong Kong and Thailand, and completed by cast and crew members from Malaysia, China, Singapore, and Thailand whose native languages were Cantonese, Thai, Mandarin, and English.

The Eye was an enormous international hit, spawning a 2005 Indian remake, *Naina,* directed by Shripal Morakhia and known in English as *Evil Eyes,* and a 2008 Hollywood version, also titled *The Eye,* directed by David Moreau and Xavier Palud, starring Jessica Alba. In addition, the Pang brothers themselves directed two sequels, *Gin gwai 2* (*The Eye 2,* 2004) and *Gin gwai 10* (*The Eye 10,* 2005; the "10" in the title refers to the ten ways of supposedly "seeing" the dead; in the West the film is sometimes known as *The Eye 3*). The brothers proved that a promising concept can be recycled across both linguistic and cultural borders, even when it has been inspired by "transplant" films as far back as the 1920s, in which limbs, rather than eyes, bring with them the curse of death and destruction—the "second sight" variation being the Pang brothers' key twist on the subgenre.

For their part, the Pang brothers maintain that their initial inspiration to make the film came from the true-life story of a sixteen-year-old girl who received a corneal transplant but shortly thereafter took her own life. "We'd always wondered what the girl saw when she [finally] regained her eyesight, and what actually made her want to end her life," Oxide Pang later observed. Shot in a low-key style, which creates an atmosphere of dread and unease, rather than relying on shock tactics and elaborate special effects, the Pang brothers' first version of *The Eye* is restrained, haunting, and eerily effective in its evocation of a world beyond our own.

This tendency toward international horror films, redolent of the Italian/U.S. horror co-productions of the 1960s, is further exemplified by the multipart film *Saam gaang* (*Three,* 2002). Director Kim

Ji-woon from South Korea contributed the Korean-language segment, "Memories"; Peter Chang, of Hong Kong, directed "Going Home," with dialogue in Cantonese and Mandarin; and Nonzee Nimibutr of Thailand offered "The Wheel," spoken in Thai. "Memories" concerns a man who seeks out psychiatric help when his wife disappears; suddenly, Kim Ji-woon cuts to the wife waking up on a desolate road with no of idea how she arrived there. "The Wheel" deals with cursed puppets that torment their dying master; when the puppets are stolen, the curse is transferred to the new "owners." "Going Home" is perhaps the oddest of the three vignettes. A man, Yu (Leon Lai), keeps the body of his dead wife in his apartment for years in the hope that she will one day miraculously revive and return to his side.

Three was so successful that it paved the way for *Sam gang yi* (*Three . . . Extremes,* 2004), another international co-production, with directors Fruit Chan (Hong Kong), Park Chan-wook (South Korea), and Takashi Miike (Japan) contributing to a film that is much more violent (as the title suggests) than the original. In Fruit Chan's segment, "Dumplings," an older actress seeks to reclaim her youth by eating dumplings that are supposed to renew her life; but the recipe contains a sinister ingredient. Park Chan-wook's "Cut" chronicles the kidnapping of a highly successful film director and his wife by a disgruntled extra, who forces the director to play a "game" in which his wife's fingers will be chopped off, one at a time. In Miike's "Box," a woman has a recurring nightmare in which she is buried alive. This film, too, was extremely well received, and Chan even expanded "Dumplings" into a feature film in 2006.

Meanwhile, Korean horror flourished with such directors as Ahn Byeong-ki (*Gawi* [*Nightmare,* 2000], *Pon* [*Phone,* 2002], *Bunshinsaba* [*Ouija Board,* 2004], and *APT* [*Apartment,* aka *9:56,* 2006]), Bong Joon-ho (*Gwoemul* [*The Host,* 2006] and *Salinui chueok* [*Memories of Murder,* 2003]), Kim Dong-bin (*The Ring Virus* [1999; no Korean title for this film] and *Redeu-ai* [*Redeye,* 2005]), Park Ki-hyeong (*Yeogo goedam* [*Whispering Corridors,* aka *High School Girl's Ghost Story,* 1998], and *Acacia* [2003]), Kim Ji-woon (*Janghwa, Hongryeon* [*A Tale of Two Sisters,* 2003] and *Choyonghan kajok* [*The Quiet Family,* 1998]), and Kong Su-chang (*Telmisseomding* [*Tell Me Something,* 1999] and *R-Point* [2004, no Korean title for this film]), to name just a few key directors and their films. But it is important to note that South Korean cinema has a long and

traumatic history. The first Korean film was made in 1919, while Japan occupied the nation. As the industry progressed, only films that the Japanese government decreed noncontroversial were allowed to be screened; the rest were destroyed. By 1937, when Japan invaded China, Korean films became, by the conqueror's design, Japanese propaganda. In 1942 Korean-language films were banned entirely; henceforth, all production had to be in Japanese only.

Kim Ki-young, known as "Mr. Monster" in South Korea for his decidedly offbeat projects, was one of the few individualistic directors who flourished after World War II, even after the country was split in two by tensions between the United States and the Soviet Union. In 1973 the military government in South Korea imposed even stricter censorship, and in May 1980 the so-called Gwangju Massacre occurred, in which between one and two thousand demonstrators were shot dead by government soldiers for protesting against the military's control of political and social affairs.

Although true democratic reform did not take place until 1988, the Gwangju Massacre served as a flashpoint for the eventual liberalization of Korean society and the relaxation of censorship. Despite Hollywood's inroads since that time, the South Korean cinema has made an international name for itself with films that differ from J-Horror in their striking, often operatic use of extreme violence. They are perhaps the result of years of repression, internal struggle, occupation, and government censorship.

Nevertheless, horror has a long cinematic tradition in Korea, reaching back to the early 1950s and '60s. One such films is Lee Man-hee's *Ma-ui quedan* (*The Devil's Stairway,* 1964), in which a surgeon kills a nurse with whom he is having an illicit affair and then is haunted by her ghost. Others include Kim Ki-young's celebrated *Hayno* (*The Housemaid,* 1960), a film that references both Luis Buñuel's surrealistic classic *Susana* (1951) and John Brahm's equally unusual *Guest in the House* (1944) in its story of a young woman who is hired to help the family of a young composer and gradually takes over her employer's domain. The young woman becomes pregnant by her employer and suffers a miscarriage encouraged by the composer's wife (the housemaid throws herself headlong down a flight of stairs, in apparent homage to John M. Stahl's 1945 noir classic *Leave Her to Heaven*). She then murders the composer's son and tries to convince the grieving couple to commit

ritualistic suicide with her by swallowing poison. In *The Housemaid*'s final moments, it is revealed that the entire narrative is a newspaper story that the composer has been reading to his incredulous wife; turning directly to the audience, he breaks through the "fourth wall" and, in a neatly self-reflexive, Buñuelian touch, admonishes viewers that this bizarre scenario might occur in their own lives.

Despite the implied violence and horror employed by some of the recent K-Horror films, many contemporary Korean directors, such as Park Chan-wook, embrace the graphically violent vision of such artists as Takashi Miike. In Park Chan-wook's notorious *Vengeance* trilogy, which begins with *Boksuneun naui geot* (*Sympathy for Mr. Vengeance*, 2002), Ryu (Shin Ha-kyum), a deaf-mute factory worker, endlessly toils in order to save up money for his critically ill sister, who needs an immediate kidney transplant. Ryu offers to donate one of his own kidneys, but his blood type is not a suitable match.

Fired from his job, Ryu strikes a grisly deal with a black market organ dealer who promises to find a matching kidney for Ryu's sister, but at a high price: Ryu must give up one of his own kidneys and turn over his entire severance pay. When the deal is consummated, the black market impresario vanishes without making good on his part of the bargain. Understandably enraged, Ryu becomes even more apoplectic when he learns that a matching kidney has been found and that the operation will cost 10 million Korean won—the exact amount of his forfeited severance pay.

This situation leads to an unbelievably complex tale of kidnapping, suicide, and murder. Ryu and a friend, Cha Yeong Mi (Bae Doona), conspire to kidnap the daughter of one of Ryu's former bosses, but Ryu's sister discovers the plot and kills herself, unwilling to be a party to Ryu's actions. Driven insane with grief, Ryu tracks down the illegal organ dealers, cuts out their kidneys, and eats them. But we have still not reached the climax of this unremittingly brutal film, which ends in a maelstrom of murder, dismemberment, and revenge. As in all of his films, Park Chan-wook brings a highly stylized sheen to the proceedings, with sleek camera work, bright, almost "pop" colors, and intense manipulation of the image through digital special effects.

The director's next film, *Hangul* (*Oldboy*, 2003), based on a popular Japanese graphic novel, or *manga,* is even more notorious and equally

48. Violent revenge in Park Chan-wook's *Sympathy for Mr. Vengeance.*
Courtesy: Tartan Films/Photofest.

violent. A tale of revenge, suicide, torture, and murder, it nevertheless received significant critical praise in Korea and throughout the world. *Oldboy,* which the director considers to be the second part of his *Vengeance* trilogy, centers on the travails of Oh Dae-su (Choi Min-sik), a man who has been locked in a hotel room for nearly fifteen years by Lee Woo-jin (Yu Ji-tae) for no apparent reason. Released, Oh Dae-su seeks vengeance on his captor, who continues to toy with Oh Doe-su even after his release. The remarkably labyrinthian tale that follows, encompassing incest, murder, hypnosis, and more than a passing element of ambiguity, becomes a dreamlike fable in which passion and emotion are

the ruling factors in all the characters' lives. Park Chan-wook's elegantly choreographed bloodshed ultimately takes a back seat to the film's genuine preoccupation with affairs of the heart, as well as considerations of time, memory, and retribution.

The final film in the *Vengeance* series, *Chinjeolhan geumjassi* (*Sympathy for Lady Vengeance,* 2005), is equally complex and violent. Lee Geum-ja (Lee Yeong-ae), a young woman convicted of murdering a schoolboy, is sentenced to a lengthy term in prison. Her seeming embrace of Christianity and "atonement" for her crime win an early release. But almost immediately, she embarks on a systematic plan of revenge against the real killer, the powerful and depraved Mr. Baek (Choi Min-sik), who had threatened to kill Lee Geum-ja's infant daughter, Jenny (Kwon Yea-young), unless Lee falsely confessed to the crime. As matters unfold, Lee Geum-ja discovers that Mr. Baek is in fact a serial child killer who videotapes his crimes in graphic detail. Enlisting the aid of Detective Choi (Nam Il-su), whose investigation led to her false imprisonment, Lee Geum-ja contacts the relatives of all the children whom Baek has murdered. After drugging and kidnapping Baek, Lee Geum-ja and Choi transport him to an abandoned children's school outside of Seoul.

There the relatives decide, after careful deliberation, to murder Baek. They brutally hack him to death and videotape the ritual murder so that all are implicated and none can break the silence without admitting to complicity in the slaughter. After burying the corpse on the abandoned school grounds, the group repairs to a bakery where Lee has worked since her release from prison. Together they conduct a memorial "birthday celebration" for their murdered children, eating cake and singing a birthday song as an offering to the departed spirits of their sons and daughters.

Sympathy for Lady Vengeance was a palpable hit in South Korea, but it had only limited release in the West. Of the three *Vengeance* films, *Oldboy* remains the most influential film of the series, as well as the most widely viewed. For his part, director Park Chan-wook has claimed that his influences include the works of Shakespeare, Kafka, Balzac, Vonnegut, Sophocles, and Dostoevsky; among his favorite filmmakers are Samuel Fuller, Polanski, Hitchcock, Robert Aldrich, and Ingmar Bergman, as well as his fellow countryman Kim Ki-young. Despite the incessant

violence in the *Vengeance* trilogy, Park has suggested that his real purpose in making the films was to depict the uselessness of revenge and to demonstrate the ways in which it affects everyone associated with it. Interestingly, when Park was offered the chance to direct the Hollywood remake of Sam Raimi's *The Evil Dead,* he passed on the project.

Elsewhere around the world, horror continued to flourish, though not with the same intensity. *Vikanen* (*The Substitute,* 2007), from the Danish director Ole Bornedal, is an interesting horror comedy in which a malevolent alien being masquerades as a seemingly normal sixth-grade substitute teacher. When the students try to warn their parents, they are met with scorn and disbelief; the children are addicted to video games, their parents claim, and thus live in a fantasy world where they can no longer distinguish between reality and fiction. But, as it turns out, the kids are absolutely right. Once again, the supposed authority figures in a horror film prove to be unreliable, with potentially fatal consequences.

In Australia and New Zealand, Michael Laughlin's *Dead Kids* (aka *Strange Behavior,* 1981) deals with a string of horrific murders in a small town in Illinois (surprisingly enough). David Blyth's *Death Warmed Up* (1984) tells the story of a young man who is brainwashed by an insane behavioral scientist to kill his parents. Committed to an insane asylum for the murders, he tracks down the scientist after his release and must battle a race of zombies created by the mad doctor in order to survive.

New Zealand's Peter Jackson, who went on to considerable international acclaim for his *Lord of the Rings* series, began his career with the cheerfully parodic *Bad Taste* (1988), in which invading hordes of aliens embark on wholesale slaughter of the human race for food. Jackson followed this with the equally eccentric *Meet the Feebles* (1989), a comedy horror movie featuring a group of murderous puppets, and *Brain Dead* (1992), a zombie comedy with over-the-top violence and darkly humorous intent. Looking at these early films, one can see that until Jackson became a more mainstream filmmaker, he was headed in much more eccentric directions.

Among other offerings, Rod Hardy's *Thirst* (1979) is a quietly effective vampire film; Tony Williams's *Next of Kin* (1982) is a supernatural horror film that centers on a decidedly unusual nursing home; Colin Eggleston's *Outback Vampires* (1987) reuses the standard premise of three stranded hitchhikers forced to spend the night in a house inhabited by

49. Peter Jackson's early splatter film *Dead Alive* (aka *Brain Dead*). Courtesy: Jerry Ohlinger Archive.

vampires; Carmelo Musca and Barrie Pattison's *Zombie Brigade* (1987) deals with the bodies of dead war heroes rising from their graves to wreak havoc upon the living; and Michael and Peter Spierig's *Undead* (2003) is yet another comedy zombie thriller. Although many of these films— especially Jackson's early works—are interesting and energetic, they lack the sense of innovation and desperate urgency of their Asian counterparts. Too often they are tired retreads of American horror films of the period, conjuring the traditional threats of vampires, werewolves, and zombies, and resorting to unimaginative (if enthusiastic) use of gore effects.

One notable exception to this trend is Andrew Traucki and David Nerlich's *Black Water* (2008), an Australian horror film that is entirely indigenous in its structure and thematic content. Based on a real-life story of a crocodile attack in Australia in 2003, the film's set-up is simple: a group of teens on a camping trip is stranded when their boat capsizes in the midst of a crocodile-infested swamp. The balance of the film, which is superbly photographed, directed, and edited for maximum suspense, is a struggle to survive against the crocodiles, which are depicted as relentless, impersonal killing machines.

Another example of recent Australian horror can be found in Greg McLean's *Wolf Creek* (2005), a film that follows in the bloody footsteps of *The Most Dangerous Game* (1932) and *The Texas Chainsaw Massacre*. Three young backpackers are terrorized by an itinerant bushman, Mick Travis (John Jarrat), whose seemingly affable, if boastful, exterior masks his true persona as a serial killer who hunts his victims for the "sport" of it. Sadly, *Wolf Creek* is based on true events, specifically the activities of one Ivan Milat, dubbed "the backpacker murderer," who kidnapped and tortured his victims in and around Belanglo State Forest, outside of Sydney, in the early 1990s. Still another model for the character of Mick Travis was Bradley John Murdoch, who killed a British tourist and assaulted his girlfriend in the north of Australia in July 2001. As with all such films, the real horror here is all too human, and all too tangible.

American horror films, in the meantime, have continued at a relentless pace, though they have been taking far fewer risks with their thematic material than their foreign counterparts. As in the 1970s and '80s, the emphasis is on profitable franchises as opposed to "one-off" films that might break new ground; with the cost of Hollywood films at an all-time high, perhaps this strategy is understandable, if regrettable. There are, however, a few exceptions to the general rule. Bernard Rose's *Candyman* (1992), based on a short story, "The Forbidden," by Clive Barker, is an effective and surprisingly socially conscious thriller. Virginia Madsen plays Helen Lyle, an academic researcher doing fieldwork on urban legends. She hears about the Candyman, the evil spirit of a murdered slave who appears to anyone who looks in a mirror and repeats his name five times. At the Cabrini-Green housing projects in Chicago, Helen "summons" Candyman (Tony Todd) by repeating the incantation, and a string of murders begins. The police put little credence in the

existence of the Candyman, leaving Helen to solve the mystery of the killings on her own. With a resourceful and forceful heroine, and a superb score by modernist composer Philip Glass, *Candyman* is at once genuinely eerie, steeped in atmosphere, and superbly realized.

Rusty Cundieff, a protégé of Spike Lee, put a fresh spin on the horror anthology film with *Tales from the Hood* (1995), in which a mysterious undertaker, Mr. Simms (Clarence Williams III), spins four cautionary tales to a trio of drug dealers who have invaded his funeral home. Sharply written, well acted, and bolstered by a trenchant moral for each segment, *Tales from the Hood* is, for a change, a socially conscious horror film, one that seeks to educate, not bludgeon, the viewer. *Tales from the Hood* is almost unique among contemporary horror films for possessing a moral compass, a reason for existence in a cinematic landscape cluttered with meaningless corpses and peopled by anonymous, faceless, and often mutely interchangeable phantom killers.

Yet, for the most part, modern American horror films are simply overblown killing machines. *The Saw* franchise keeps on grinding away, from the 2004 original by James Wan to *Saw VI* (2009), directed by Kevin Greutert, offering more gore and torture porn with each passing installment and less and less imagination. The *Final Destination* series racks up one grisly death after another, starting with James Wong's 2000 original and continuing through David R. Ellis's *The Final Destination* (2009), in which more hapless teens are killed by the whims of fate, this time in 3-D. Dennis Illiadis remade Wes Craven's *The Last House on the Left* in 2009 in a manner more brutal and unforgiving than the original could ever have imagined. The corpses in all these films pile up on the ash heap of imagination.

The 1981 slasher film *My Bloody Valentine,* directed by George Mihalka, got a 3-D remake (always the sign of an expiring franchise) with Patrick Lussier's *My Bloody Valentine* (2009). In both films, a crazed miner runs around killing anything that moves with an immense pick axe, but in 3-D the plot reveals itself even more as a gratuitous series of simplistic shock effects. Director Michael Haneke remade his 1997 German "art" splatter film *Funny Games* as (once again) *Funny Games* in 2007, a nearly shot-for-shot copy of the original film, this time in English. In both versions, two young men torment a hapless family with a series of violent and sadistic "games," which culminate in the

systematic massacre of the entire group. Jan de Bont remade Robert Wise's 1964 film *The Haunting* as a CGI-driven haunted house spectacle in 1999, again to much less effect.

John Erick Dowdle's *The Poughkeepsie Tapes* (2009), shot in hand-held digital video, offered yet another serial killer who videotapes his victims' torments. The killer keeps all the tapes meticulously catalogued and ready for viewing, as a sort of scrapbook of memories that no one would really want to embrace. Roland Joffe's *Captivity* (2007), perhaps the most notorious "torture porn" film, graphically depicts the brutalization of Jennifer Tree (Elisha Cuthbert) for no reason other than her captors' amusement. In the meantime, Jaume Balagueró and Paco Plaza's imaginative Spanish horror film *REC,* about a mysterious virus that infects a downtown apartment building, turning the residents into rabid monsters, was the subject of a seemingly inevitable American remake. Like the original, Dowdle's *Quarantine* (2008), with nearly the same plot line and characters, was shot in cinema verité style as "actual" on-the-scene television news coverage.

Godzilla, or something very much like it, returned as a gigantic CGI monster in Matt Reeves's derivative *Cloverfield* (2008), in which an enormous, mostly unseen monster terrorizes Manhattan. Once again, the film is shot as if being recorded on a handheld video camera for that "you are there" feeling. It's an effective monster film, but there's no real innovation here, and only Phil Tippett's typically superb special effects keep the film moving toward a rather predictable climax. Producer/director Paul W. S. Anderson continued to plunder video games and earlier genre films to create a series of slick, empty films. *Event Horizon* (1997) is *Hellraiser* on a spaceship, while Anderson's *Resident Evil* (2002), Alexander Witt's *Resident Evil: Apocalypse* (2004), and Russell Mulcahy's *Resident Evil: Extinction* (2007) are video game franchise films at their least innovative. Anderson directed the first film in the series and produced all three films.

In 2008 Anderson also created a typically slick but hollow remake of Paul Bartel's 1975 film *Death Race 2000,* this time called *Death Race*. As in a video game, the object is to run over innocent pedestrians for points. Bartel's film was a curious blend of comedy and social criticism created on a shoestring budget for Roger Corman's New World Pictures; the remake had funding to spare, but added nothing to the original. And,

of course, there's always Anderson's 2002 *Alien vs. Predator,* previously discussed, which takes Ridley Scott's original and compelling vision and reduces it to a simplistic PG–13 thrill ride.

In 2005 Jim Gillespie teamed with Kevin Williamson, the scenarist of the *Scream* franchise, to make *Venom,* a horror film set in the Louisiana bayous. As in Gillespie's earlier slasher film, *I Know What You Did Last Summer* (1997), in which an ancient mariner with a hook, resembling no one so much as the Gorton's fisherman, lumbers through the film killing the predictable assembly line of teenage victims (amazingly, the film gave birth to an even less inspired sequel, Danny Cannon's *I Still Know What You Did Last Summer,* 1998), yet another group of teenagers is ritually slaughtered by Ray (Rick Cramer), a former gas station owner who is turned into a ravenous zombie by a voodoo curse. Is there anything original out there anymore?

As the twenty-first century approaches its second decade, it seems that most new ideas come from outside the Hollywood dream factory. Endlessly repeating themselves, the new American horror films seem to offer nothing more than sadism and violence in place of invention; we must look elsewhere for inspiration. Robert Rodriguez's 1986 horror film *From Dusk Till Dawn* was an interesting mix of Tex/Mex vampirism and action film, with an intriguing script by Quentin Tarantino and accomplished performances by George Clooney, Harvey Keitel, Juliet Lewis, Salma Hayek, and Tarantino himself. But did anyone really *need* Scott Spiegel's *From Dusk Till Dawn 2: Texas Blood Money* (1999) or P. J. Pesce's *From Dusk Till Dawn 3: The Hangman's Daughter* (2000), both straight-to-DVD sequels that sullied the critical reputation of an innovative and engaging film? Indeed, cheap sequels like these vitiate the power of the few original films that do come along, if only because audiences, having been decidedly cheated over and over again, have grown weary of the continued deception and avoid the genre entirely. Thus the genre "eats itself," and innovation is jettisoned in favor of the safe returns of an endless cycle of sequels and imitations.

Daniel Myrick and Eduardo Sanchez's *The Blair Witch Project* (1999) was shot in a combination of 16mm film and video, used mostly non-professional actors, cost a total of $35,000 to make, and grossed more than $248 million worldwide, simply because it displayed thought and originality in its presentation and execution, and suggested or implied

50. A camping trip turns into a nightmare in *The Blair Witch Project*. Courtesy: Jerry Ohlinger Archive.

the truly horrific aspects of the supernatural, rather than whipping them up in a whirlwind of special effects. In short, the film showed some respect for its audience and made the viewers *think* about what they were seeing on the screen. The filmmakers refused to settle for simple shock moments, obvious genre tropes, or a tired, recycled narrative structure. But the film's sequel, Joe Berlinger's *Book of Shadows: Blair Witch 2* (2000), dispensed with all of these fresh concepts in favor of a conventional supernatural thriller; despite a much larger budget, the film failed miserably at the box office. What was missing? The spark of an original vision.

Other recent imaginative horror films, such as Neil Marshall's survivalist thriller *The Descent* (2005), seem destined, too, to lose themselves in their offspring. Already, Jon Harris's *The Descent 2* (2009) is upon us, picking up the adventures of a group of female cavers, as the only surviving member of the disastrous expedition depicted in *The Descent* returns to the scene of the original, where events unfold much as before. M. Night Shyamalan, at least, has created a series of engagingly unique

horror and suspense films, starting with *The Sixth Sense* (1999), the film that introduced the phrase "I see dead people" to the popular lexicon. Eschewing sequels, Shyamalan has instead created a series of thematically related but radically different films, most recently *The Happening* (2008), in which waves of mass suicide hit the United States, starting in New York. Although this film has links to the Japanese horror film *Suicide Club,* it is in no sense a remake, but rather a variation on a theme. Some of Shyamalan's films are less successful than others, but at least he tries to reinvent himself with each new film. Martin Scorsese has also taken an interesting stab at the horror genre recently, with his intermittently effective period thriller *Shutter Island* (2010), in which detective Teddy Daniels (Leonardo DiCaprio) is sent to investigate mysterious happenings at an isolated island prison for the criminally insane. Even Eli Roth, after a promising beginning with the gruesome yet effective *Cabin Fever* (2002), has declared that he is uninterested in extending the *Hostel* series after the first two films; he wants a new direction.

Perhaps a vampire film like Catherine Hardwicke's *Twilight* (2008) is an early clue to this new direction. Shot on location in Washington and Oregon with excellent but relatively unknown actors—at the time, anyway—*Twilight* concentrates on the relationship between the two leading characters, Bella Swan (Kristen Stewart) and the reluctant vampire Edward Cullen (Robert Pattison). The film has grossed more than $396 million since its release on November 21, 2008, proving that audiences are hungry for some substance in their horror films, and perhaps a dash of romance.

Yes, it's another film aimed at teenagers. Yes, it's based on a series of best-selling novels. And indeed, it is primarily a romance film. But like Kathryn Bigelow's *Near Dark, Twilight,* also directed by a woman, concentrates on the *characters* in the story and the situation they find themselves in—an impossible love—to make the audiences empathize and relate to Hardwicke's protagonists, just as Val Lewton made the characters in his classic horror films of the 1940s exist not only in the supernatural world, but also the real one, with the problems and passions we all share and must deal with every day.

Significantly, and perhaps ominously, despite the runaway success of the original, the film's producers decided to dispense with Catherine Hardwicke's services as director on the final three films in the *Twilight*

51. Twenty-first-century teenage vampire romance: *Twilight*. Courtesy: Jerry Ohlinger Archive.

series. Hardwicke had reservations about the next script and wanted some time to work on it; the producers of the original film, however, wanted to rush ahead. The result, Chris Weitz's *The Twilight Saga: New Moon* (2009) was more formulaic, but still a massive commercial success. Only time will tell whether this was a wise decision. To make us believe in the unreal, horror directors must keep one part of our consciousness fixed on the actual, so that the ideal horror film finds a spot where fantasy and reality melt in a satisfying blend of fear and anticipation. The future of horror, as with all genres, lies in perpetual renewal. In this sense of an eternal beginning, then, lies the future of horror.

And yet there seems to be no stopping the wave of graphic violence embraced by contemporary audiences. Stewart Hendler's *Sorority Row* (2009) centers on a prank gone wrong, in which a young woman is accidentally murdered, yet seemingly returns from the grave to wreak gruesome vengeance on those who dispatched her to the realm of the dead. Dominic Sena's *Whiteout* (2009) chronicles the hunt for a murderer in the frozen north. Karyn Kusama's *Jennifer's Body* (2009) stars ingénue-of-the-month Megan Fox as a teenage demon bent on murdering her male classmates. Ruben Fleischer's *Zombieland* (2009) is a horror comedy starring Woody Harrelson that bears more than a passing resemblance to

Shaun of the Dead. Adam Gierasch's *Night of the Demons* (2009) stars Edward Furlong in an updated haunted house story, set in New Orleans, with predictable doses of violent mayhem. Paul Weitz's *Cirque du Freak: The Vampire's Assistant* (2009) centers on a vampire circus. And the Universal monsters are being cranked up one more time, with Joe Johnston's remake of *The Wolf Man* (2010), with Benicio Del Toro as the accursed Lawrence Talbot, Geraldine Chaplin as Maleva, the Gypsy woman, and Anthony Hopkins as Sir John Talbot, Lawrence's father. This new version was begun with director Mark Romanek, but with his departure, Johnston ramped up the CGI effects, creating a film of little distinction or resonance.

In 2007 director Oren Peli, a video game designer and former stock market day trader who had never made a film before, wrote, produced, and directed the ingenious ghost story *Paranormal Activity*. Shot on video for a mere $11,000, the film was picked up by DreamWorks/Paramount for just $300,000 as the template for a potential big-budget remake, but producers Jason Blum and Steven Schneider argued that the original raw film, lacking any stars or special effects, would be much more effective than any Hollywood remake. The film has only a few actors and is staged as a documentary, which it is not; indeed, it went through several endings before the final version emerged in 2009.

Paranormal Activity centers around Katie (Katie Featherston) and Micah (Micah Sloat), a young couple living in a nondescript Southern California "starter" home, which nevertheless seems haunted by demons. To find out what's happening to them, Micah sets up a video camera to film himself and Katie while they sleep; the results are unnerving, to say the least. Cleverly launched with a series of "midnight only" screenings in select college towns around the country, *Paranormal Activity* soon generated massive buzz and opened to overwhelmingly positive reviews and stellar box-office receipts, generating more than $100 million in rentals in the United States alone.

The most intriguing aspect of the film is that it works without any special effects, gore, or graphic violence of any kind; all is suggested, as in the films of Val Lewton in the 1940s. The film's "R" rating is solely for language. Peli effectively builds an atmosphere of genuine suspense and menace by using the simplest of visual devices (lights mysteriously flash on and off, doors open and close, sheets drift off the couple's bed) and creates a film that manages to scare audiences with the implied dread

52. A scene from Oren Peli's *Paranormal Activity* (2009), one of the new wave of
more suggestive, non-violent horror films. Courtesy: Photofest.

of what *might* be happening. Best enjoyed with a large audience, the film
became a modern horror phenomenon and beat out the latest installment
of the *Saw* franchise, Kevin Greutert's *Saw VI* (2009), once again signal-
ing that contemporary audiences may be done with "torture porn."

Another highly intriguing horror film of recent vintage is Jaume
Collet-Serra's *Orphan* (2009), a tensely plotted tale of a young couple,
John and Kate Coleman (Peter Sarsgaard and Vera Farmiga), who adopt
Esther (Isabelle Fuhrman), a seemingly adorable young girl from Eastern
Europe, when Kate's third child is stillborn. Attempting to integrate
Esther into their existing family structure, however, proves difficult.
There's a very good reason for this; as we discover in the last few min-
utes of the film, Esther is not a child at all, but a grown woman afflicted
by dwarfism and harboring a homicidal mania and a strong Electra com-
plex. Using a mask of submissive girlishness, Esther has been moving
from family to family, systematically killing off all the family members
who block her access to the father figure she desperately seeks to possess.
In each case, the father, quite naturally, rejects her advances, and Esther
reacts by killing him as well. Because she makes the deaths look like a
series of accidents, the authorities regard her as a victim of tragic circum-
stance and keep returning her to the child welfare system, where she lies
in wait for the next family to adopt her. Now, it's John and Kate's turn.

As Esther, Isabelle Fuhrman—she was only twelve when the film was shot—turns in a performance that is a marvel of concision and menace. Enlisting Kate and John's eight-year-old, hearing-impaired daughter, "Max" (Aryana Engineer), as her unwitting accomplice, Esther begins a campaign of terror against Max's brother, Daniel (Jimmy Bennett), who quickly realizes that, as the film's tag line notes, "There's something wrong with Esther." John, the family patriarch, remains remarkably clueless during the entire film, going so far as to blame Kate for Esther's "problems," and discovers too late the degree of Esther's deception. It doesn't help matters that Kate, a recovering alcoholic, is seen by her husband as well as her therapist as unreliable and given to blaming others for her actions. In short, no one believes Kate, and this gives Esther the fatal upper hand.

The film's final narrative twist, in which Esther is revealed to be a thirty-three-year-old woman, much like the gender-switch finale of William Castle's *Homicidal* (*Orphan* was produced by Dark Castle Films, a production entity set up in homage to William Castle), is withheld until the last possible moment and comes as a genuine shock to the viewer. Director Jaume Collet-Serra, born in Spain, broke into the film business directing music videos and commercials before making his first feature, the forgettable *House of Wax* (2005), an in-name-only remake of the 1953 original. However, he displays real visual flair with *Orphan*, which was enthusiastically embraced by viewers, if not critics. Roger Ebert, however, gave the film a largely positive review, commenting, "You want a good horror film about a child from hell, you got one. Do not, under any circumstances, take children to see it. Take my word on this."

Horror movies will always be with us. They are relatively cheap to make and play to a ready-made audience; even if they don't become megahits, they always make their money back with overseas sales, DVD rentals, and pay-per-view screenings. But what does it say about us, as a society, when we are so entranced by the spectacle of human suffering and dismemberment? As it becomes easier and easier to create violent prosthetic and digital effects, anything is possible. But as the limits of sadism and violence keep getting pushed further and further, and what constitutes an "R" rating seems almost a limitless landscape of brutality and violence, the horror film will ultimately find that it needs to reinvent

itself, not in graphic details, but in the mind of the audience, where true horror cinema ultimately resides. There are limits to the detailed depiction of violence; what we need now is a return to the spell cast by the truly imaginative originators of the genre, when the darkened theater auditorium promised not only release, but also escape. In the end, it seems, we must come back to the roots of horror and begin all over again.

Top Horror Web Sites

1. The Internet Movie Database. The best general clearinghouse for all film genres. Good external review links.
 http://www.imdb.com
2. Horror Talk. Reviews, DVD releases.
 http://www.horrordvdtalk.com/
3. The Horror Source. Reviews, materials, trailers, scripts, and other materials.
 http://www.horrorsource.com/
4. Dark Horizons. Solid industry information here.
 http://www.darkhorizons.com
5. British Horror Films. Featuring work by Hammer and Amicus. Includes reviews, photos, posters, sounds, and a message board.
 http://www.britishhorrorfilms.co.uk
6. FrankensteinFilms.com. Information on the Frankenstein monster, as well as on Mary Shelley's book.
 http://members.aon.at/frankenstein/
7. Ain't It Cool News. General Web site on contemporary films with fan-oriented reviews and coverage.
 http://aintitcoolnews.com
8. Classic Horror. An excellent overview of the field.
 http://classic-horror.com
9. House of Horrors. Discusses horror movies and directors.
 http://www.houseofhorrors.com/
10. HammerWeb. The official Web site for Hammer Films.
 http://www.hammerfilms.com
11. The Chamber of Horrors. Timeline of history of horror movies, with commentary.
 http://www.chamberofhorrors.20m.com/

12. Scream World. Information on the *Scream* films and other related works.

 http://members.tripod.com/~Scream_World/Main_page.html

13. Forever Horror. A fan site, with information on various horror films and series.

 http://www.michalak.org/fh/

14. Supernatural Films. Excellent Web site edited by Tim Dirks.

 http://www.filmsite.org/supernatfilms.html

15. Horror Attic. Zombie and slasher horror films.

 http://www.geocities.com/hchong78/main

16. Bloody-Disgusting. Brutal and violent horror films.

 http://www.bloody-disgusting.com/

17. Oh My Gore. French-language Web site on horror films.

 http://www.ohmygore.com/

18. Darkweb Online. Useful database of horror, science fiction, and fantasy films.

 http://www.darkwebonline.com/

19. Horror Films. A great overview of the genre by Tim Dirks.

 http://www.filmsite.org/horrorfilms.html

20. All Horror Movies. A clearinghouse for all things horror.

 http://www.allhorrormovies.com/

21. Dark Angel's Realm of Horror. Video clips and horror film history.

 http://usersites.horrorfind.com/home/horror/realm/

22. Horror Express. Covers the production of horror films.

 http://www.horrorexpress.com/

23. The Horror House. Classic horror.

 http://www.angelfire.com/ok3/horrorhouse/

24. E-Splatter. Splatter film site, with reviews and links.

 http://www.esplatter.com

25. Asian Horror Movies. Asian horror films examined in detail.

 http://www.asian-horror-movies.com

26. Horror Film Compendium. Horror film reviews from the classic to contemporary films.

 http://www.xmission.com/~tyranist/horror/

27. Horror-Web. A good all-purpose site: reviews, interviews, and other material.

 http://horror-web.com/

28. Horror Flix. News, reviews, forums, discussion of horror films.
 http://www.horrorflix.net/
29. Carfax Abbey. Excellent site with reviews, biographies, and other information.
 http://www.carfax-abbey.com/
30. Pretty Scary. Horror Web site with women directors, actors, writers, and producers in horror. Highly recommended.
 http://www.pretty-scary.net/

50 Classic Horror Films

1. *Alien* (1979, directed by Ridley Scott)
2. *Audition* (1999, directed by Takashi Miike)
3. *Black Sabbath* (1963, directed by Mario Bava)
4. *Black Sunday* (1960, directed by Mario Bava)
5. *Bride of Frankenstein* (1935, directed by James Whale)
6. *The Brides of Dracula* (1960, directed by Terence Fisher)
7. *The Cabinet of Dr. Caligari* (1920, directed by Robert Wiene)
8. *Candyman* (1992, directed by Bernard Rose)
9. *Carrie* (1976, directed by Brian de Palma)
10. *Cat People* (1942, directed by Jacques Tourneur)
11. *The Curse of Frankenstein* (1957, directed by Terence Fisher)
12. *The Curse of the Werewolf* (1961, directed by Terence Fisher)
13. *Deep Red* (1975, directed by Dario Argento)
14. *The Devil Rides Out* (1968, directed by Terence Fisher)
15. *Dracula* (1931, directed by Tod Browning)
16. *Dracula: Prince of Darkness* (1966, directed by Terence Fisher)
17. *The Evil Dead* (1981, directed by Sam Raimi)
18. *The Exorcist* (1973, directed by William Friedkin)
19. *The Eye* (2002, directed by Danny and Oxide Pang)
20. *The Fog* (1980, directed by John Carpenter)
21. *Frankenstein* (1931, directed by James Whale)
22. *Freaks* (1932, directed by Tod Browning)
23. *Friday the 13th* (1980, directed by Sean S. Cunningham)
24. *The Grudge* (2000, directed by Takashi Shimizu)
25. *Halloween* (1978, directed by John Carpenter)
26. *Horror of Dracula* (1958, directed by Terence Fisher)
27. *The Howling* (1981, directed by Joe Dante)
28. *The Hunchback of Notre Dame* (1923, directed by Wallace Worsley)
29. *Island of Lost Souls* (1933, directed by Erle C. Kenton)

30. *The Mummy* (1932, directed by Karl Freund)
31. *Night of the Living Dead* (1968, directed by George Romero)
32. *A Nightmare on Elm Street* (1984, directed by Wes Craven)
33. *Nosferatu* (1922, directed by F. W. Murnau)
34. *The Omen* (1976, directed by Richard Donner)
35. *The Orphanage* (2007, directed by J. A. Bayona)
36. *Peeping Tom* (1960, directed by Michael Powell)
37. *Phantom of the Opera* (1925, directed by Rupert Julian)
38. *Psycho* (1960, directed by Alfred Hitchcock)
39. *Reanimator* (1985, directed by Stuart Gordon)
40. *The Revenge of Frankenstein* (1958, directed by Terence Fisher)
41. *Rosemary's Baby* (1968, directed by Roman Polanski)
42. *The Shining* (1980, directed by Stanley Kubrick)
43. *Suspiria* (1977, directed by Dario Argento)
44. *The Texas Chainsaw Massacre* (1974, directed by Tobe Hooper)
45. *The Thing* (1982, directed by John Carpenter)
46. *The Vampire Lovers* (1970, directed by Roy Ward Baker)
47. *Videodrome* (1983, directed by David Cronenberg)
48. *White Zombie* (1932, directed by Victor Halperin)
49. *The Wicker Man* (1973, directed by Robin Hardy)
50. *The Wolf Man* (1941, directed by George Waggner)

Bibliography

Acocella, Joan. "In the Blood." *The New Yorker,* March 16, 2009: 101–107.

Anderson, John. "Horror Revisits the Neighborhood." *New York Times,* March 15, 2009: AR 15.

Armstrong, Kent Byron. *Slasher Films: An International Filmography, 1960 through 2001.* Jefferson, NC: McFarland, 2003.

Asibong, Andrew. *Francois Ozon.* Manchester, UK: Manchester UP, 2008.

Balmain, Colette. "Mario Bava's *The Evil Eye*: Realism and the Italian Horror Film." *Post Script* 21.3 (Summer 2002): 20–31.

Bansak, Edmund G. *Fearing the Dark: The Val Lewton Career.* Jefferson, NC: McFarland, 1995.

Baraket, Mark. *Scream Gems.* New York: Drake, 1977.

Becker, Susanne. *Gothic Forms of Feminine Fictions.* New York: Manchester UP, 1999.

Benshoff, Harry M. "Blaxploitation Horror Films: Generic Reappropriation or Reinscription?" *Cinema Journal* 39.2 (Winter 2000): 31–50.

———. *Monsters in the Closet: Homosexuality and the Horror Film.* Manchester, UK: Manchester UP, 1997.

Berenstein, Rhona J. *Attack of the Leading Ladies: Gender, Sexuality, and Spectatorship in Classic Horror Cinema.* New York: Columbia UP, 1995.

Bishop, Kyle. "The Sub-Subaltern Monster: Imperialist Hegemony and the Cinematic Voodoo Zombie." *Journal of American Culture* 31.2 (June 2008): 141–152.

Bordwell, David. *Planet Hong Kong: Popular Cinema and the Art of Entertainment.* Cambridge, MA: Harvard UP, 2000.

Boulenger, Gilles. *John Carpenter: The Prince of Darkness.* Los Angeles: Silman-James, 2001.

Brode, Douglas. *Lost Films of the Fifties.* New York: Citadel, 1988.

Brottman, Mikita. *Offensive Films: Toward an Anthropology of Cinéma Vomitif.* Westport, CT: Greenwood, 1997.

Brunas, Michael. *Universal Horrors: The Studio's Classic Films, 1931–1946.* Jefferson, NC: McFarland, 1990.

Butler, Ivan. *Horror in the Cinema.* 2nd ed. New York: A. S. Barnes, 1970.

Carroll, Noel. *The Philosophy of Horror, or, Paradoxes of the Heart.* New York: Routledge, 1990.

Ceram, C. W. *Archaeology of the Cinema.* Richard Winston, trans. New York: Harcourt, Brace, 1960.

Chibnall, Steve, and Julian Petley, eds. *British Horror Cinema.* New York: Routledge, 2002.

Clarens, Carlos. *An Illustrated History of the Horror Film.* New York: G. P. Putnam's/ Paragon, 1967.

Clover, Carol J. *Men, Women, and Chainsaws.* Princeton: Princeton UP, 1992.

Conrad, Randall. "Mystery and Melodrama: A Conversation with Georges Franju." *Film Quarterly* 35.2 (Winter 1981): 31–42.

Cooper, I. Andrew. "The Indulgence of Critique: Relocating the Sadistic Voyeur in Dario Argento's *Opera.*" *Quarterly Review of Film and Video* 22.1 (2005): 63–72.

Craig, J. Robert. "From Karloff to Vosloo: *The Mummy* Remade." *Popular Culture Review* 13.1 (January 2002): 101–110.

———. "Howling at the Moon: The Origin Story in Werewolf Cinema." *Popular Culture Review* 17.1 (Winter 2006): 31–39.

Creed, Barbara. *The Monstrous-Feminine: Film, Feminism, Psychoanalysis.* New York: Routledge, 1993.

Cumbow, Robert C. *Order in the Universe: The Films of John Carpenter.* Lanham, MD: Scarecrow, 2000.

Curry, Christopher. *A Taste of Blood: The Films of Herschell Gordon Lewis.* London: Creation Books, 1999.

Dannen, Fredric, and Barry Long. *Hong Kong Babylon: The Insider's Guide to the Hollywood of the East.* New York: Miramax, 1997.

Derry, Charles. *Dark Dreams: A Psychological History of the Modern Horror Film.* New York: A. S. Barnes, 1977.

Dika, Vera. *Games of Terror: Halloween, Friday the 13th, and the Films of the Stalker Cycle.* Rutherford, NJ: Fairleigh Dickinson UP; London: Associated UP, 1990.

Dixon, Wheeler Winston. *The Charm of Evil: The Life and Films of Terence Fisher.* Metuchen, NJ: Scarecrow, 1990.

———. *The Films of Freddie Francis.* Metuchen, NJ: Scarecrow, 1991.

Doherty, Thomas. *Teenagers and Teen Pics: The Juvenilization of American Movies in the 1950s.* Boston: Unwin Hyman, 1988.

Edmundson, Mark. *Nightmare on Main Street: Angels, Sadomasochism, and the Culture of Gothic.* Cambridge, MA: Harvard UP, 1999.

Frann, F. M. Michel. "Life and Death and Something in Between: Reviewing Recent Horror Cinema." *Psychoanalysis, Culture & Society* 12.4 (December 2007): 390–397.

Freland, Cynthia A. *The Naked and the Undead: Evil and the Appeal of Horror.* Boulder, CO: Westview, 2000.

"Fritz Lang's *Metropolis*: Key Scenes Rediscovered," *Zeit Online,* July 2, 2008. http://www.zeit.de/online/2008/27/metropolis-vorab-englisch#prof. Accessed September 2, 2009.

Gagne, Paul R. *The Zombies That Ate Pittsburgh: The Films of George A. Romero.* New York: Dodd, Mead, 1987.

Galloway, Patrick. *Asia Shock: Horror and Dark Cinema from Japan, Korea, Hong Kong, and Thailand.* Berkeley, CA: Stone Bridge, 2006.

Gilvear, Kevin. "Discovering Korean Cinema: Horror." *DVD Times.* http://dvdtimes.co.uk/content.php?contentid=13173. Accessed May 9, 2009.

Goldsmith, Arnold L. *The Golem Remembered, 1909–1980: Variations of a Jewish Legend*. Detroit: Wayne State UP, 1981.

Gordon, Mel. *The Grand Guignol: Theatre of Fear and Terror*. New York: Da Capo, 1997.

"Grand Guignol." *Wikipedia*. http://en.wikipedia.org/wiki/Grand-Guignol. Accessed March 12, 2009.

Grant, Barry Keith, ed. *The Dread of Difference: Gender and the Horror Film*. Austin: U of Texas P, 1996.

Guerrero, Edward. "AIDS as Monster in Science Fiction and Horror Cinema." *Journal of Popular Film and Television* 18.3 (1990): 86–93.

Halligan, Benjamin. *Michael Reeves*. Manchester, UK: Manchester UP, 2003.

Hand, Richard, and Michael Wilson. *Grand-Guignol: The French Theatre of Horror*. Exeter, UK: U of Exeter P, 2002.

Handling, Piers, ed. *The Shape of Rage: The Films of David Cronenberg*. Toronto, New York: New York Zoetrope, 1983.

Hanke, Ken. *A Critical Guide to Horror Film Series*. New York: Garland, 1991.

Hawkins, Joan. "Sleaze Mania, Euro-Trash, and High Art: The Place of European Art Films in American Low Culture." *Film Quarterly* 53.2 (Winter 1999–2000): 14–29.

Heffernan, Kevin. "Inner-City Exhibition and the Genre Film: Distributing *Night of the Living Dead* (1968)." *Cinema Journal* 41.3 (2002): 59–77.

Herzogenrath, Bernd, ed. *The Films of Tod Browning*. London: Black Dog, 2006.

Hills, Matt. *The Pleasures of Horror*. New York: Continuum, 2005.

Hirschhorn, Clive. *The Universal Story*. New York: Crown, 1983.

Holte, James Craig. *Dracula in the Dark: The Dracula Film Adaptations*. Westport, CT: Greenwood, 1997.

Hopkins, Lisa. *Screening the Gothic*. Austin: U of Texas P, 2005.

Humphries, Reynold. *The American Horror Film: An Introduction*. Edinburgh: Edinburgh UP, 2002.

Hutchings, Peter. *Hammer and Beyond: The British Horror Film*. New York: Manchester UP, 1993.

Jackson, Neil. "*Cannibal Holocaust*, Realist Horror and Reflexivity." *Post Script* 21.3 (Summer 2002): 32–45.

Jensen, Paul M. *Boris Karloff and His Films*. New York: A. S. Barnes, 1974.

Jewell, Richard B., with Vernon Harbin. *The RKO Story*. New York: Arlington House/Crown, 1982.

Johnson, Tom. *Censored Screams: The British Ban on Hollywood Horror in the Thirties*. Jefferson, NC: McFarland, 1997.

Jones, Alan. *The Rough Guide to Horror Movies*. London: Rough Guides, 2005.

Jones, Stephen. *The Essential Monster Movie Guide*. New York: Billboard, 2000.

Juno, Andrea, and V. Vale. *Incredibly Strange Films: Research #10*. San Francisco: V/Search Publications, 1986.

Kehr, David. "Buried Treasures from Japanese Vaults," *New York Times*, March 15, 2009: AR 9.

Keisner, Jody. "Do You Want to Watch? A Study of the Visual Rhetoric of the Postmodern Horror Film." *Women's Studies* 37.4 (June 2008): 411–427.

Kinsey, Wayne. *Hammer Films: The Bray Studios Years*. London: Reynolds and Hearn, 2002.

———. *Hammer Films: The Elstree Studios Years*. Sheffield, UK: Tomahawk, 2007.

"Korean Horror & Suspense Movies." http://horror.about.com/od/korean/Korean.htm. Accessed May 8, 2009.

Landy, Marcia. *British Genres: Cinema and Society, 1930–1960*. Princeton: Princeton UP, 1991.

Lentz, Harris M. *Science Fiction, Horror & Fantasy Film and Television Credits*. Vols. 1–2. Jefferson, NC: McFarland, 2001.

Mank, Gregory William. *Bela Lugosi and Boris Karloff: The Expanded Story of a Haunting Collaboration*. Jefferson, NC: McFarland, 2009.

Mathijis, Ernest, and Xavier Mendick, eds. *Alternative Europe: Eurotrash and Exploitation Cinema since 1945*. London, New York: Wallflower, 2004.

Maxford, Howard. *The A-Z of Horror Films*. Bloomington: Indiana UP, 1997.

Mayne, Judith. *Claire Denis*. Urbana: U of Illinois P, 2005.

McCallum, Lawrence. *Italian Horror Films of the 1960s*. Jefferson, NC: McFarland, 1998.

McDonagh, Maitland. "Broken Mirrors/Broken Minds: The Dark Dreams of Dario Argento." *Film Quarterly* 41.2 (Winter 1987–1988): 2–13.

McMahan, Alison. *Alice Guy Blaché: Lost Visionary of the Cinema*. New York: Continuum, 2002.

McRoy, Jay. *Japanese Horror Cinema*. Honolulu: U of Hawaii P, 2005.

———, ed. *Nightmare Japan: Contemporary Japanese Horror Cinema*. Amsterdam: Rodopi, 2008.

Milne, Tom. *The Overlook Film Encyclopedia: Horror*. Woodstock, NY: Overlook, 1994.

Morton, Lisa. *The Cinema of Tsui Hark*. Jefferson, NC: McFarland, 2001.

Muir, John Kenneth. *Wes Craven: The Art of Horror*. Jefferson, NC: McFarland, 1998.

Murphy, Robert. *Sixties British Cinema*. London: British Film Institute, 1992.

Newman, Kim, ed. *The BFI Companion to Horror*. London: Cassell, 1996.

O'Brien, Geoffrey. *The Phantom Empire*. New York: Norton, 1993.

Palmer, Randy. *Herschell Gordon Lewis, Godfather of Gore: The Films*. Jefferson, NC: McFarland, 2000.

Paul, Louis. *Italian Horror Film Directors*. Jefferson, NC: McFarland, 2005.

Peary, Danny. *Cult Movies 3*. New York: Simon and Schuster/Fireside, 1988.

Perry, George. *Forever Ealing*. London: Pavilion, 1981.

Pirie, David. *A Heritage of Horror: The English Gothic Cinema 1946–1972*. New York: Avon/Equinox, 1973.

———. *A New Heritage of Horror: The English Gothic Cinema*. London: I. B. Tauris, 2008.

Prince, Stephen, ed. *The Horror Film*. New Brunswick: Rutgers UP, 2004.

Robb, Brian J. *Screams & Nightmares: The Films of Wes Craven*. Woodstock, NY: Overlook, 1998.

Russell, Dennis. "Beyond Cheap Thrills: Dark Visions of Slasher/Gore Film Fans." *Popular Culture Review* 8.1 (February 1997): 59–74.

Salmon, Andrew. "Seoul's Long, Hot, Horrid Summer." http://www.iht.com/articles/2004/09/18/salmon-ed3-.php. Accessed May 8, 2009.

Sangster, Jimmy. *Inside Hammer*. London: Reynolds and Hearn, 2001.

Schneider, Steven Jay, ed. *Horror Film and Psychoanalysis: Freud's Worst Nightmare*. Cambridge: Cambridge UP, 2004.

"Seattle Maggie." "K-Horror Needs a Haircut." http://www.cinecultist.com//archives/000572.php. Accessed May 8, 2009.

Sharrett, Christopher. "The Horror Film in Neoconservative Culture." *Journal of Popular Film and Television* 21.3 (1993): 100–110.

Siegel, Joel E. *Val Lewton: The Reality of Terror*. New York: Viking, 1973.

Silke, James R. *Here's Looking at You, Kid*. Boston: Little, Brown, 1976.

Silver, Alain, and James Ursini, eds. *Horror Film Reader*. New York: Limelight, 2000.

Silverman, Jason. "K-Horror Is New J-Horror." *Wired*. http://www.wired.com/culture/lifestyle/news/2007/03/72897. Accessed May 8, 2009.

Skal, David J. *The Monster Show: A Cultural History of Horror*. New York: Norton, 1993.

Skal, David J., and Elias Savada. *Dark Carnival: The Secret World of Tod Browning—Hollywood's Master of the Macabre*. New York: Anchor Books, 1995.

Telotte, J. P. *Dreams of Darkness: Fantasy and the Films of Val Lewton*. Urbana: U of Illinois P, 1985.

Teo, Stephen. *Hong Kong Cinema: The Extra Dimensions*. London: British Film Institute, 1997.

Tohill, Cathal, and Pete Tombs. *Immoral Tales: European Sex and Horror Movies 1956–1984*. New York: St. Martin's/Griffin, 1995.

Tombs, Pete. *Mondo Macabro: Weird and Wonderful Cinema Around the World*. New York: St. Martin's/Griffin, 1998.

Tudor, Andrew. *Monsters and Mad Scientists: A Cultural History of the Horror Movie*. London: Basil Blackwell, 1989.

Vieira, Mark A. *Hollywood Horror: From Gothic to Cosmic*. New York: Harry N. Abrams, 2003.

Wada-Marciano, Mitsuyo. "J-HORROR: New Media's Impact on Contemporary Japanese Horror Cinema." *Canadian Journal of Film Studies* 16.2 (Fall 2007): 23–48.

Wai-ming Ng, Benjamin. "When Sadako Meets Mr. Vampire: The Impact of *Ringu* on Hong Kong Ghost Films." *Asian Cinema* 19.1 (Spring/Summer 2008): 143–156.

Waller, Gregory A., ed. *American Horrors*. Urbana: U of Illinois P, 1987.

Wee, Valerie. "Resurrecting and Updating the Teen Slasher." *Journal of Popular Film and Television* 34.2 (Summer 2006): 50–62.

Weiss, Andrea. *Vampires and Violets: Lesbians in Film*. New York: Penguin, 1992.

Wells, Paul. *The Horror Genre: From Beelzebub to Blair Witch*. New York: Wallflower, 2000.

Will, David, and Paul Willemen, eds. *Roger Corman: The Millenic Vision.* Edinburgh: Edinburgh Film Festival, 1970.

Wright, Bruce Lanier. *Nightwalkers: Gothic Horror Movies, The Modern Era.* Dallas: Taylor, 1995.

Wright, Gene. *Horrorshows: The A to Z of Horror in Film, TV, Radio and Theatre.* New York: Facts on File, 1986.

INDEX

About the Author

WHEELER WINSTON DIXON is the James Ryan Endowed Professor of Film Studies and Professor of English at the University of Nebraska, Lincoln, and with Gwendolyn Audrey Foster, editor-in-chief of the *Quarterly Review of Film and Video*. His newest books include *Film Noir and the Cinema of Paranoia* (Rutgers University Press and Edinburgh University Press, 2009); *A Short History of Film*, written with Gwendolyn Audrey Foster (Rutgers University Press and I.B. Tauris, 2008); *Film Talk: Directors at Work* (Rutgers University Press, 2007); *Visions of Paradise: Images of Eden in the Cinema* (Rutgers University Press, 2006); *American Cinema of the 1940s: Themes and Variations* (Rutgers University Press, 2006); and *Lost in the Fifties: Recovering Phantom Hollywood* (Southern Illinois University Press, 2005). In 2003 Dixon was honored with a retrospective of his films at the Museum of Modern Art in New York, and his films were acquired for the permanent collection of the museum, in both print and original format.